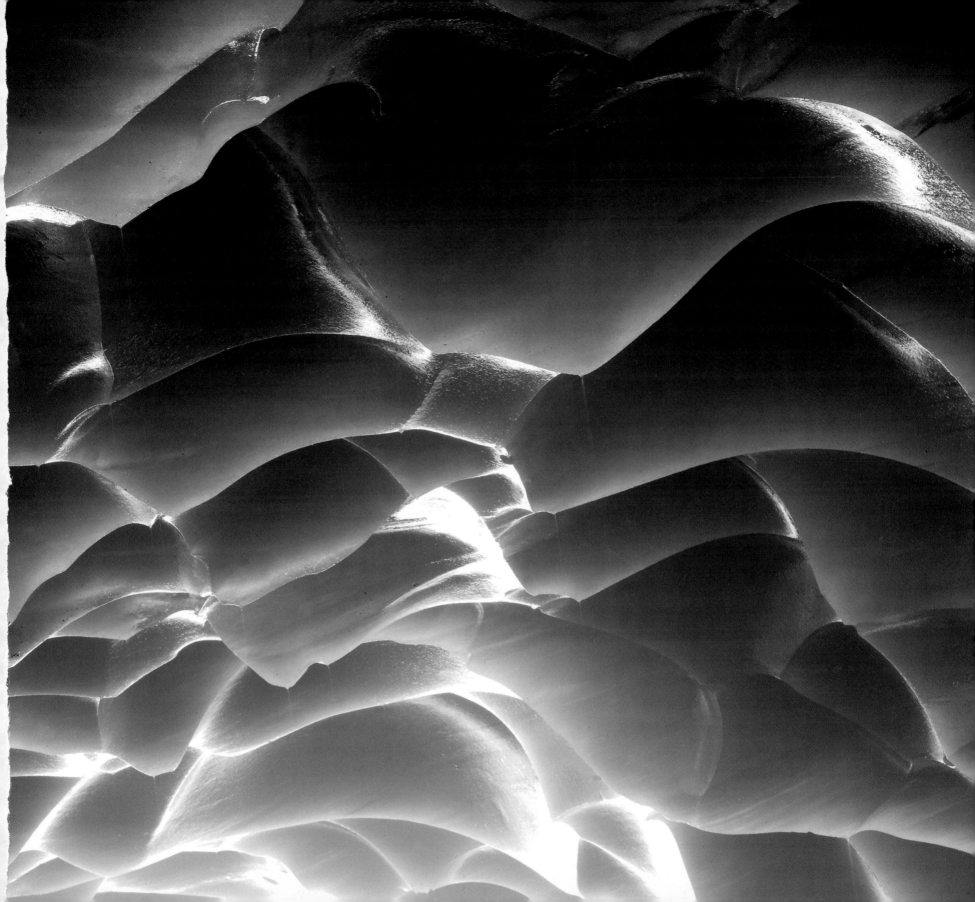

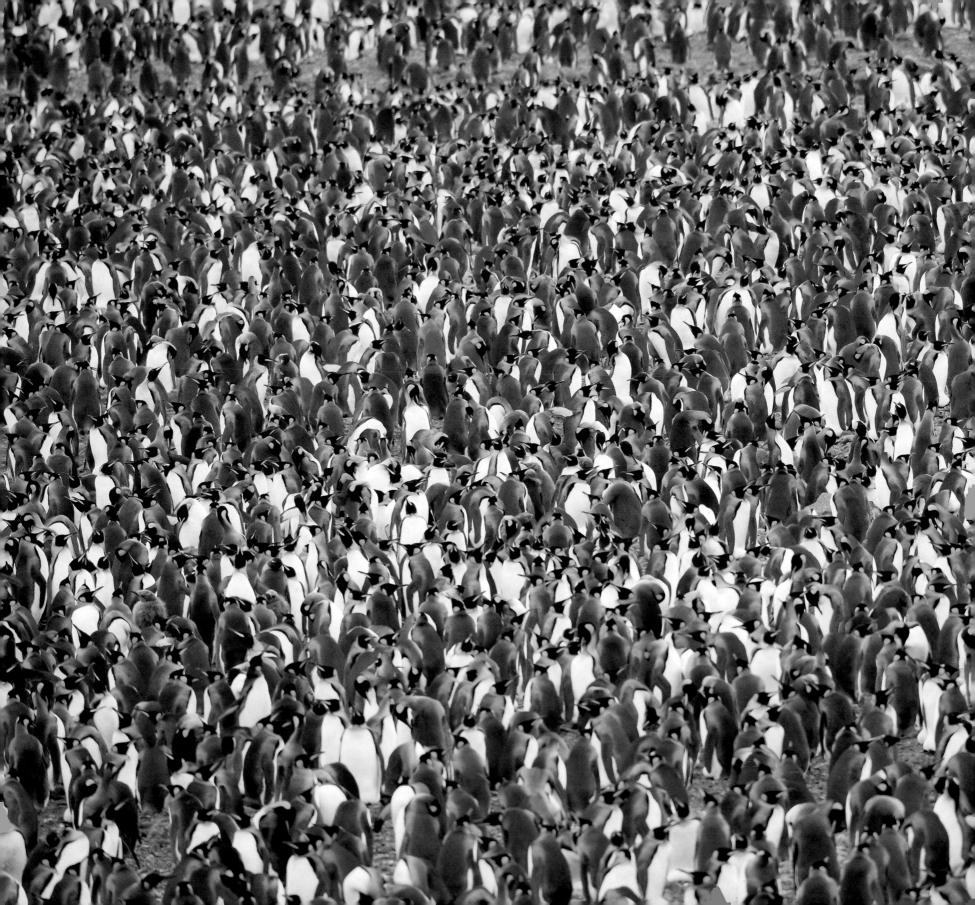

PLANET ICE

A CLIMATE FOR CHANGE

PHOTOGRAPHY BY

JAMES MARTIN

YVON CHOUINARD ∗ GINO CASASSA ∗ RICHARD ALLEY ∗ IAN STIRLING

NICK JANS ∗ BROUGHTON COBURN ∗ GRETEL EHRLICH

BRAIDED RIVER

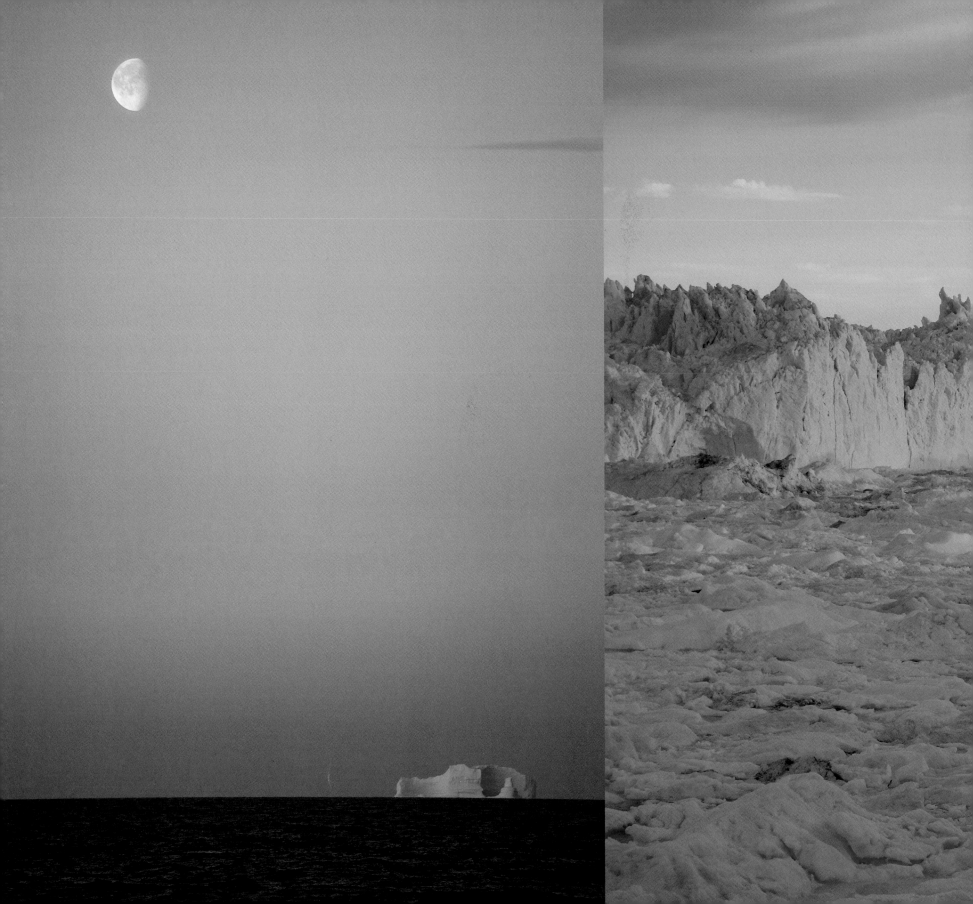

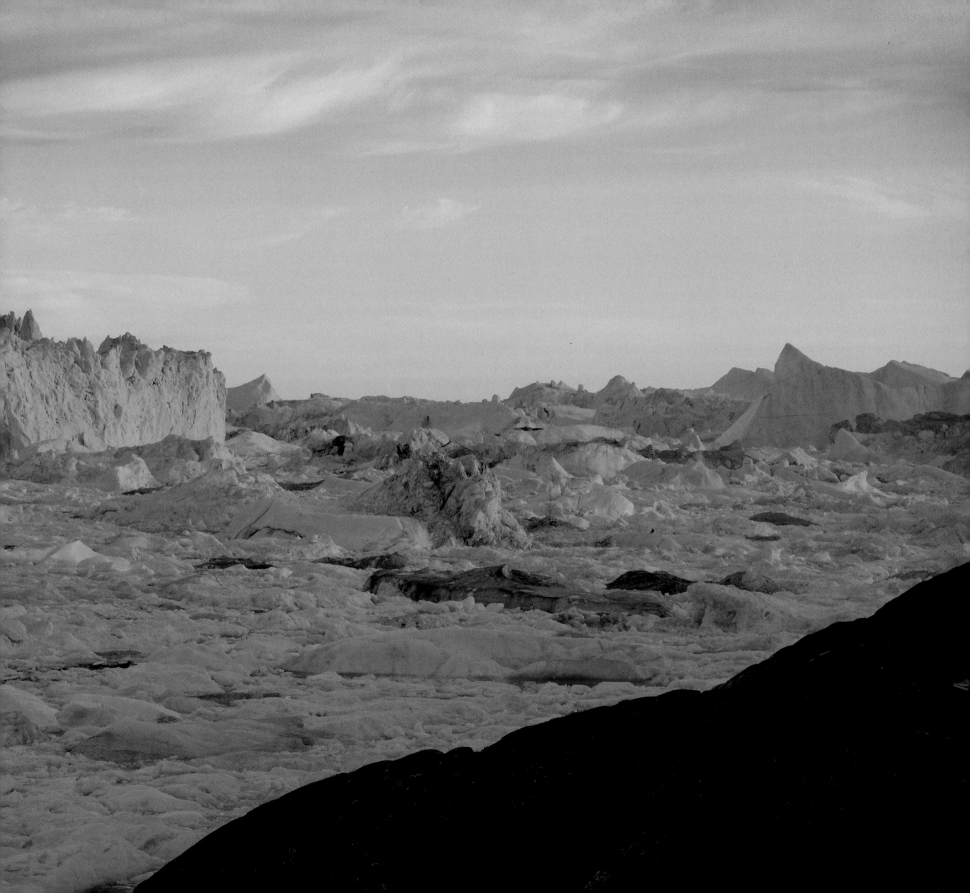

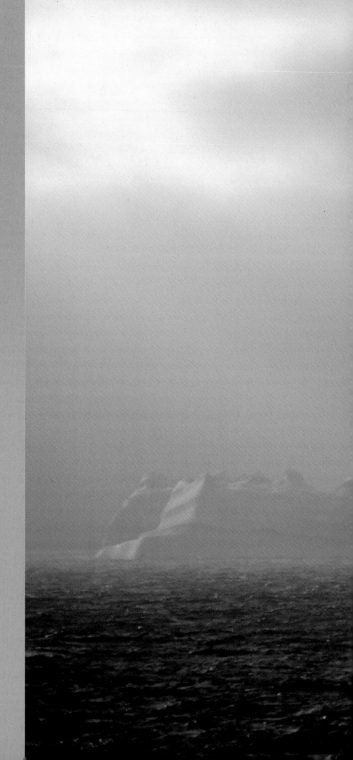

For Joe Van Os,
who brought me to the emperor penguins
and South Georgia Island
and changed the course of my life

–James Martin

PAGE 1 Wind and water have hollowed out an ice cave in Jasper National Park, Alberta, Canada.

PAGE 2 Tens of thousands of king penguins congregate on the northern beaches of South Georgia Island where they raise their young.

PAGE 3 Pack ice near Greenland

PRECEDING PAGES, LEFT Moonrise over an iceberg in the North Atlantic

PRECEDING PAGES, RIGHT Small icebergs carried by swift currents pass stranded giants at the mouth of the ice fjord in western Greenland.

RIGHT Tabular icebergs, fragments from disintegrating ice shelves, are common downwind (east) of the Antarctic Peninsula in the South Atlantic.

Contents

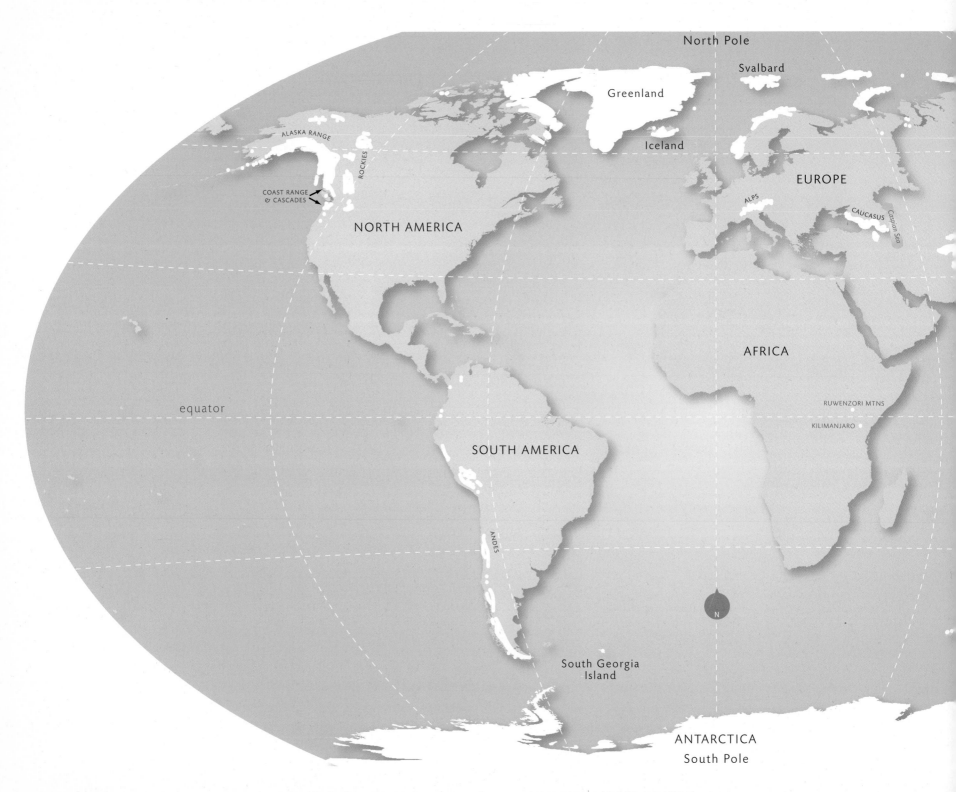

8

North Pole

Svalbard

Greenland

Iceland

EUROPE

ALASKA RANGE

ROCKIES

COAST RANGE
& CASCADES

NORTH AMERICA

ALPS

CAUCASUS

Caspian Sea

AFRICA

equator

RUWENZORI MTNS

KILIMANJARO

SOUTH AMERICA

ANDES

N

South Georgia
Island

ANTARCTICA
South Pole

SOURCE: GLOBAL LAND ICE MEASUREMENTS FROM SPACE, NATIONAL SNOW AND ICE DATA CENTER (HTTP://NSIDC.ORG/GLIMS)

DISTRIBUTION OF GLACIERS AND ICE AROUND THE WORLD

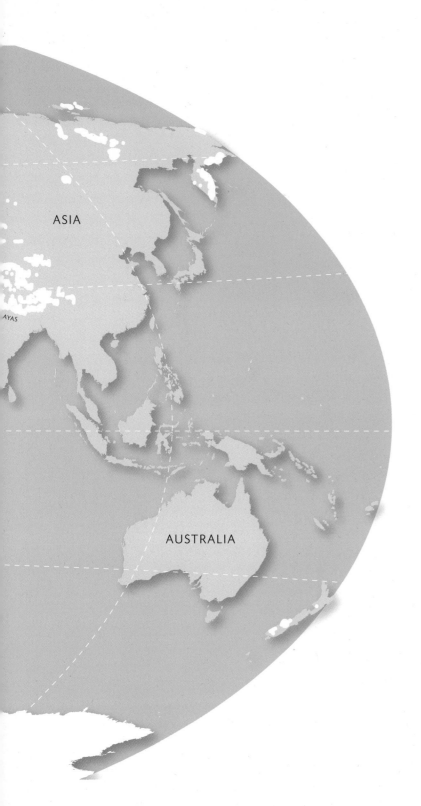

ASIA

AYAS

AUSTRALIA

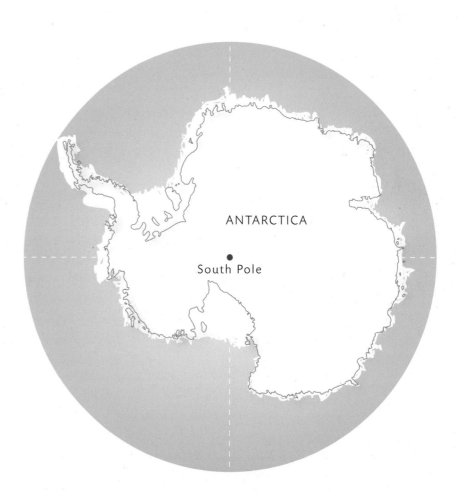

PLANET ICE MAPS

- ● **Town**
- ✶ **CAPITAL CITY**
- ■ **RESEARCH STATION**
- • Pole
- ▲ MOUNTAIN
- ⟨⟨⟨⟨⟨⟨ *Glacier*

ANTARCTICA

•
South Pole

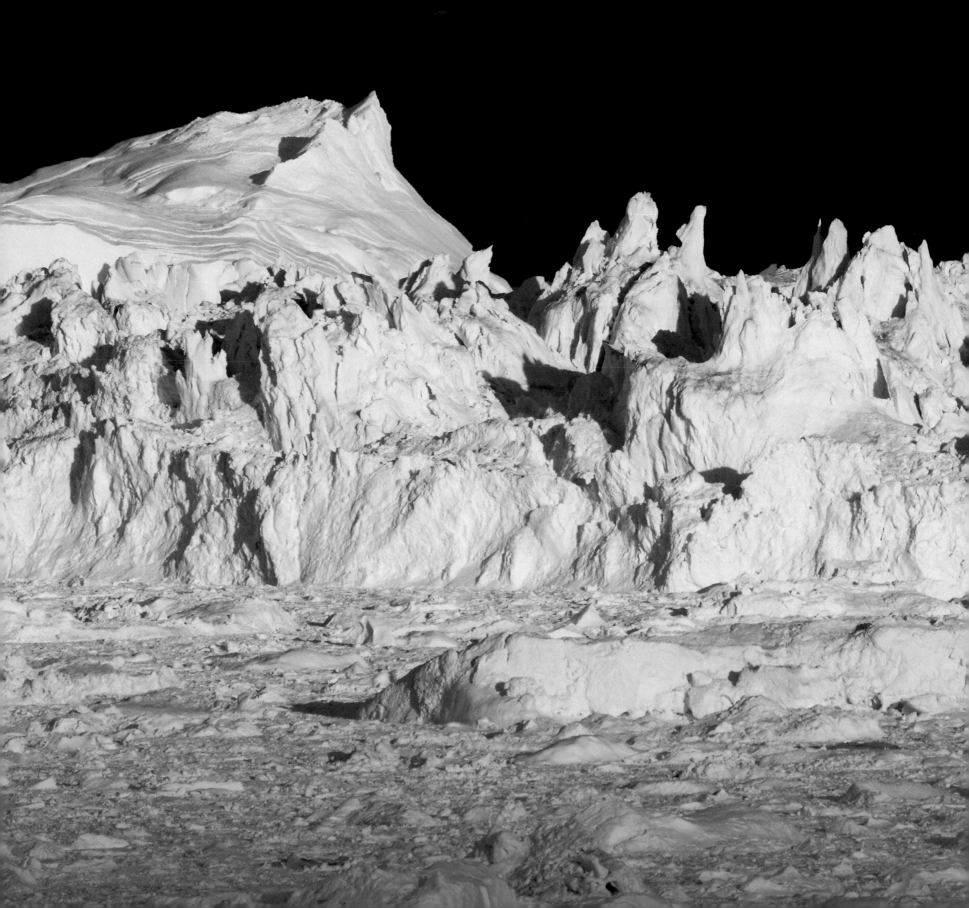

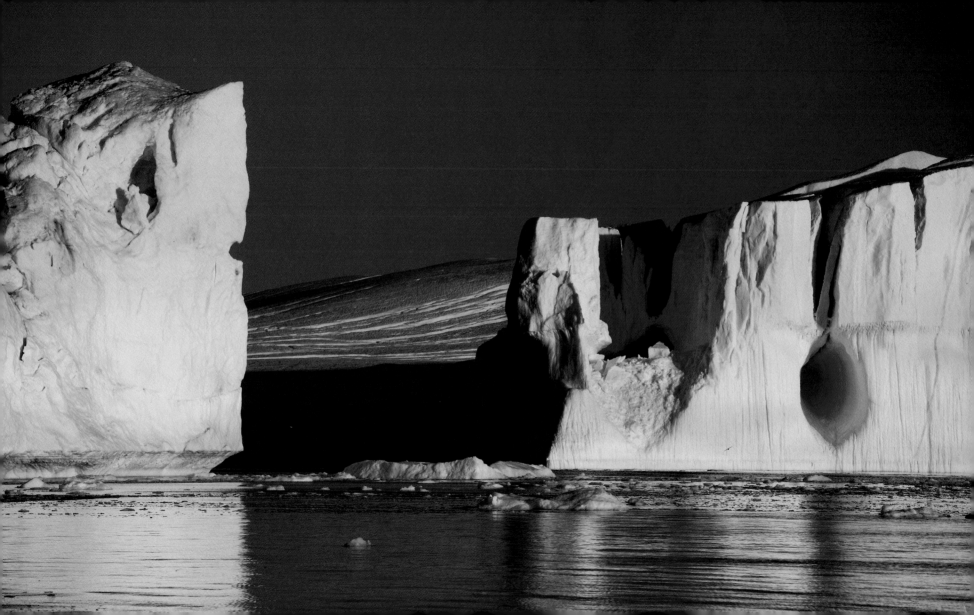

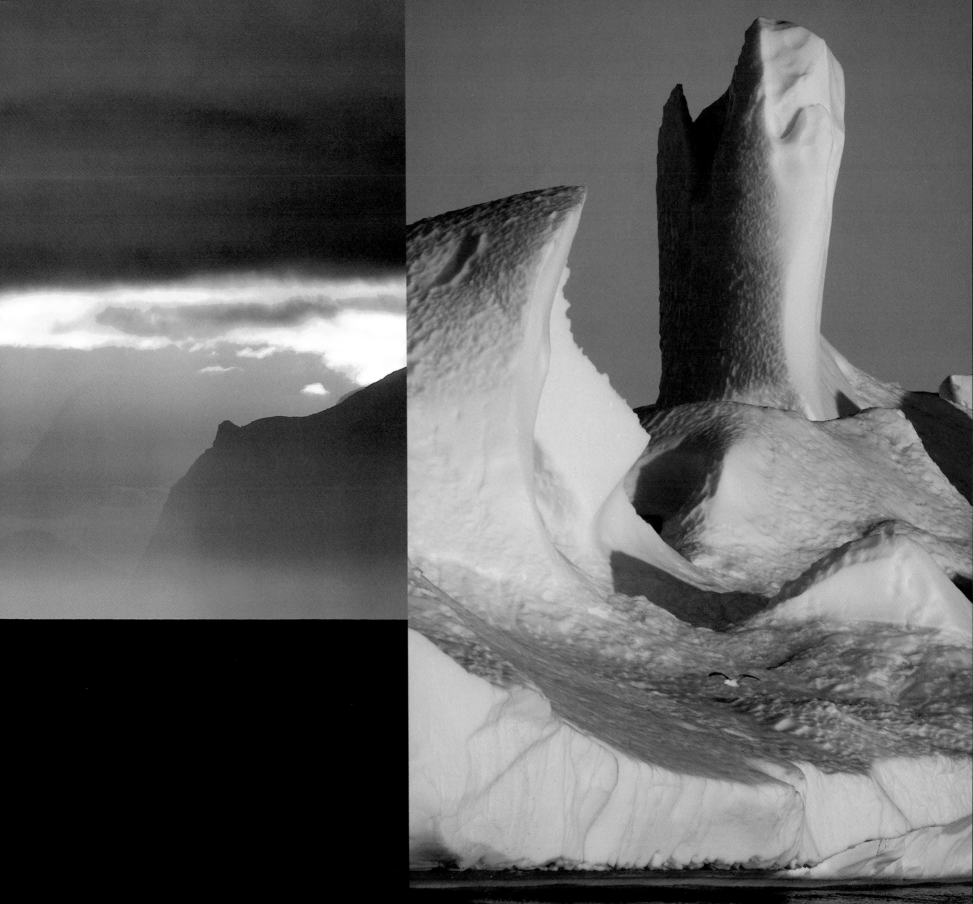

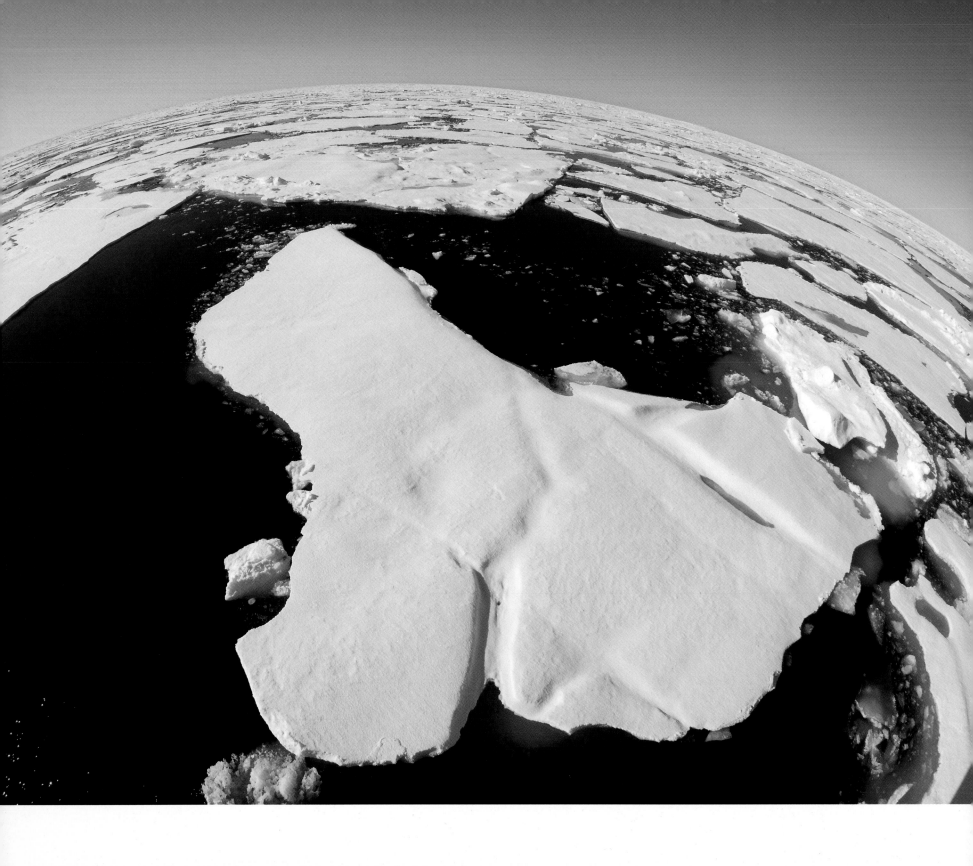

PREFACE
PLANET ICE

Helen Cerullo

A s ancient ice melts and retreats, its wild power is rapidly chang-ing our planet. This book takes us on a worldwide journey of Earth—of "Planet Ice"—to Antarctica, Greenland, Patagonia, Alaska, Mount Everest, the Andes, Mount Kilimanjaro, the Alps, the Rockies, the Cascades, China, Iceland, and more.

Examining the history of ice on Earth provides a lens that allows us to see our future. Current conditions affected by human activity reveal how life must swiftly adapt to a warming world. Climate shifts are altering our landscapes as well as the people, animals, birds, insects, fish, plants, and pollinators that have interacted for millennia as an elegant interrelated marvel of life. If we continue to let carbon pollu-tion go unchecked, future generations will pay the price for our current unsustainable consumption of energy.

All life is connected, and the consequences of fragmentation are complex. Without the benefit of time for generations to adapt to a warming world, many species will be severely compromised. Some will perish and become distant memories. The polar bear's plight has generated the most visible public outrage, but there are many other less visible and charismatic organisms at equal risk. Penguins, those charming creatures of the Southern Hemisphere, are also being affected by climate change. Sixteen of the world's seventeen species of penguin

LEFT A fisheye image shot from the bow of an icebreaker
north of the Arctic Circle

15

depend on ice and a cold environment for their survival.

With freshwater, we know the difference that a change of one degree of temperature can make—from a liquid to a solid, from a solid to a liquid. Floods from increasing sea levels, as well as widespread droughts from lack of freshwater previously held in reserve as glaciers, ice, and snow in the mountains, would change our planet. Instead of the seasonal cycle of melt and freeze that has sustained our planet for millions of years, ice could melt in a horrific acceleration, and the precious freshwater on which all life depends would be squandered. We could lose rain forests and experience food shortages. This is the cautionary tale of *Planet Ice.*

Climate change is a hard topic to personalize; it is often a largely abstract concept without a sense of urgency. Politicians continue to underestimate the impact of climate change, and scientists remain frustrated in their efforts to get our leaders to understand the issues. We ourselves can be reluctant to change comfortable habits until immediate and personal threats compel us to act. However, if we wait for these threats to knock on our front doors, it will be too late to stop the momentum. We must act now—and it is up to us to encourage brave and visionary change in our communities, our workplaces, schools, and government.

As members of the consumer economy that contributed to these conditions, it is our responsibility to lead. The resulting transformation could reap rewards—for our environment as well as our economy—in return. Many of our industries that have served our comfortable living standards for decades are stagnant. We have the ingenuity and resourcefulness now to introduce invigorating new ways to do business—fuel transportation, grow crops, heat homes, provide energy. It is a matter of faith in our entrepreneurial heritage and our political courage. This is an exciting time to be alive—we are at a crucial point: We can make decisions that will impact the course of future life on Earth. And we can embrace hope, because there are solutions to draw upon.

Why continue to use more than we need to on the chance that future generations might suffer for it? Why not champion change and innovation that provide stimulus for new economies? These are dynamic times, full of possibility. Rather than squander the opportunity, please join us in creating solutions. Through our work at Braided River—and, with this book, multimedia presentations, media outreach, and exhibits—the compelling images of ice by James Martin and the science and stories of the life that depends on its continued presence can inspire both dialogue and change.

For up-to-date links to resources and a wide array of choices from energy to individual action, please visit www.BraidedRiver/PlanetIce/Resources for timely ways to get involved.

Modest changes by many people can make a difference. This is the hopeful story of *Planet Ice.*

Helen Cherullo is publisher of The Mountaineers Books and executive director of Braided River, a not-for-profit conservation partner of The Mountaineers Books. For more information, visit www.BraidedRiver.org.

On an ice shelf in the Weddell Sea near the Antarctic Circle, a tourist encounters an emperor penguin.

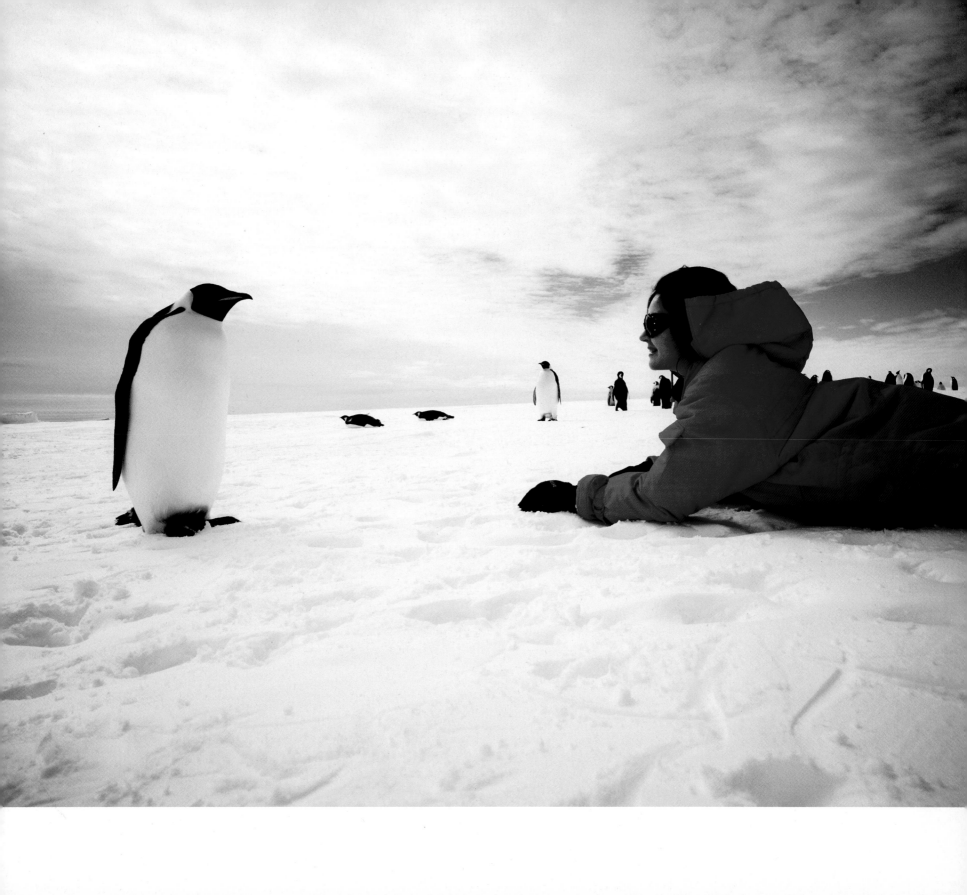

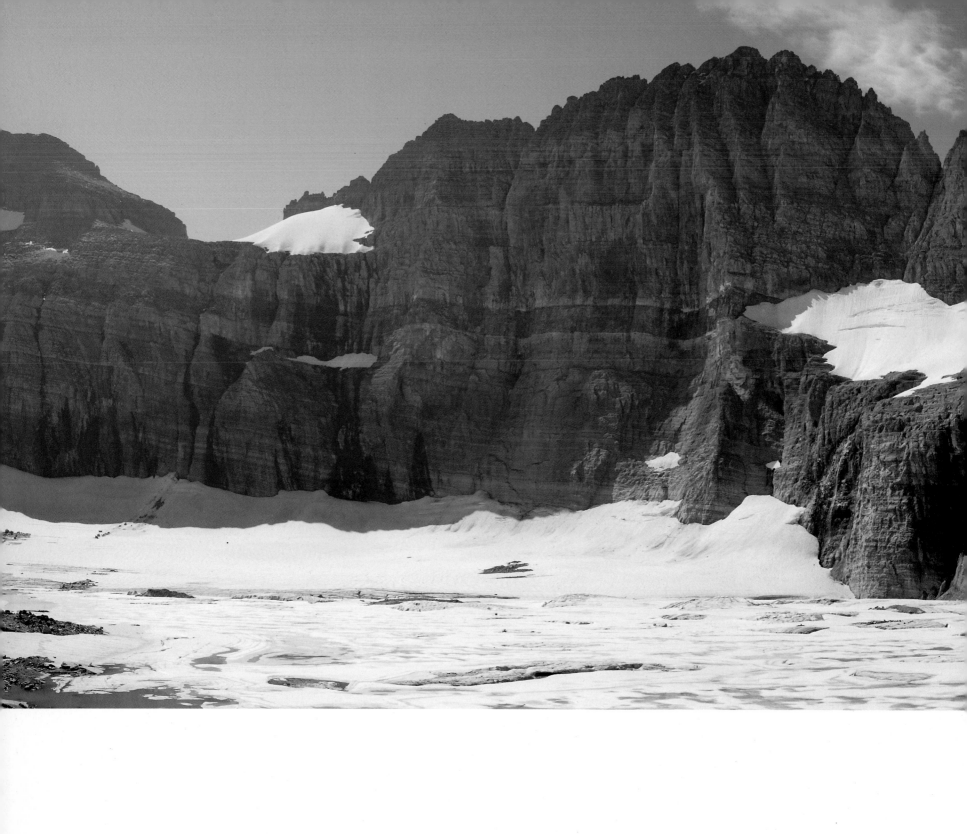

One hundred and fifty years ago, the Grinnell Glacier in Glacier National Park, Montana, filled this basin halfway to the summit ridge; today, all that remains is a patch of ice to the left of this partially frozen lake.

FALLING FOR ICE
A PHOTOGRAPHER'S PASSION

Introduction by James Martin

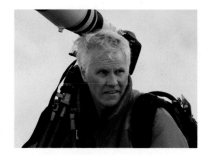

JAMES MARTIN, once a climbing guide in the North Cascades and Canadian Rockies, is a Seattle-based writer and photographer and currently a photography trip leader for Joseph Van Os Photo Safaris and executive director of Art Wolfe Inc. Martin has contributed to numerous magazines, such as *Outdoor Photographer, Smithsonian, Outside,* and *Sports Illustrated;* he also has seventeen books to his credit, including *Digital Photography Outdoors* and *Extreme Alpinism* with Mark Twight. He is represented by Getty Images. Please visit www.planeticebook.com to view more of Martin's images. *Photograph by Dan Larsen*

From this high camp in the Glacier Peak Wilderness in Washington State's North Cascades, the route of the Ptarmigan Traverse ascends the glacier across the valley.

I started working on *Planet Ice* to encourage people to appreciate the role of ice on Earth. Ice carves the landscape, drastically changing the topography we live upon. Ice reflects heat back into space, helping to regulate global temperatures. It provides habitat for unique animals adapted to these harsh environments. Ice stores freshwater that sustains life on entire continents.

While these facets of ice have important, tangible effects on life around the world, it is the beauty of ice and the wild environments where it abides that initially animated my interest. When I was growing up, I fell hard for ice, dazzled and awestruck. This book is a love story.

In high school, I pored over U.S. Geological Survey (USGS) aerial photographs of Alaskan glaciers snaking through high ranges, lobed piedmont glaciers flowing off Ellesmere Island in the Canadian Arctic like melting ice cream, cities of seracs tilted at wild angles and falling in slow motion over cliffs. I devoured books on glaciology, learning to read glacial fingerprints: mountains carved into spires, arêtes, matterhorns; river valleys excavated into U shapes; continents bulldozed, soil scraped down to grooved and polished granite studded with erratic boulders; end moraines recording the farthest extent of the ice; medial moraines showing how thick the ice grew. I studied ice pitches on famous climbs: White Spider on the Alps's Eiger, the Khumbu Icefall

on Everest, the narrow gullies of the Scottish Highlands. I dreamed of crossing ice sheets or pack ice, alone in places that resemble the outer planets more than our welcoming Earth.

Over the years, I have visited the places of my dreams and have experienced all that I imagined—and more. Far from cities, in the wildest corners of the world, I lost track of the ephemera of civilization, appreciating the natural world, ice in particular. I began to see ice not as an object but as a process. Living glaciers move over uneven terrain, deforming, cracking into crevasses, fragmenting into unstable ice towers. Ice melts, creating streams, ponds, or lakes. Snow on the ice melts into suncups that, under intense sun, deepen and thin into spikes called *nieves penitentes*, or "snow monks." Each encounter with ice has deepened my delight in its shifting forms.

Crossing glaciers and climbing mountains, I sometimes found myself doubting my chances of survival. High winds and subzero temperatures leave little room for error, and nothing strips away the unnecessary like the prospect of death. The more difficult the climb, the tighter the focus.

One winter, on the Triplets in the North Cascades of Washington State, legendary climber Jim Nelson and I raced against darkness and lost, finding ourselves at the top of a steep, smooth rock wall covered in just a few inches of ice. A fall would almost certainly have been fatal. With no anchor available for a rappel, without headlamps or ropes, we started down, each of us balancing on four crampon points and the picks of two short ice axes. A hard swing of the ax or crampons shattered the thin ice. All our attention was concentrated on carefully setting

LEFT **A minke whale feeds in an ice-choked bay along the Antarctic Peninsula.**

RIGHT **A landscape of ice arches, tunnels, and odd shapes appeared when a surface lake drained on the Greenland Ice Sheet.**

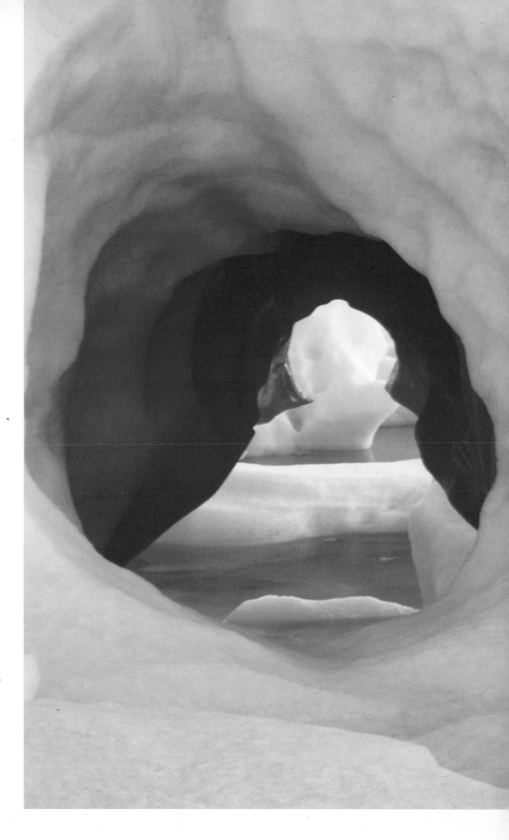

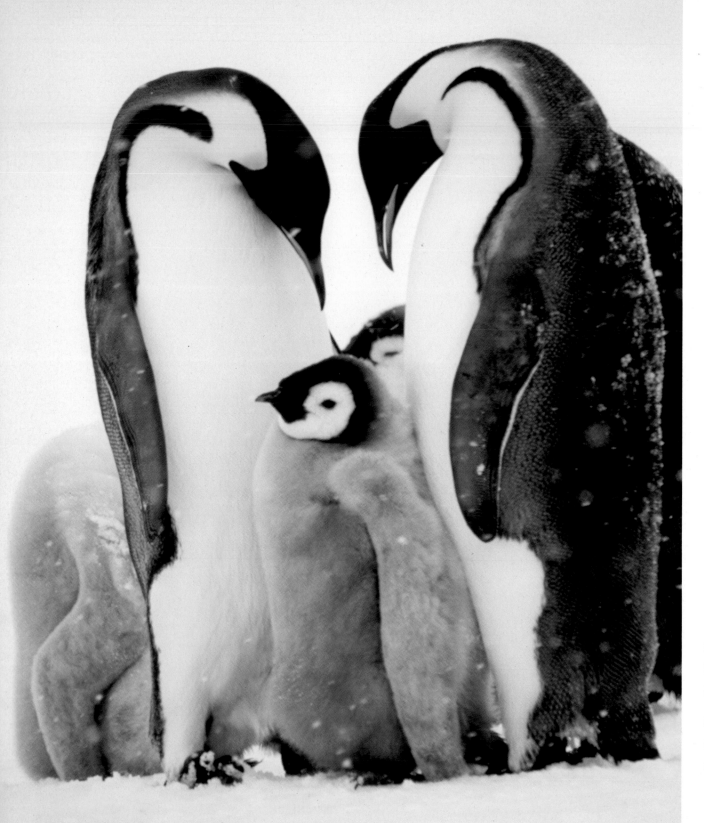

LEFT Adult emperor penguins care for a rapidly growing chick on the Riiser-Larsen Ice Shelf, Antarctica.

RIGHT A polar bear and her cub sleep in the snow near Churchill, Manitoba, Canada.

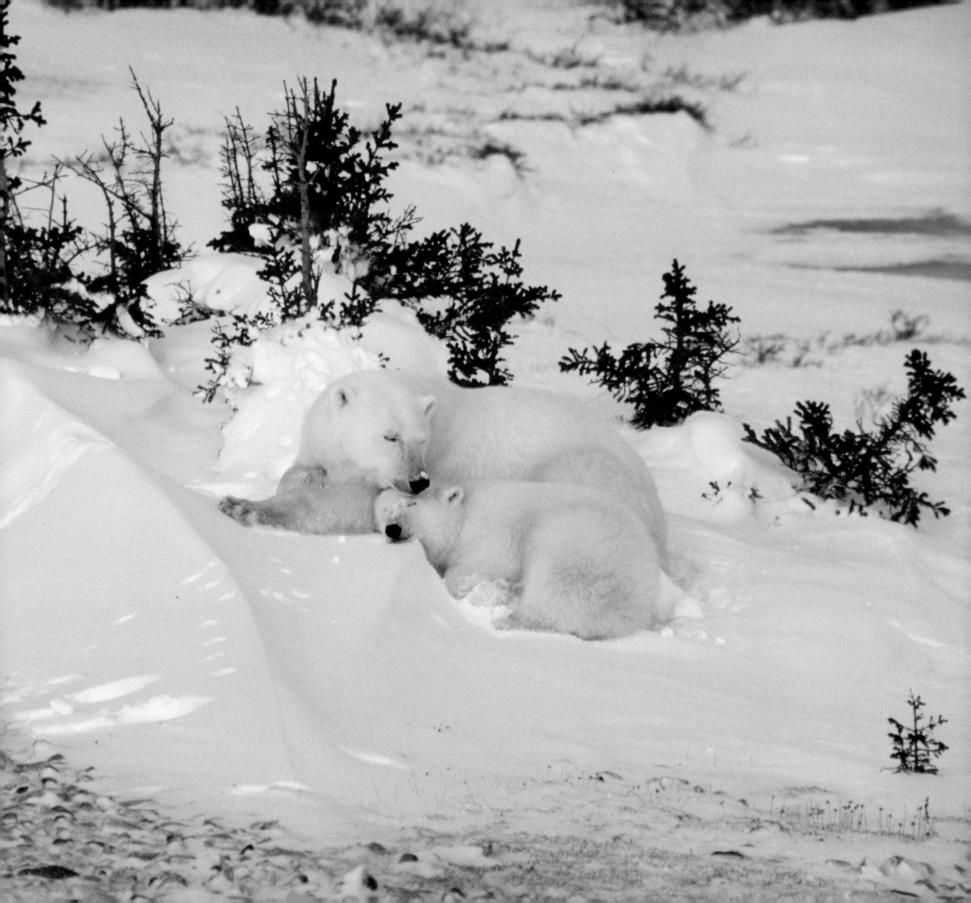

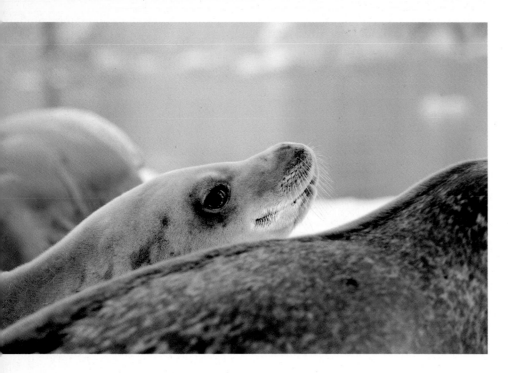

ABOVE **A crab eater seal rests on an Antarctic iceberg; once they are out of the water, their only enemy is the leopard seal.**

OPPOSITE **First light tints Mount Kilimanjaro, Tanzania. Only remnants are left of the glaciers that once blanketed the summit.**

the tools, assessing the placement, and moving smoothly. The world was reduced to a few square feet of ice; both future and past ceased to exist.

Each such experience has acted like a reset button: for a while, I see life with new eyes. After I've spent days or weeks in the mountains, the saturated greens of the lowlands seem luscious and overripe. When I return home, I revel in comforts, but I soon ache for another dose of the austere landscapes I have come to love: black rock, white ice, the sky gray or icy blue. On the ice, the world looks scrubbed clean; the artifacts of culture are missing—but not missed.

These landscapes of ice are multiple and worldwide. Glacier ice is found on every continent except Australia. In the tropical and temperate regions, it is confined to mountains, but near the poles the ice sheets and glaciers flow down to sea level and the ocean freezes solid. Wherever temperatures fall sufficiently, ice forms on lakes, on rivers, and in tiny cracks in rock. When the ice expands, the mountains crumble, slowly but surely, while lake ice shoves the shoreline like a road grader. When the spring thaw arrives, river ice tumbles like a rock avalanche in slow motion. Ice shapes our planet from the polar regions to the equatorial Himalayas. And while it was the pure form of ice itself that first attracted me, I have grown to appreciate the adaptations of animals that have evolved to survive in environments I can only visit.

In Antarctic Bay, a southern minke whale circled our Zodiac raft, and I heard its grand, percussive exhalation, an octave lower than the lowest note of a pipe organ. As we waited for its next breath, we heard only the crackling of ice meeting water. Suddenly we heard the whale's immense lungs contracting, then spray raining on the sea. We saw its slick black back and small fins briefly sliding through air, reentering the frigid water with hardly a splash.

On the other side of the world, walking a bluff above the ice fjord near Ilulissat, Greenland, I again heard the distinctive sound of whales, a spare rhythm of single-note exhalations and long rest notes. At the end of the fjord—a 40-kilometer-long (25-mi) channel filled with icebergs

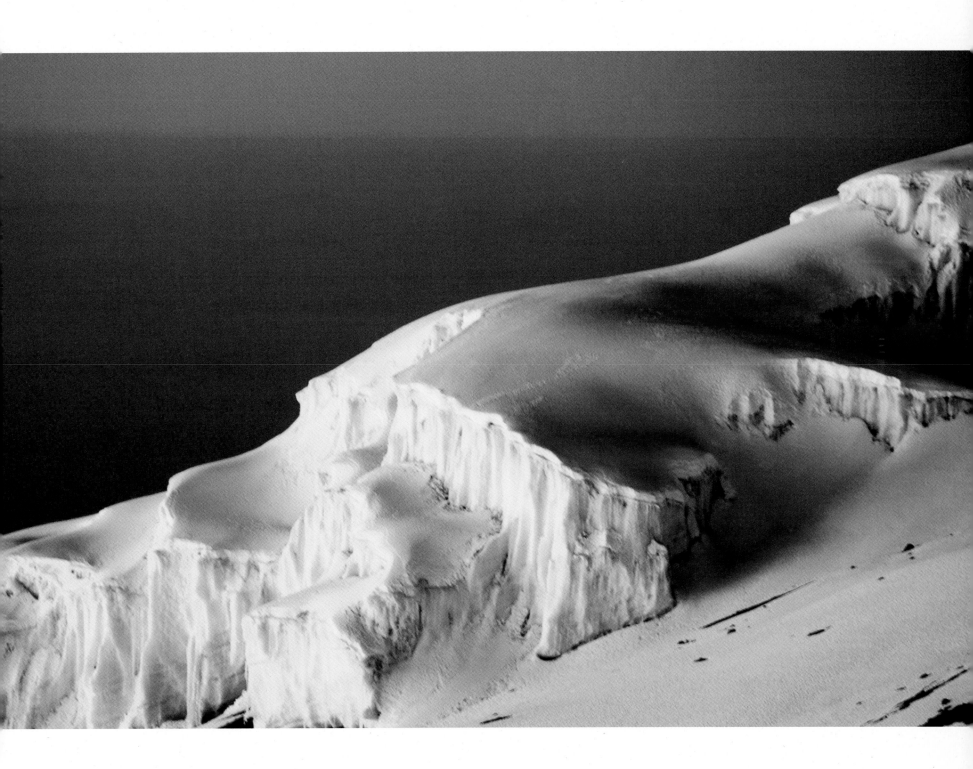

SHAPED BY ICE

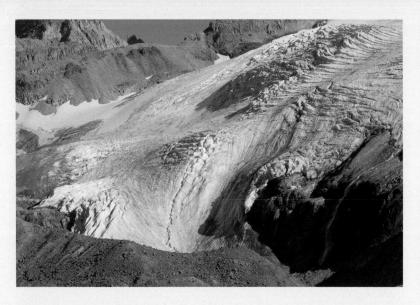

This end moraine bulldozed by a glacier flowing off the north face of Mount Athabasca in Canada looks like a crater rim.

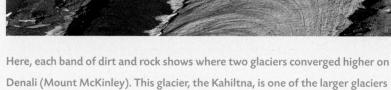

Here, each band of dirt and rock shows where two glaciers converged higher on Denali (Mount McKinley). This glacier, the Kahiltna, is one of the larger glaciers in Denali National Park, Alaska.

▲ END MORAINES

When the ice of a glacier is frozen to the rocks beneath, those rocks are shielded from erosional processes. But when ice is thawed at the bottom, the glacier often erodes land faster than rivers do, carving truly spectacular features. With all that eroding going on, the loose rocks must be dumped somewhere. A glacier outlines itself by dumping loose rock material into a pile, called an end moraine. End moraines form as streams emerging from beneath the glacier lose speed and deposit their sediment load, as till (water-saturated mud) is dragged along beneath the glacier until the ice ends, and as any rocks that fell on the ice are released by melting ice. –*Richard Alley*

▲ MEDIAL MORAINES

When a glacier retreats, any till (water-saturated mud) it was smearing along is left behind as a layer spread across the landscape. Much of the corn of Iowa and Illinois grows on the till plains of former ice sheets. Often, small lakes form in hollows in those surfaces, or where ice blocks from a decaying glacier were buried and then melted away, leaving kettle holes. Most of the ten thousand lakes of Minnesota, and probably the majority of natural lakes on the planet, are gifts of glaciers. Many stones are carried by large glaciers in stripes called medial moraines. These stones are picked up from rocky points of land where small glaciers flow together. –*Richard Alley*

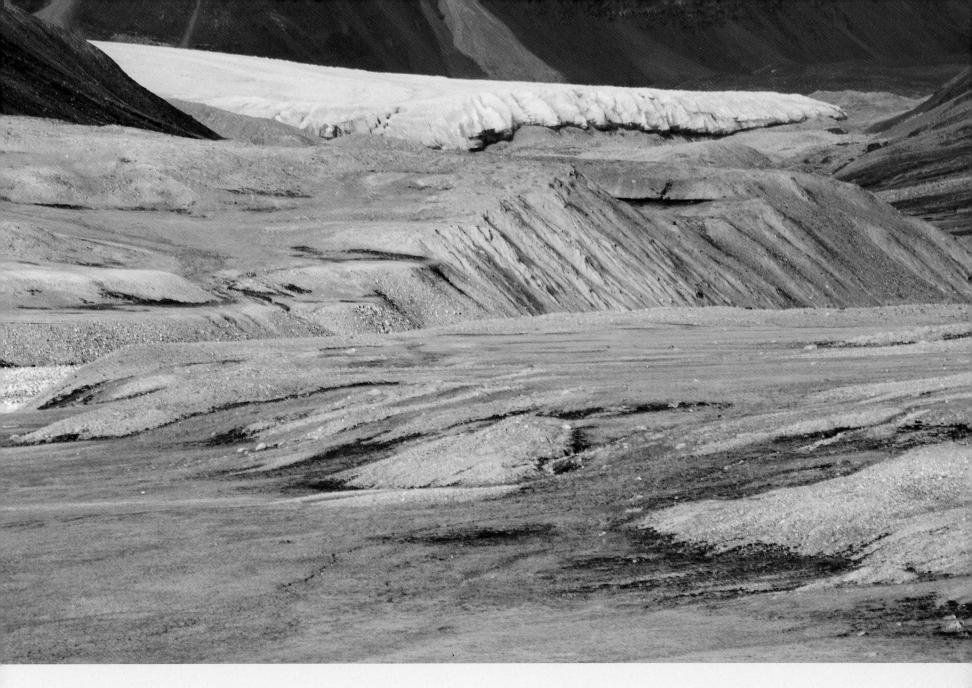

A quickly retreating glacier in eastern Greenland leaves behind
ground moraines, till-covered areas with irregular topography cut
by a meandering stream.

disgorged by the Jakobshavn Glacier—I saw spray like smoke signals in the open water. Humpbacks were feeding in the current, surfacing between small icebergs and crushed ice, flipping their tails skyward.

Miles off the northeast Greenland coast, I watched another iconic mammal from the deck of an icebreaker. The ship's captain followed a polar bear as it negotiated the sea ice miles from shore. I marveled at the animal's adaptation to Arctic life as the captain anticipated its route, understanding that to conserve energy it would rather walk on the pack ice than swim.

On the Riiser-Larsen Ice Shelf in Antarctica's Weddell Sea, I first encountered emperor penguins, the only large animals to winter so far south. I felt as if I had met Martians. To incubate their eggs, each male balances one on top of his feet and covers it with a roll of flesh. The penguins huddle together against Antarctic winds in the dead of winter, in darkness and terrible cold. After a while in the wind, each male takes a turn moving into the warm center of the group. From above, it looks like an eddy in slow motion.

⌁

As my understanding of ice has deepened, I have grasped how ice and climate interact and profoundly influence ecosystems and human civilizations, especially as we are altering this ancient balance.

Decades after an ascent of Mount Athabasca in the Canadian Rockies, I stood again on the slope where I had first practiced ice climbing. The Columbia Icefield seemed to be reeling the Athabasca Glacier up the scoured slope, and no ice remained where we had climbed out of crevasses. The Crowfoot Glacier's talons had been amputated; the Angel Glacier's body had been sliced in half; the

Spikes of ice known as *nieves penitentes* ("snow monks") form in snow and ice on high mountains that receive intense sunlight.

Tumbling Glacier had tumbled. The ice seemed to be rotting on the cliffs. As I crisscrossed the globe to document the life of ice, this experience repeated. I saw changes I had assumed would proceed in geologic time instead happening in a generation.

Ice is disappearing around the world, and the likely consequences are poorly understood. The rapid loss of reflective sea ice surrounding the North Pole, exposing heat-absorbing water, could lead to warming oceans. Retreating glaciers in the Himalayas—what some call the Third Pole—may affect half the world's water supply. Melting permafrost in the Northern Hemisphere could flood the atmosphere with methane, triggering even more rapid warming.

Almost all scientists agree that the planet is warming quickly, that human activities play an important role, that there will be costs and perhaps a few benefits. These conclusions are about as controversial in the scientific community as the theories of continental drift or evolution. But consensus falls apart when scientists predict the future. Will sea level rise a couple of inches or many feet? Can we expect milder winters or desertification? Will hundreds of millions die or just be inconvenienced? Only time will tell.

Ultimately, it is the loss of ice's beauty and its wild refuges that I can't stand, seeing the places I love diminished year by year. Perhaps human will and ingenuity can arrest impending disasters—and I hope so—but for the balance of my lifetime, I know that I will witness the world's store of beauty decline.

✦

When I first envisioned *Planet Ice*, I imagined a color version of a book I admired: *Glacier Ice*, written by Edward LaChappelle and illustrated

The north side of Ama Dablam, seen from Dingboche village on the trek to Everest Base Camp in Nepal

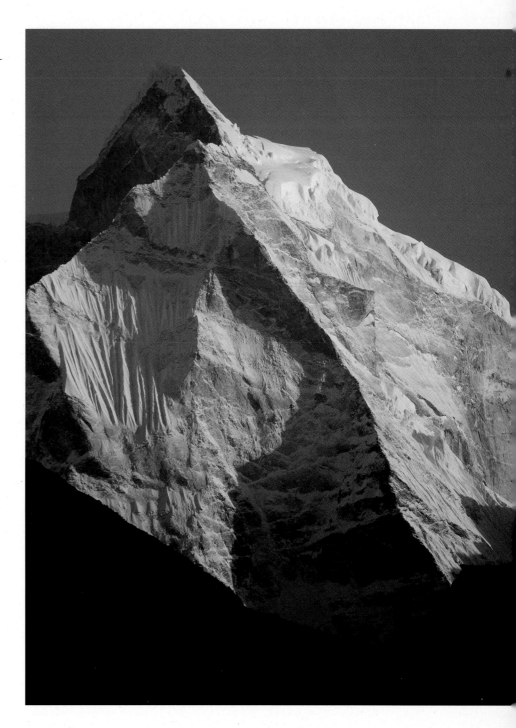

with dramatic black-and-white aerial images by USGS photographer Austin Post. Their book depicts ice in the grand landscapes of the mountains and the poles.

By the time I began photographing for *Planet Ice*, the ice I love was under assault. In response, I expanded the book's scope to include the interplay of ice and climate, a view of human and animal life on the ice, and stories of personal encounters with cold environments. I began this collaboration with Braided River to assemble a group of authoritative and talented essayists as well as donors and foundations to fund this book about ice and climate change and to promote public outreach.

Yvon Chouinard, founder of Patagonia Inc. and ice-climbing pioneer, leads the collection. He describes how his approach to climbing ice became his approach to life, inviting us to consider that though we humans can achieve technological marvels, the real marvel may be living in concert with the only planet we have. Chilean glaciologist Gino Casassa then describes the Earth's snow and ice—their multiple varieties, their properties—so that we might understand how critical the frozen world is to ecosystems and to human life. Richard Alley, eminent climate scientist and a lead writer for the Intergovernmental Panel on Climate Change, continues the story, eloquently making the case for why ice matters—and why human-caused climate change is unquestionably changing ice.

Ian Stirling, the dean of polar bear researchers, brings us to the world of Arctic ice and its great white inhabitants, describing their exquisite adaptation to their only possible home. Without the ice, he says, there will be no polar bears. Alaskan writer Nick Jans broadens our view to an explicitly human realm, from the symbiotic relationship grown up over millennia between the ecosystems of the Arctic and the Iñupiaq people to the geopolitical battles that may arrive along with an ice-free Arctic Ocean. Broughton Coburn, who has worked three decades in the Himalayas and written three books concerning its peoples and ecological challenges, reminds us that there is a "Third

Climbers approach the summit of Margherita Peak in the Ruwenzori Range, the highest peak in central Africa's fabled "Mountains of the Moon."

THEN & NOW

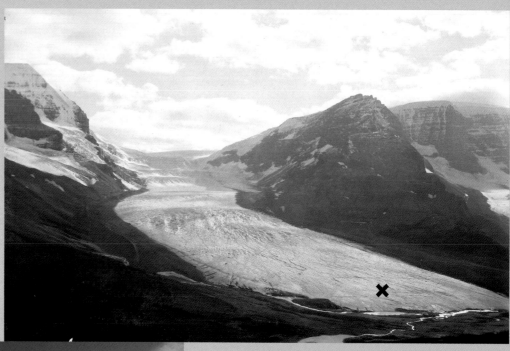

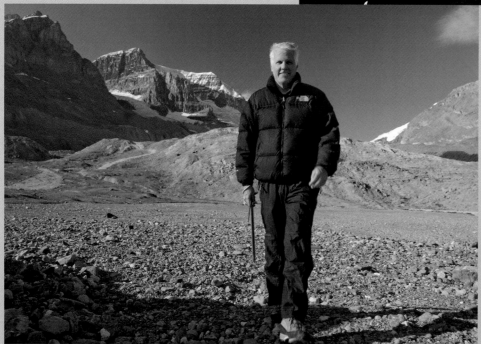

ABOVE **Athabasca Glacier, Canadian Rockies, by Byron Harmon, circa 1903-1942.** *Photograph courtesy the Whyte Museum of the Canadian Rockies (V263/NA-5859, Byron Harmon)*

LEFT **Athabasca Glacier, 2008. Photographer James Martin stands (shown above with an X) —as seen from a slightly different perspective—where thirty years ago he learned to ice climb in Banff National Park, Alberta, Canada. In 1975 the rocky plain and low hill behind him were covered with ice.** *Photograph by Jennifer Wu*

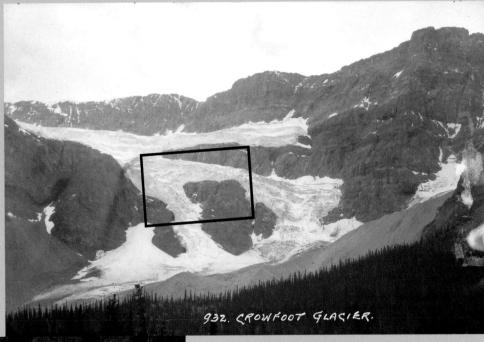

932. CROWFOOT GLACIER.

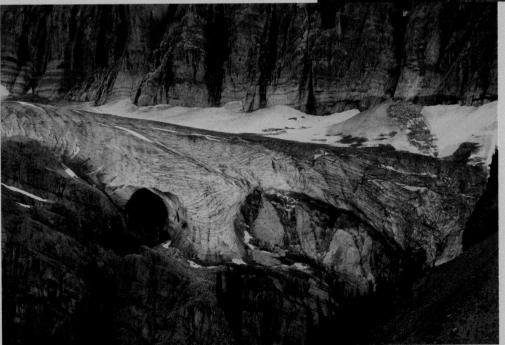

ABOVE **Crowfoot Glacier, Canadian Rockies, by Byron Harmon, circa 1903-1942.** *Photograph courtesy the Whyte Museum of the Canadian Rockies (V263/NA-5727, Byron Harmon)*

LEFT **Detail of the Crowfoot Glacier (shown above in the inset), 2008. The talons of the Crowfoot Glacier in Banff National Park, Alberta, Canada, once cascaded to the lake below in three parallel flows; today, only stubs remain.**

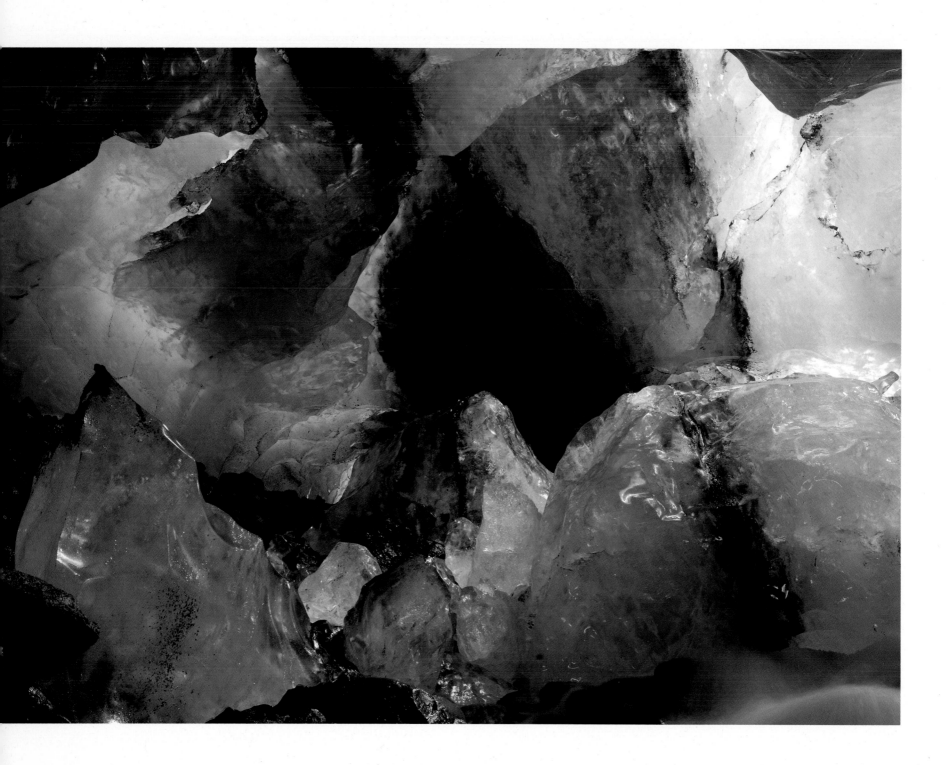

Pole" beyond the Arctic and Antarctic: the Himalayas, their immense watersheds home to more than a billion people. Mountain villagers are struggling to cope with the changing springtime snowmelt, and residents of coastal areas and islands are threatened with rising sea levels. Coburn urges that we plan for these changes we are causing. Finally, Gretel Ehrlich, author of *This Cold Heaven: Seven Seasons in Greenland*, expresses with great poetry and power what we hope is not an elegy— for ice, or for human life on this planet.

In my own fieldwork for *Planet Ice*, I pinballed around the world to capture images of ice in the Arctic and Antarctic, in tropical highlands, in mountains high and low. I flew to the Greenland Ice Sheet and cruised through pack ice on an icebreaker. I hiked to Everest Base Camp in Nepal, climbed Kilimanjaro in Tanzania, explored the "Mountains of the Moon" on the Congo-Uganda border. I flew over ice-clad Alaskan giants, chronicled glacial recession in the Alps, traveled to Iceland, revisited Patagonia, trekked through the Peruvian Andes, and retraced my steps through the Canadian Rockies. These places are remote, their plights abstract—until we realize that their plights are our own.

It's relatively easy to convey how the loss of ice will damage the planet, but it's more difficult to express the stark beauty of ice to people who have never seen its many forms firsthand. Photographs are a pale substitute for direct experience, but I hope that my images can spark interest and understanding—and an appreciation for the pure wonder of ice.

I also hope that *Planet Ice* rouses people to act, to insist that our governments rise to the challenge of global warming and reverse course, thus preserving the beauty and health of our planet and enriching our lives. Beauty sustains us, it snaps us awake, silencing the techno-chatter in our heads. With commitment and action, this love story of mine could become a tale of global passion between people and ice. Awed by ice's power and amazed by its beauty, we might even give the story a happy ending. ❋

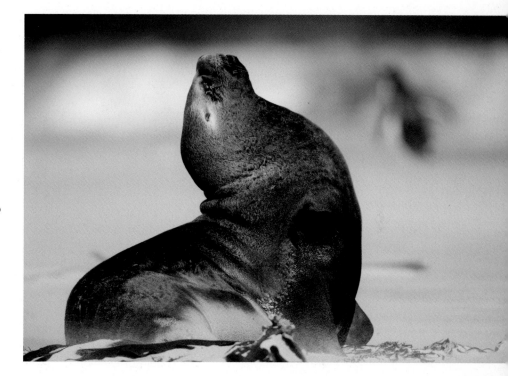

ABOVE **A southern sea lion suns itself on a Falkland Islands beach as a gentoo penguin approaches the surf.**

LEFT **Ice blocks glow like gems near an ice cave entrance in Iceland.**

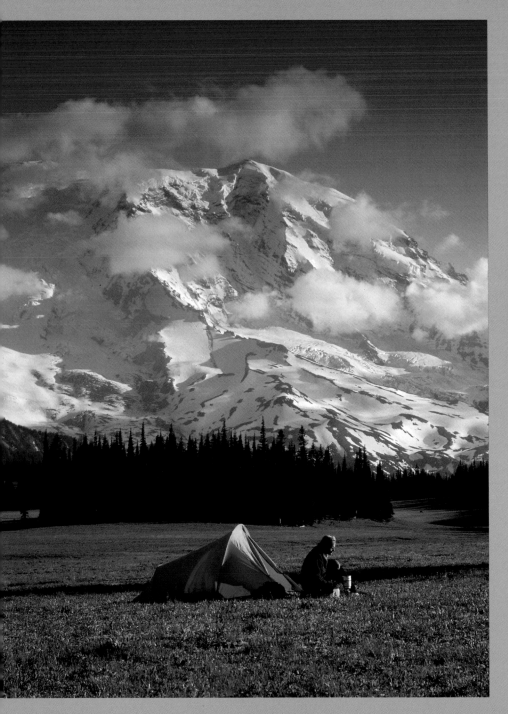

FOCUS ON ICE

ACCESSIBLE ICE: SOME OF THE WORLD'S MAJOR GLACIATED REGIONS

If you live in Europe or North America, you can be in a landscape of massive glaciers within a day. The scoured basin and end moraine of Portage Glacier on the Kenai Peninsula are an hour away from Anchorage, Alaska. From Geneva, Switzerland, make your way to Chamonix, where a train and gondola will take you to the largest glacier in France, the Mer de Glace on Mont Blanc.

Though you can find ice on nearly every continent—from sea level to the high Himalayas, from near-total coverage in Antarctica to only about 10 square kilometers (less than 4 sq mi) in Africa—by far the world's iciest regions are Antarctica and Greenland, comprising millions of square kilometers of glaciated terrain. For comparison, Canada ranks next at about 200,000 square kilometers (77,220 sq mi) of land cloaked in glaciers; Central Asia, China, and Tibet, including the Himalayas, come in at roughly 142,000 square kilometers (54,825 sq mi), South America at 25,000 square kilometers (9650 sq mi), and Scandinavia and the Alps each at about 2900 square kilometers (1120 sq mi). All told, the world's glaciers cover an area nearly the size of the South American continent.

The Columbia Icefield in the Canadian Rockies, Mount Rainier in Washington State, and Glacier National Park in Montana are all easier to get to than the polar regions, as are the glaciated fjords and mountains of Scandinavian countries like Norway. In Alberta, Canada, the Athabasca

Mount Rainier's glacier-clad slopes, in Mount Rainier National Park, Washington State, are some of the most accessible glaciers in the Lower 48.

Glacier that spills from the Columbia Icefield is the most visited glacier in North America. Short trails lead to smaller alpine glaciers that dot Mount Rainier and Glacier National Park. From Oslo, take a guided glacier hike in Norway's Jostedalsbreen Glacier National Park. Each of these mountainous regions is a bounty of accessible snow and ice, though in many cases the glaciers are in retreat. The U.S. Geological Survey predicts that Glacier National Park will lose all its glaciers by 2030.

Iceland, hovering just south of the Arctic Circle, is a country of ice—ice caps, icebergs, and towering faces of calving glaciers. The country's principal ice cap, Vatnajökull, is thinning and shrinking simultaneously, revealing a vast lake called the Jökulsárlón, or glacier lagoon. Icebergs float in the tranquil water; as they melt and become smaller, they flow out to sea, but wind and tide strand some of them on the beach.

The world's glaciers are not static—they undergo constant flux invisible to the casual observer. But you can still see them for yourself in some of the world's major glaciated regions:

- Alaska Range; United States
- St. Elias Range; Canada, United States
- Cascades and Rockies; Canada, United States
- Andes; Argentina, Chile, Peru, Ecuador, Bolivia
- Norway
- Iceland
- Alps; France, Italy, Switzerland, Austria
- Tibetan Plateau; China
- Himalayas; Bhutan, China, India, Nepal, Pakistan –*James Martin*

A hiker near a 4725-meter (15,500-ft) pass in Peru's Cordillera Blanca; bare rock beneath the glacier shows that the ice has retreated rapidly.

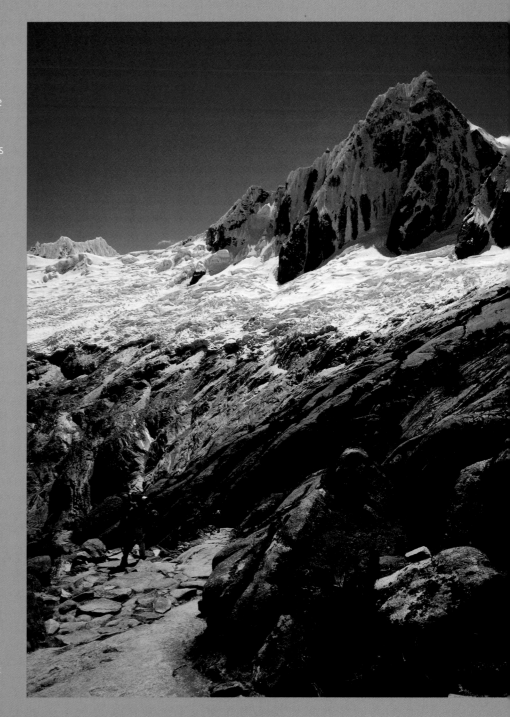

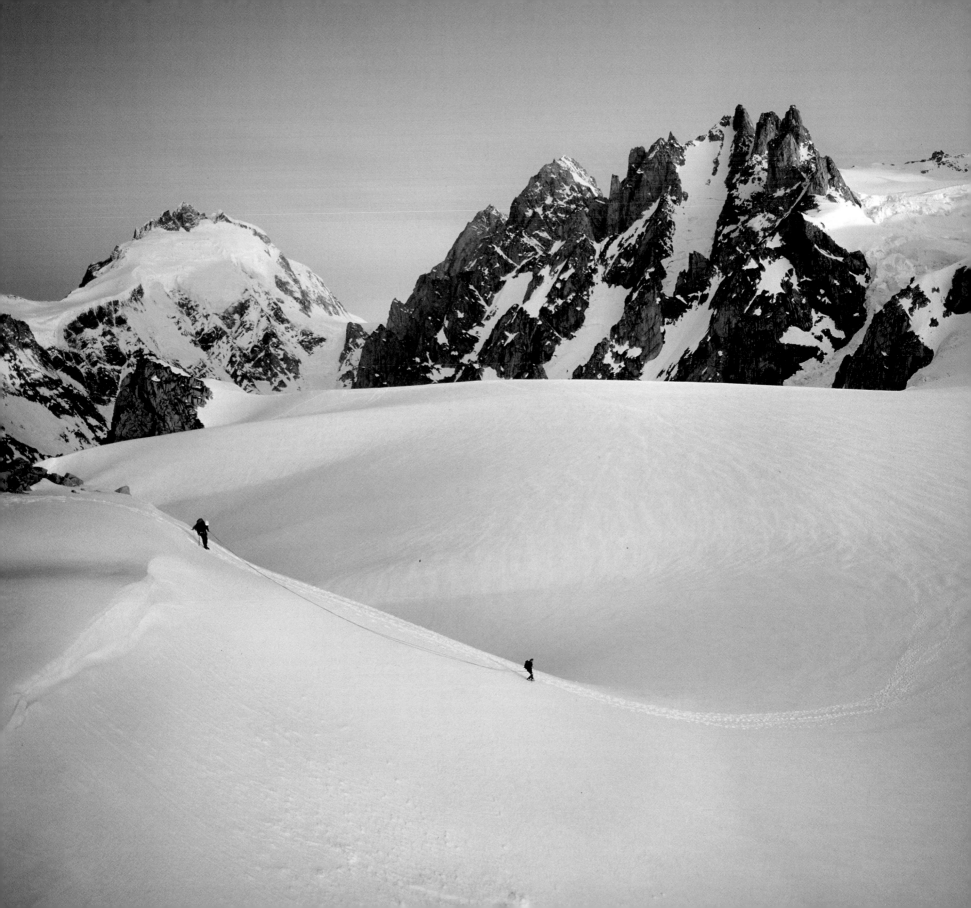

MY LIFE ON ICE
INITIATIVE, BOLDNESS, AND BALANCE

Yvon Chouinard

YVON CHOUINARD, founder of Patagonia Inc. and author of the seminal *Climbing Ice,* has had countless groundbreaking experiences in the world of ice climbing. Involved in the evolution of many sports, Chouinard spent much of the 1970s and 1980s climbing year-round on every continent, establishing new routes in Yosemite, Patagonia, Africa, Alaska, and elsewhere. He was a major influence in the "clean climbing" movement away from pitons, which damage rock, to chocks and other harmless climbing gear. *Photograph by Branden Aroyan*

Climbers cross a snowfield in the Coast Mountains of British Columbia, Canada, with the Serra Peaks and Mount Waddington, at 3994 meters (13,104 ft) British Columbia's highest peak, in the background.

Over my lifetime, I have been seriously involved in many outdoor sports: mountain climbing, telemark skiing, spearfishing, kayaking, surfing, and fly-fishing. I have thrown myself passionately into each of these activities until I achieved 75 percent or so proficiency. Then I would move on to something else. Even with climbing, I would specialize in one form of alpinism for a time, such as big walls or jam cracks or expeditions to the highest peaks, until I reached sufficient but not perfect mastery. Overspecialization, the last 25 percent, did not seem worth the effort.

The closest I have come to mastery, though, is climbing snow and ice. My favorite is mixed climbing, with one foot on *verglas* (thin ice covering rock) and the other on snow. Starting in 1966 and for the next couple of decades, I climbed during summers and winters on the snowy ranges of every continent. When I began, ice equipment was primitive and provincial—in fact, it was different in each country where climbing was practiced.

Technique was primitive too and was divided roughly into two schools: those who used flat-footed (or French) cramponing techniques and those who relied on front points. Neither side was willing to admit the worth of the other. It *is* possible to do all your ice climbing with only one technique, but it isn't efficient, nor does it make for a very

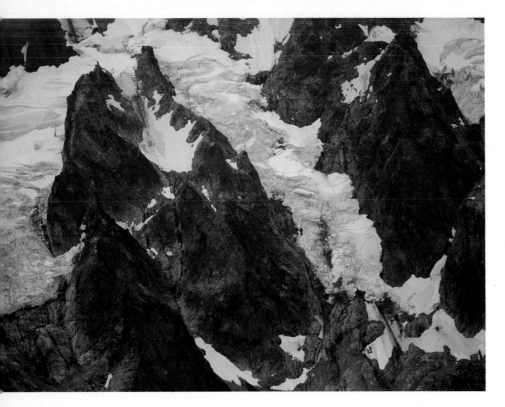

ABOVE **Luna Cirque in the northern
Pickets, North Cascades National
Park, Washington State, is in one of
the Lower 48's most heavily glaciated
regions.**

RIGHT **Don Mason climbs the back
side of a curtain of ice where Louise
Falls in Banff National Park, Alberta,
Canada, detaches from the cliff.**

interesting experience—like knowing only one dance: when the music changes, you are still dancing, but rather out of step.

When I returned from winter climbing in the Alps or from Ben Nevis in Scotland, my head would spin with excitement about what I had learned—and with ideas for improving the gear. Tom Frost (my partner at Chouinard Equipment) and I had already redesigned and improved almost every rock-climbing tool. Now we turned to ice gear, to new crampons, ice axes and hammers, and ice screws.

I have been fortunate to have participated in several of my "passion" sports during their golden age. It's always exciting to be involved in the evolution of any sport in the early days, when new techniques and equipment are invented almost daily. And it's easy to improve equipment when what you start with is so primitive.

I first put my head underwater with a face mask in 1951 at La Jolla Cove in California, when I was thirteen. Afterward, I would practice holding my breath in high-school math class so I could free-dive more deeply for lobster and abalone. To ward off the cold, I wore an army-surplus wool flight suit. For a weight belt, I used an army cartridge belt filled with lead from melted car batteries; the "safety" clasp was made from a door hinge.

When I first was learning to surf in 1954, I made my own surfboard out of balsa wood and wore a wool sweater to stay warm. When telemark skiing was reinvented in the early 1970s in the California Sierras and the Colorado Rockies, we started with ordinary cross-country skis with no side cut, then gradually evolved the technique and equipment to the point where, today, people can "free-heel" even in the most extreme conditions.

Inventing better equipment made climbing ice easier and less tiring; we could spend more time concentrating on the climb itself and less on cursing our gear. But technological development, even in climbing, comes not without cost.

Although a designer and innovator, I have always believed that

rejecting a possible technology is the first step in allowing human values to govern the pursuit of progress—just because we *can* doesn't mean we *should*. Climbing itself—with its emphasis on initiative, boldness, and balance—moves against the technological solution. As I developed new ice equipment, I worked on creating new techniques that relied *less* on gear. I stretched myself, used only my ice ax for clawing in situations with steeper and more brittle ice. I kept my second ice tool holstered for whole pitches and climbs. The idea was technological inversion: to apply fewer tools with more sophisticated technique. I was rewarded for walking this edge by seeing more sharply what was around me, and I felt more deeply what comes boiling up from within. Henry David Thoreau put it that "simplification of means and elevation of ends is the goal." The two can't help but happen together.

Or not happen at all. I believe sport follows politics, and in this age of fear-based conservative government, the kids of the wigged-out parents of the 1960s generation are living risk-averse, even virtual-reality, lifestyles. Businesspeople and their political lackeys know what needs to be done to keep the planet from warming, but they are afraid to do it, afraid that their actions might affect the bottom line and kill national and worldwide economies. No wonder rock climbing has become a sport for boulders, gyms, and bolted crags—little real-world risk is involved. On a big mountain like Everest, the simplification of means and elevation of ends are not really part of the goal. Waterfall climbing is still popular, but fewer and fewer practitioners take the time and the risk to learn what it requires to climb ice in the high mountains far from cities.

Climbing snow and ice slopes is dangerous, particularly on snow slopes, where most accidents happen. Judging the condition of a snow slope is a deep and complicated art. A slope prone to avalanche can hide its weak layer several yards below the probing skier or climber. A slope that is safe one day can be a death trap the next, when the temperature goes up or down or the wind blows. Everyone I know

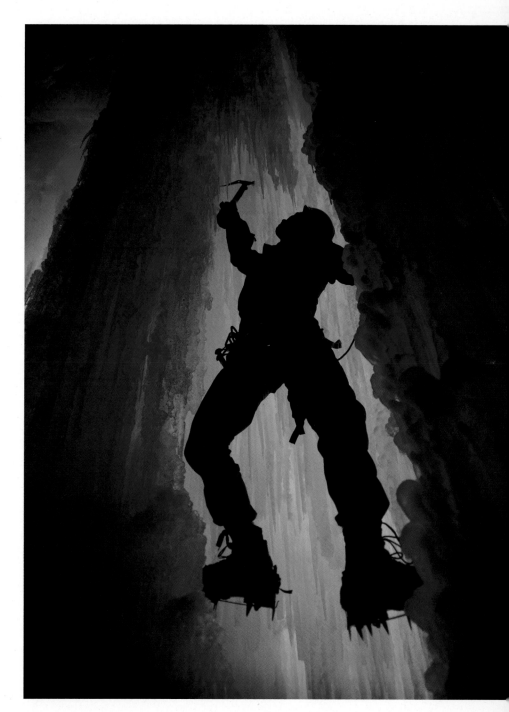

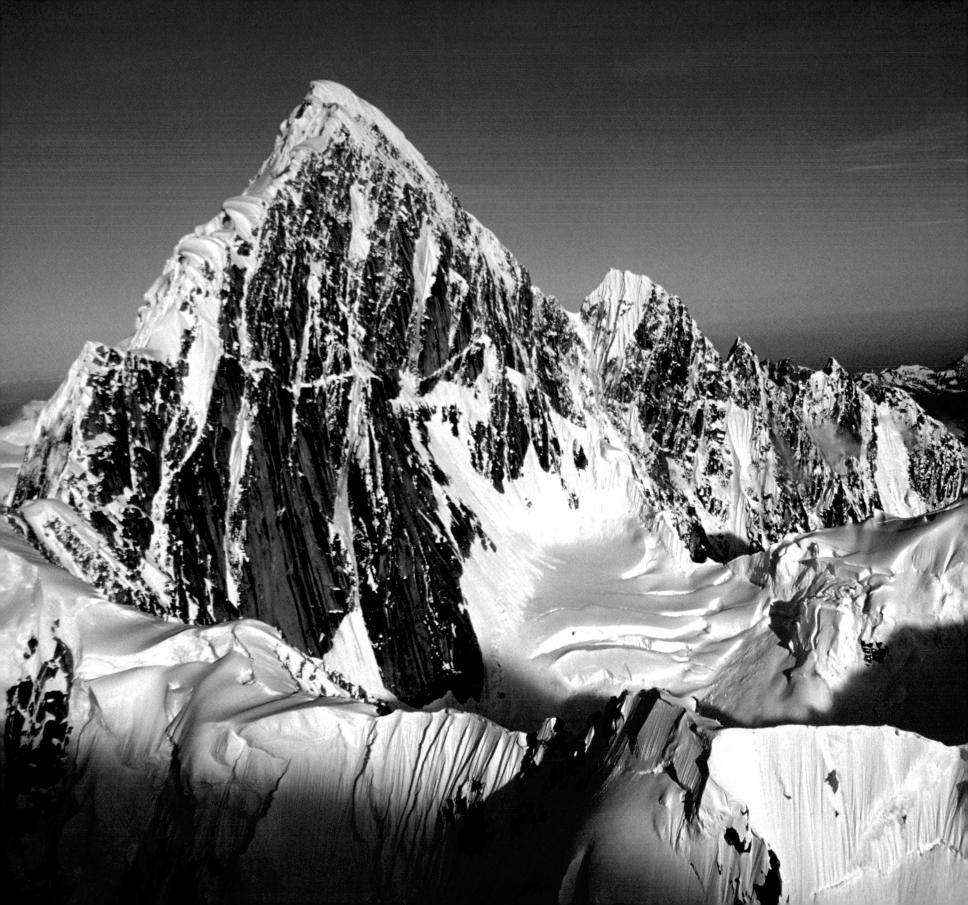

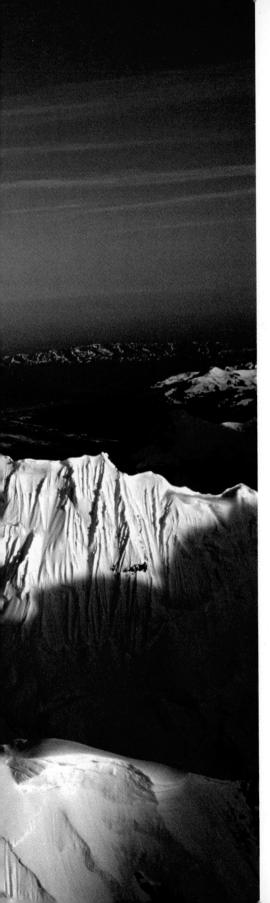

who teaches avalanche safety has triggered or been caught in at least one avalanche. Of the three that I have been involved in, two were set off by myself or one of my partners.

The first time was in Scotland: Doug Tompkins and I were well into the day on a climb when I asked him for the rope, and he said, "You've got it." Well, I didn't, and we weren't about to go all the way back to the lodge. So we decided to drop down into the cirque and solo some Grade II routes on Hell's Lum. It was blowing a blizzard up on the plateau but not snowing lower down, and there were patches of blue sky. Frost feathers were growing on our wool clothes, and our eyelids and nose hairs were all frozen over; it was a typical day in the Cairngorms.

Doug was ahead, cramponing and traversing across what we thought was hard, wind-packed snow. All of a sudden my rectum clutched like a poodle's after it sees a bulldog. And I said to Doug, "Hey, man, this snow feels really funny. Let's get…"

Pop! And off it went. A yard-thick slab broke off right at our feet, and we were both left hanging by our ice axes, which luckily we had planted high.

My second close call also came in Scotland, on Ben Nevis, where we were working on an ice-climbing film for National Geographic. We were filming from near the base of Comb Buttress, and though the spring thaw was on, the snow didn't seem overly dangerous. I had the rope on and was standing at the base of Number Two Gully when off to the side I caught a glimpse of Johnny Cunningham and Hamish MacInnes running off: almost immediately I got hit by chunks of snow. I thought it was only falling icicles, so I had just hunched down to protect my head when a wet snow avalanche hit me. They say I did a bunch of slow flips before I landed on my back. The rope was wrapped around my legs, and all I could do was try to stay on top of the sliding snow until I worked my way off to the side. Gear was strewn all over the place, and the big 20-kilogram (44-lb) tripod I had been standing

Mount Huntington is one of the most beautiful mountains in the Alaska Range; seen here at sunset, its knife-edge ridges were carved by glaciers on either side.

SHAPED BY ICE

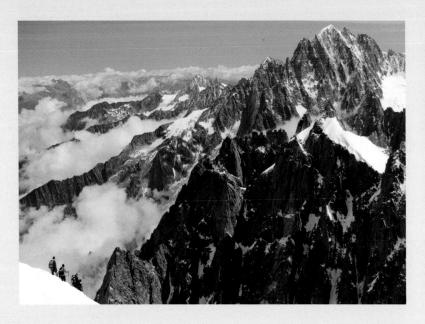

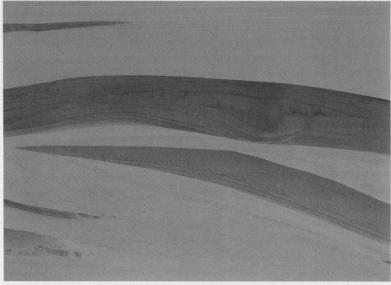

The arêtes and gullies of the Aiguille Verte, above, one of the giants in France's Savoy Alps above Chamonix, were carved by remnants of an ice cap that once covered most of the range.

Large crevasses on the surface of the Boston Glacier in North Cascades National Park, Washington State, evoke a painter's brushstrokes.

▲ CIRQUES, ARÊTES, AND HORNS

At the heads of glaciers, the ice gnaws into mountains to form bowls, called cirques. We're really not sure how the ice does this, but the results are spectacular. The cirques themselves are beautiful. When two glaciers meet after gnawing in from opposite sides, a knife-edged ridge called an arête is left between. Three or more cirques intersect at a horn. The scenery of the Alps, including the Matterhorn, is the product of glaciers. *—Richard Alley*

▲ CREVASSES

On an ice sheet or glacier, ice on the east side flows east, while ice on the west side flows west, so the ice between stretches. Where this stretching is especially fast, great cracks called crevasses may open near the surface. Crevasses also open where fast-moving ice streams poke through slower-moving ice. A "dry" crevasse can be deep, but the crevasse won't make it to the bottom of the glacier—the weight of the ice squeezes the crack closed at great depth. But fill the crevasse with water, and it can go all the way to the bed—the water wedges the crack open. *—Richard Alley*

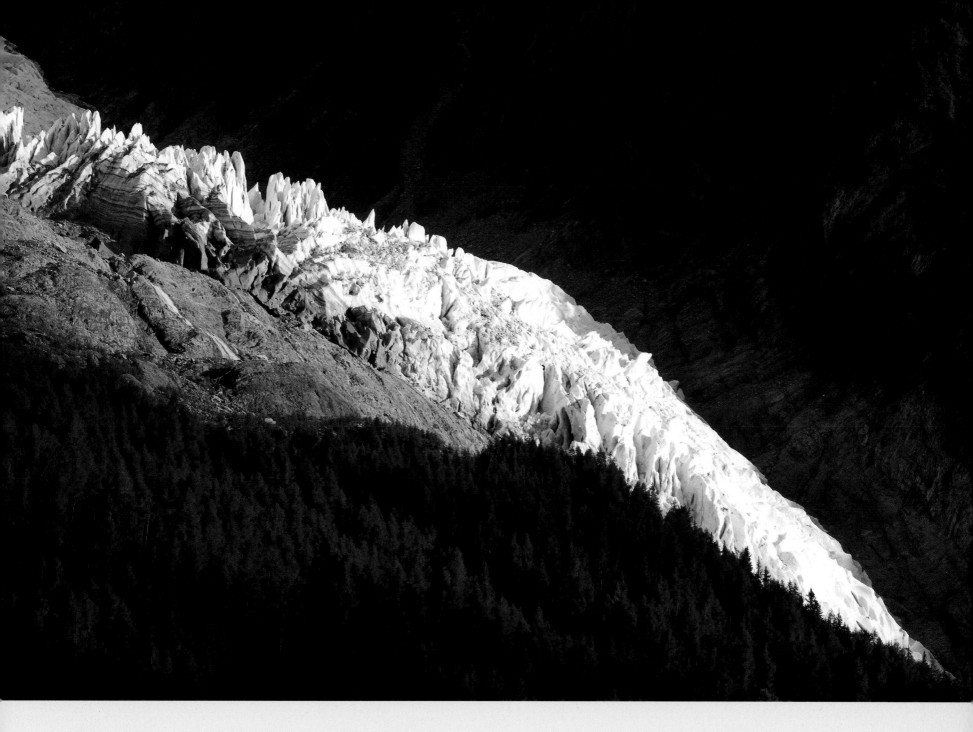

A glacier originating from Mont Blanc, the highest peak in Europe's Alps, flows below tree line; where the slope changes abruptly, the glacier has broken up into towers called seracs.

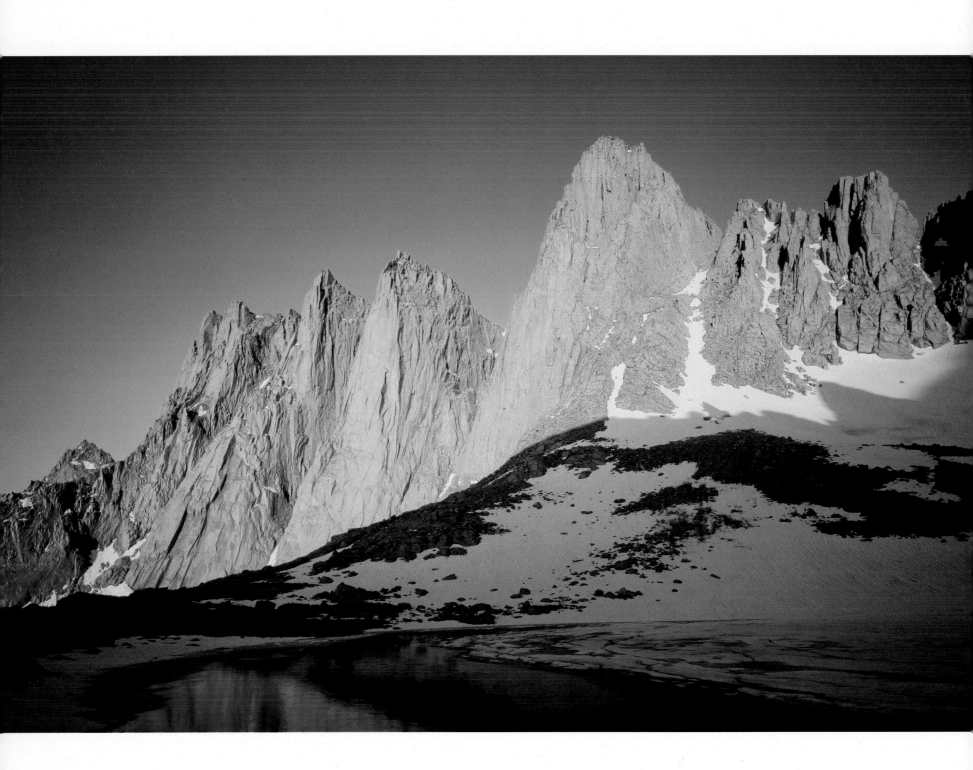

next to had its legs sheared right off. It turns out that a cornice had fallen, setting off an avalanche in the gully.

The third incident occurred on Minya Konka in eastern Tibet. Rick Ridgeway, Kim Schmitz, Jonathan Wright, and I had just taken a load up to Camp 2 and were coming back down at a fast pace, stomping and sliding down the soft snow. I was leading and should have recognized the obvious danger signs: the several feet of fresh snow was only a couple days old, we were on the lee side of a corniced ridge, and the temperature had risen considerably since morning. At the moment when I first intuitively felt the danger, a soft slab broke just above us and carried us down 457 meters (1500 ft) and over a 9-meter (30-ft) cliff before stopping. Nine meters ahead lay a 91-meter (300-ft) cliff. I had a concussion and broken ribs; Rick, various cuts and bruises; Kim, a broken back—and Jonathan died from a broken neck.

Avalanches aren't the only danger to the alpine climber. The single most difficult mixed snow and ice pitch I've climbed was on a first winter ascent of Raven's Gully Direct in the Scottish Highlands, again with Doug Tompkins. We had been climbing perfect snow, following Hamish MacInnes's line up to where the route's direct finish starts, moving as fast as possible, breezing past obstacles. Then the ice pillar we were climbing shattered beneath us; above, we saw a fading shaft of light over a giant chockstone stuck between two icy walls.

The ice coating the walls was too thick for boots and too thin for crampons—and the distance between the walls required a wide stem: Spread-eagling with his crampons, Doug managed 3 meters (10 ft) before he jumped down. Trying a different climbing technique, the Nureyev split, I did 4.5 meters and lost it. Doug got to 6 meters, and… at 9 meters (30 ft) up, the tip of a knifeblade piton we'd placed for

protection held for a tie-off just before my legs accordioned. The thin ray of light was growing faint as Doug winched me up for one last try. The next 9 meters to the chockstone was indeed a shaky endeavor. After that, all we had left to climb was a dank, greasy slot. Doug attacked the thin ice and powder snow with tied-off ice screws and delicate body English—and, after what seemed like an hour, yelled "Ahooya." We weren't yet on top, but we were out of the gully.

My coldest climb was in Alaska on Denali, which is lower in elevation than Everest but far colder, the latter being at the same latitude as Miami. On our summit day, with temperatures around −40° Celsius (−40° F), the plastic buckles on our packs shattered from the frost. Even the plastic lid of our thermos broke. The black ice was so old and hard that our ice screws were useless.

My most frightening experience on ice was not on a climb but in a tent in Antarctica. Doug Tompkins and I had just spent nineteen hours on an ice face and had returned to our camp exhausted and cold, when the wind started up. We kept our clothes and boots on and slipped into our sleeping bags. For the next seventy-two hours, we fought to prop up the tent walls from the williwaws that came every fifteen minutes and threatened to blow us to pieces. We had nothing to drink and only a bit of chocolate to eat. We watched the seams on the tent slowly rip apart. During those three days, we knew only abject fear and concentrated on simple survival. We vowed that if we did survive, we would never repeat this craziness again.

Not all memorable moments in ice climbing involve the fear of death. Once I stood at the tip-top of snow-covered Mount Stanley in Uganda having a pee—and for a moment was the source of the Nile.

The most complex and enjoyable pitch of ice I've ever climbed was also in Africa, on Mount Kenya. The Diamond Glacier high on the southern side drains and refreezes into a narrow couloir that cascades in a series of frozen waterfalls, one of which creates a vertical curtain of melded-together icicles. My partner, Mike Covington, wrote about

Mount Whitney from Iceberg Lake, in California's Sierra Nevada; although ice carved the range's spires and faces, only a dozen or so pocket glaciers remain.

it in the *American Alpine Journal*: "Although the headwall seemed to loom just above, I climbed almost a full pitch past [Yvon's] belay before getting to the base of the fragile obstacle. We were in the clouds now, and the setting had changed drastically from a warm and friendly environment into a safer but more eerie one. The climbing was steep, and the visibility was usually less than a pitch. An occasional icicle fell, or running water dripped from ledge to ledge. Otherwise the silence was all consuming. Peaceful but spooky."

The right side of the headwall was barred by multiple rows of sharp-fanged icicles. The best ice, on the left side, disappeared into the mist at an intimidating angle. We decided to climb the thin ice at the center, and I made my way up, jamming my hands between the ice and the rock, to a small cave at the top of a 12-meter (40-ft) outcrop. From the cave, I had to cut a hole through an ice curtain. As Covington recalled, "Two or three whacks, and some huge icicles departed the face, exploded onto the ramp near me, and then fired off down the couloir in the mist below." To get back out onto the smooth, nearly vertical sheet of ice above, I crawled through the hole and placed my ice hammer up inside the cave, then leaned out as if trying to reach over a roof. One swing of the ax, and it was buried in the ice above. Then I removed my hammer and placed it up alongside the ax. Both tools gave off a precariously dull *thunk*. "I tensed," wrote Covington, "expecting a fall as he leaned way out and engaged a crampon inches above the lip of the curtain. Slowly he moved up onto the ice and then removed a tool and swung again. This time the ax found good ice, and Yvon let out a welcome 'Wha hoo!' There was still 20 feet [6 m] of nearly vertical ice before the angle eased, but it was in the bag now."

The Diamond Couloir no longer exists as we climbed it. On occasional heavy-snow years, it still exists as a snow couloir, but it's no longer cold enough for the ice curtain to form.

In thinking back on the snow and ice climbs I've done, I realize that many of them no longer exist. The Black Ice Couloir on Wyoming's Grand Teton is gone. Its classic alpine north face, like the north faces of the Alps's Eiger and Matterhorn, is too dangerous to climb in summer. The ice in the fissures that once helped hold these faces together is gone, and rockfall is now much more prevalent.

When I first climbed in the Canadian Rockies in 1958, the Columbia Icefield flowed down almost to the then-dirt road between Banff and Jasper, Alberta. Now it's a forty-five-minute walk to its terminus. The classic ice climb on the north face of nearby Mount Athabasca is now all rock.

It's September in Jackson Hole, and as I work on this essay I'm looking up at the Tetons. From my view, from the southeast, they are completely bare of snow. The Otter Body Snowfield, and the patch on the east ridge of the Grand Teton, is melted out. In my fifty years of living here, I have never seen these mountains without snow. Spring has come five weeks early for the last two years. Last year, before the young red-tailed hawks had grown protective feathers, they were bitten to death by horseflies that hatched early, or they jumped out of their nests to escape them. The mountain pine bark beetles, which are killing pine and spruce forests all over the western United States, are reproducing in numbers four times greater than usual without the weeks of –40° Celsius (–40° F) winter days to keep them in check. Grizzlies and black bears, starving from berry and whitebark pine nut failures, are roaming backyards looking for dog food and birdseed. So they are turning into "problem bears." Nineteen were shot this summer. We have had weeks of temperatures over 32° Celsius (90° F) this summer; we used to have maybe one or two days like that in a summer. It looks and feels like Nevada, not Wyoming. Many days this summer, it was so hot I couldn't spend time outside doing the things I love to do. Streams in Yellowstone Park were closed to fishing because the trout were stressed by the heated waters. My neighbor grew tomatoes at more than 2100 meters (almost 7000 ft).

I rarely ice climb anymore, but I particularly like to fly-fish for

THEN & NOW

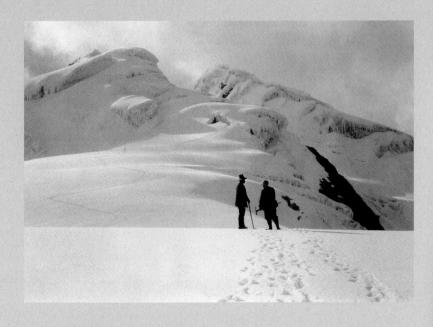

ABOVE **Two climbers approach the summit pyramids rising about 300 meters (1000 ft) above them on Mount Stanley, 1906;** *photograph by Vittorio Sella.* *© Fondazione Sella, courtesy of Panopticon Gallery, Boston, Massachusetts*

RIGHT **Africa's Mount Stanley, in Uganda near the border with the Democratic Republic of Congo, rises to 5109 meters (16,763 ft). The summit pyramids, seen here from below, have lost almost all their ice.**

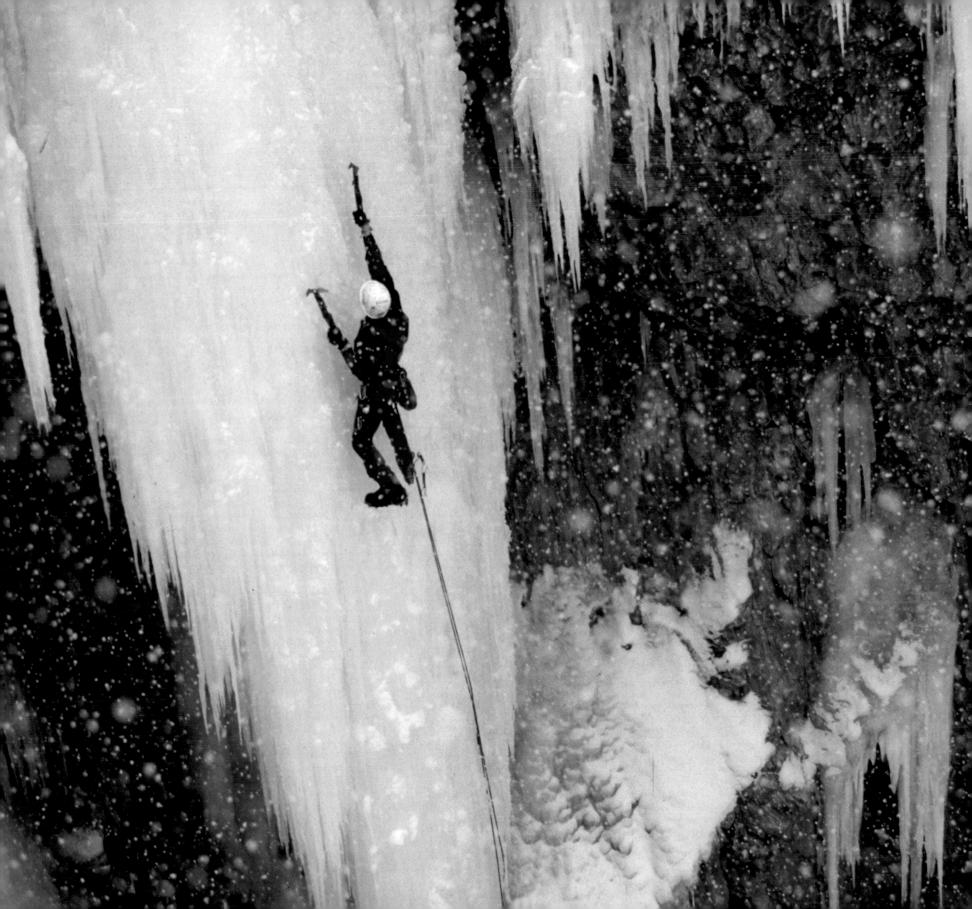

steelhead and salmon. When I fly over the Coast Mountains in British Columbia on my way to the steelhead rivers, I look down at pocket glaciers that are half or even a third the size they were when I first climbed there forty years ago. Those small icefields provide cold water all summer long to the salmon rivers that in some summers are already only a few degrees from being too hot to support the anadromous fish. Combine that with drastic clear-cutting and ham-fisted fisheries management, and the long-term outlook for salmon is grim. In two weeks of concentrated fishing this year, I caught only three steelhead.

This has been my experience of climate change, whether or not each phenomenon is a direct result of global warming. The fact remains that by our own doing, we have changed the climate of our home planet—scientists all over the world agree on this, as reports from the Intergovernmental Panel on Climate Change tell us. And we are causing another great extinction; we are in danger of losing one in four mammal species, one in eight birds, a third of all amphibians, and 70 percent of all the plant species that have been studied. Because we are also large creatures of nature, we are not exempt.

Anthropocentric thinking got us into this mess in the first place, and the same flawed logic says that we can reverse global warming merely by changing technology. Consider the futility of trying to save the ski piste of the Pitztal Glacier in Austria by covering it with an insulated blanket. Instead, the solution to our overheating of the planet has to begin with us in the developed world consuming less and more intelligently—and using technology, but *appropriate* technology. In some cases this may mean that we "turn around and take a forward step," as the conservationist David Brower advocated.

The icefalls, snow gullies, and glaciers that have carved me into what I am today are melting, and I am perhaps bearing witness to the last of the great salmon and polar bears, the end of cold, free-flowing rivers. The Zen philosopher part of me says that the value of the climbs I've made, the business I've grown, and the fish I've caught and released was in the doing. I accept that the only sure thing is change.

At the same time, living a life close to nature has taught me to try and protect what I love by leading an examined life, bearing witness to the evils and injustices of the world, and acting with whatever resources I have to fight those evils. This is something everyone needs to do in his or her own way.

A few days after Doug Tompkins and I spooked ourselves in the hurricane winds of Antarctica, we did climb again, up to the top of a minor peak. Looking east from the Ellsworth Range to the flat expanse of ice and through the ozone-free air, we could see the curvature of the Earth. I realized that it's not only a fragile planet but a pretty small one too. ❋

Icelandic climber Helgi Christiansen ascends a frozen waterfall during a snowstorm in Ouray, Colorado; his body is supported by the few square inches of his crampon points and ice ax picks.

FOCUS ON ICE

THE LANGUAGE OF ICE

annual ice sea ice that freezes in winter and melts completely in summer; can be landfast or pack ice

bergschrund giant crevasse that separates flowing ice of a glacier from stationary, stagnant ice at a glacier's head

crevasse chasm that splits a glacier, created by tension as a glacier flows around uneven surfaces and at variable speeds

glacier large body of ice, originating on land and usually larger than 0.1 square kilometer (24.7 acres); formed when accumulated snow compresses over many years and becomes ice, flowing slowly down a slope or valley or spreading out over the land's surface; icefields, ice caps, and ice sheets, each larger than the last, are all made of glacier ice but far exceed isolated glaciers in size

iceberg large, floating mass of ice detached from an ice shelf or glacier that terminates in water

ice cap extensive dome-shaped mass of glacier ice that forms over land, spreading out in all directions, little influenced by underlying topography; usually larger than an icefield but smaller than an ice sheet, less than 50,000 square kilometers (12.4 million acres); the "polar ice cap" at the South Pole is better termed a polar ice sheet because of its enormous size, compared to the ice cap that covers Iceland

icefall fast-flowing, usually steep or narrow part of a glacier where ice fractures into a chaotic jumble

icefield extensive mass of glacier ice, like an ice cap but smaller and not domed, its shape and extent more influenced by underlying terrain; the Juneau Icefield northeast of Alaska's capital is made up of interconnected glaciers that spread over 12,950 square kilometers (more than 3 million acres)

ice floe cohesive, flat sheet of floating ice greater than 20 meters (65.6 ft) across; mashed-together ice floes comprise sea ice, but floes also occur in lakes and rivers

ice pack expanse of pack ice

ice sheet vast stretch of glacier ice larger than an ice cap, greater than 50,000 square kilometers (12.4 million acres) but, like an ice cap, dome-shaped and spreading out in all directions, little influenced by underlying terrain; the ice-age Laurentide Ice Sheet once covered most of Canada and a large part of the northern United States, and the world's two remaining ice sheets cover most of Antarctica and Greenland

ice shelf edge of an ice sheet that extends past land to float on the surrounding sea; Antarctica's Larsen Ice Shelf experienced its single largest collapse in 2002 when an area larger than Rhode Island shattered into thousands of icebergs and separated from the continent

lake or river ice frozen freshwater that forms floating ice in lakes and rivers

landfast ice sea ice that is attached to land and does not move with wind or currents

multiyear ice sea ice that has lasted at least one melt season; usually 2–4 meters (6.6–13.1 ft) thick and increasing in thickness as more ice grows on the underside; can be snow-covered and shaped into hummocks that look like rolling hills; multiyear ice contains less brine than annual ice and is often the source of freshwater for polar peoples

nieves penitentes literally, "snow monks," so named because they can look like kneeling people; formed when snow on ice melts into suncups that, under intense sun, deepen and then thin into spikes

pack ice sea ice that is not attached to land and so moves with wind and currents; expands in winter, retreats in summer; formed into a mass by crushed-together pans (drifting fragments of flat, thin ice) and ice floes; in summer, pack ice covers about 5 percent of northern oceans and 8 percent of southern oceans

pressure ridges linear features in sea ice, formed when wind and currents crush sea ice into buckled piles above the ice surface; on the underside of sea ice, the same forces form keels that reach down into the ocean

sea ice frozen seawater found in the Arctic and around Antarctica; can be annual or multiyear

serac pinnacle, tower, sharp ridge, or block of ice formed where a glacier's surface is fractured

suncup hollow in snow or ice created when intense sunshine causes melting and evaporation

verglas thin, clear coating of ice covering rock, formed when rainfall or melting snow freezes on a rock surface

ABOVE **The photo in this sign above the Rhone Glacier in the Swiss Alps was taken twelve years before the photograph that includes the sign.**

BELOW **Each summer, workers tunnel into the Rhone Glacier to create a tourist attraction; the ice is now so thin and melting so quickly that workers place fabric over the glacier so the tunnel doesn't melt during the summer.**

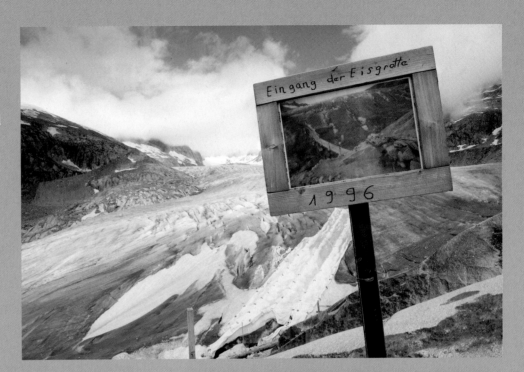

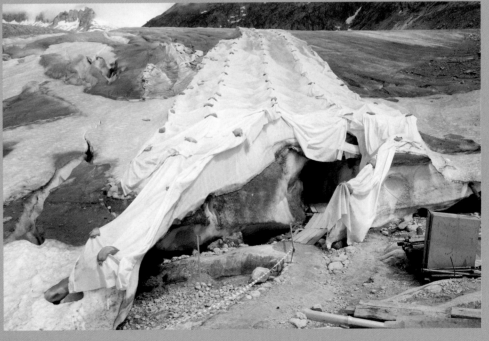

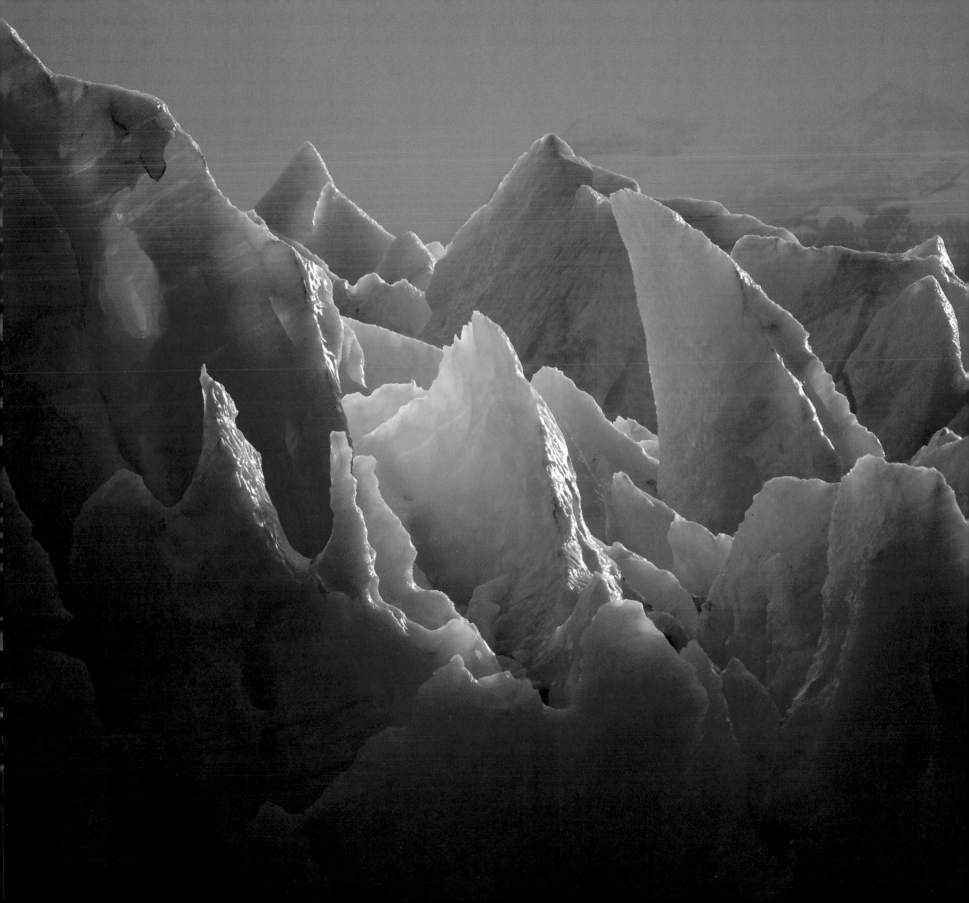

LETTERS FROM THE SKY
FROM SNOWFLAKES TO ICE

Gino Casassa

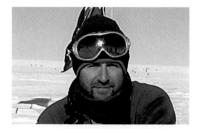

GINO CASASSA, a senior scientist at Centro de Estudios Científicos in Valdivia, southern Chile, has a degree in hydraulics engineering and a PhD in glaciology. Early on, he became an active mountaineer. He has published numerous peer-reviewed papers and book chapters about glaciology. He serves on several national and international committees, including as vice president of the International Association of Cryospheric Sciences. He was awarded a Guggenheim Fellowship in 2005 and was lead coordinating author of Working Group II of the Intergovernmental Panel on Climate Change, which was co-awarded the Nobel Peace Prize with Al Gore in 2007. *Photo courtesy of Chilean South Pole Expedition 2004*

Sunlight illuminates seracs at the terminus of the Grey Glacier in Torres del Paine National Park, Chile.

Snow and ice can evoke supreme joy in some people. Think delicious ice cream, cool iced drinks on hot summer days, skiing dream slopes of powder, heavenly glacier landscapes, or surreal snow and ice festivals. Other people associate snow and ice with suffering: bitterly cold weather, freezing pipes, exhausting shoveling to clear the path to the front door, deadly avalanches. But beyond these associations, should we really be worried about how a warming planet affects snow and ice? Are snow and ice so important?

The answer to both is, uncategorically, yes.

Snow and ice are unique and critical components of our planet. We all know that water is essential for life and that ice is simply the frozen phase of water. It is also clear that the climate controls the amount of snow and ice on Earth. What is less known is that many of the Earth's characteristics, such as its climate, are governed to a large extent by the relative abundance of ice and water.

Snow and ice have probably existed on Earth as far back as 2.7 billion years ago, during the so-called Huronian ice age when an ice sheet covered a major portion of North America. That is quite early in Earth's history, considering that our planet is 4.5 billion years old. The controversial "snowball Earth" idea proposes that the Earth was completely covered by snow and ice 850 million to 630 million

years ago. There is indeed evidence that ice sheets have covered large portions of several continents during past ice ages, but there is no evidence that all of the continents were ice covered at any given time.

Human beings (*Homo sapiens*) started to appear on Earth during the last few hundred thousand years, at the time when the Earth was experiencing cold glacial periods followed by warm interglacials. The most recent ice age began to end about 18,000 years ago, when global air temperatures were nearly 10° Celsius (50° F) colder than at present. The present interglacial is known as the Holocene epoch.

Snow and ice on Earth now take the form of ice sheets and ice shelves, glaciers, seasonal snow cover, frozen ground, sea ice, and lake and river ice. What is happening to this cold and frozen world has broad implications for all life on this planet.

PROPERTIES OF ICE AND SNOW

Ice and snow begin with water and its close interaction with air temperature and the sun. Sunshine is essentially white, being formed by equal amounts of blue, green, and red frequencies. The water molecule H_2O absorbs six times more of the red frequencies of the spectrum than the blue component, thus preferentially reflecting blue light. Blue ice is particularly obvious under diffuse light, when the sky is overcast. If ice contains large numbers of air bubbles, it will appear white due to multiple reflections of incidental light produced on the rough surface of the bubbles (which also explains why beer foam is white, even in the case of delicious dark ales).

When frozen—that is, below 0° Celsius (32° F) at sea-level pressure—the H_2O molecule expands by more than 8 percent. This behavior is quite uncommon in nature and is not at all obvious from water's chemical composition, which is one of the simplest in chemistry. This happens because water molecules are linked by weak chemical forces known as hydrogen bonds, connecting the hydrogen atoms of one molecule and the oxygen atom of the neighboring molecule. At

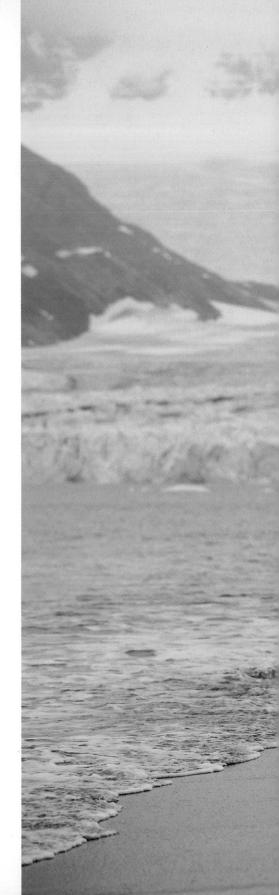

King penguins approach an icy bay off South Georgia Island as they head out to find food for their chicks.

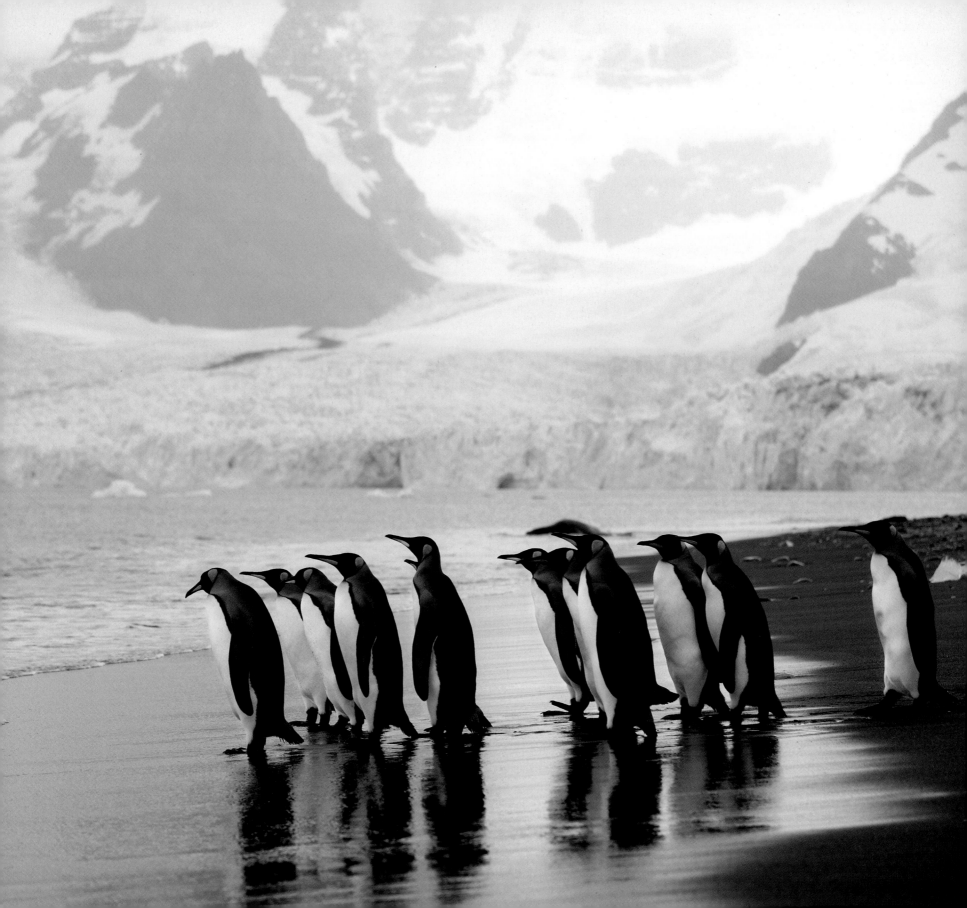

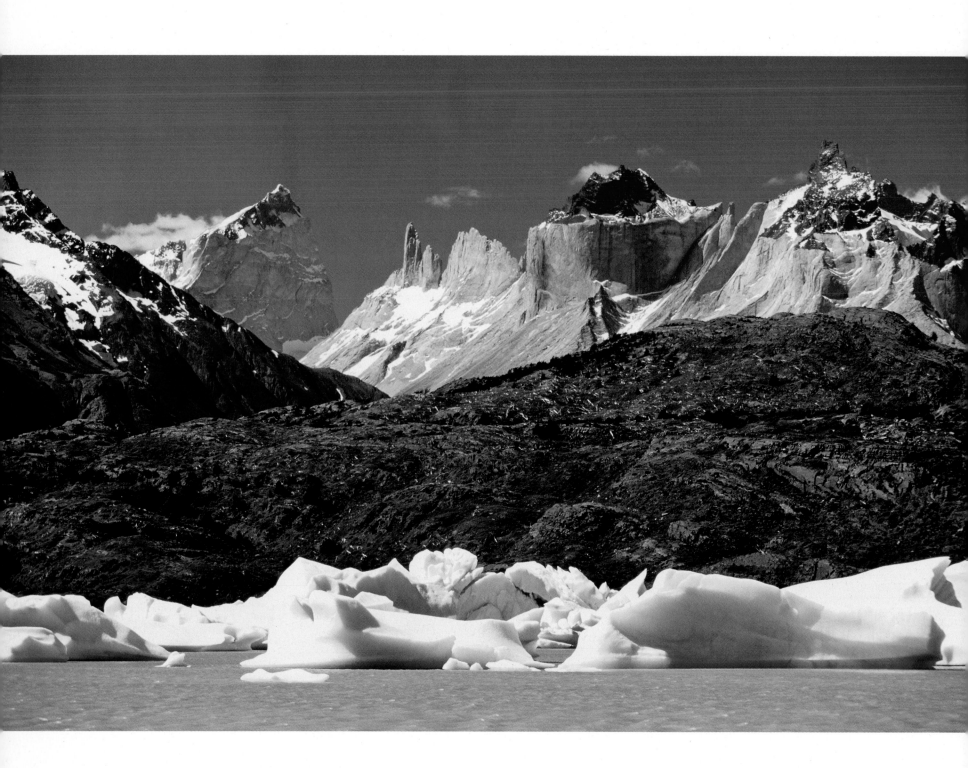

4° Celsius (39° F), water achieves its maximum density (999.972 kg/m^3), expanding at lower temperatures due to changes in these hydrogen bonds; just the opposite is expected from normal fluids and materials in general, which expand at higher temperatures. Therefore, icebergs and sea ice float on the ocean the same way that ice can float in a glass of Scotch. While this is bad news for ship traffic in polar regions (for example, the *Titanic*) and for pipes (which tend to burst in cold winters), it is good news for polar bears, which depend on sea ice for survival. The lower density of ice compared to water favors the existence of marine and freshwater ecosystems, which can develop under very low atmospheric temperatures because of the thermal isolation of the floating layer of ice.

Depending on its temperature and pressure, ice exhibits fifteen different crystalline structures, plus three amorphous phases. The crystalline structures are known as *ice I* through *ice XV*, of which only *ice I* occurs naturally on Earth; all the others exist at much lower temperatures and higher pressures than found on Earth. Amorphous ice is formed only artificially and perhaps also in outer space at extremely rapid cooling rates, which prevent the formation of a crystal lattice. *Ice Ih*, where *h* denotes the hexagonal structure of the ice crystal (which, incidentally, is the reason why all snowflakes have six points), occurs naturally on Earth. Some speculate that other ice structures might be found deep in the Earth's interior under high pressures, but if they exist, they remain undiscovered.

The deepest-occurring natural ice on Earth is at a depth of nearly 5 kilometers (3.1 mi) at the base of the Antarctic Ice Sheet, where the pressure is nearly 500 times larger than atmospheric pressure at sea level, but still less than a quarter of the pressure needed to transform *ice Ih* to other crystalline ices. At that depth, the melting temperature of ice (also known as the pressure melting point) is about −3.3° Celsius (26° F). The pressure melting effect is also a direct consequence of the nature of the hydrogen bonds that cause frozen water to expand. Pressure melting will allow, for example, the classic experiment of a fine wire hanging with weights attached to it to cut through an ice cube, thus melting its way down, with the ice refreezing (called *regelation*) on the upper side where the pressure on the wire is reduced.

Snow is essentially a mixture of ice, air, impurities, and also water if temperatures are at or above the freezing point. Snowflakes are truly "letters from the sky," as beautifully described by Japanese physicist Ukichiro Nakaya, who in the 1930s was the first to reproduce snow crystals in the laboratory. If snow undergoes sufficient compaction, as occurs on a glacier due to periodic snow accumulation, it will eventually transform into ice. Snow can also transform into ice if it melts and refreezes, liberating air bubbles, as occurs after snow falls over roads, later melts during a warm, sunny day, and then refreezes at night.

In atmospheric sciences, *accretion* is the technical term that describes the growth of snow and ice from water vapor. Accretion by formation of ice from vapor condensation or from freezing rain can be very destructive for such things as aircraft, polar ships, powerlines, and road traffic. Accretion also results from growth of solid forms of snow and ice, as with snowballs, particularly those made with wet snow (which is much stickier than dry snow). Think of the rapid growth of a snowball rolling down a slope.

Snow and ice have a very low surface friction, which allows skating, skiing, and sledding, but also causes problems such as reduced wheel traction and slippery roads. Low snow friction is also responsible for the long distances traveled by avalanches; in some cases avalanches can climb uphill for hundreds of feet. Why ice friction is so low is still not completely understood. There is some debate as to whether it is due to the presence of liquid water (resulting from the heat produced by frictional sliding) or is in fact due to the intrinsic properties of the

Icebergs in Lake Grey below the Cuernos del Paine, Chile

THEN & NOW

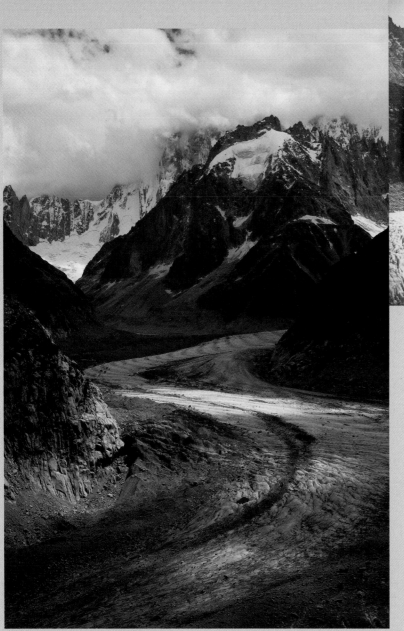

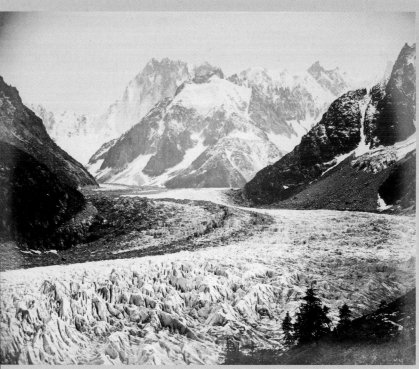

ABOVE *La mer de glace cremonia*, circa 1865; photograph of the French Alps taken by Muzet Joguet. Joguet ran a studio based in Lyon, France, during the 1860s that specialized in topographic photographs and documentary studies of civil engineering works. *Photograph by Joguet et ses Fils courtesy of National Media Museum / Science & Society Picture Library*

LEFT Mont Blanc's Mer de Glace in France's Savoy Alps hasn't retreated much in distance, but it has lost more than 300 meters (1000 ft) in thickness since the early 1900s.

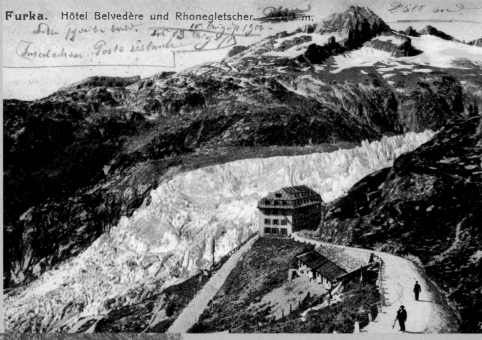

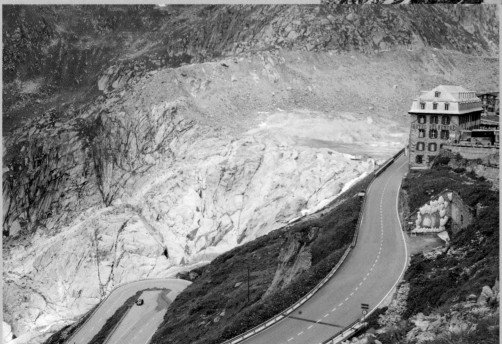

ABOVE **Rhone Glacier with the Hotel Belvedere, circa 1906.** *Photograph courtesy the Society for Ecological Research, Munich*

LEFT **The Hotel Belvedere was built a century ago in the Swiss Alps so tourists could enjoy the spectacle of the Rhone Glacier's icefall tumbling hundreds of feet to the valley below. Here, a remnant of the once-mighty glacier can be seen in the bowl to the left of the hotel; below it is white rock.**

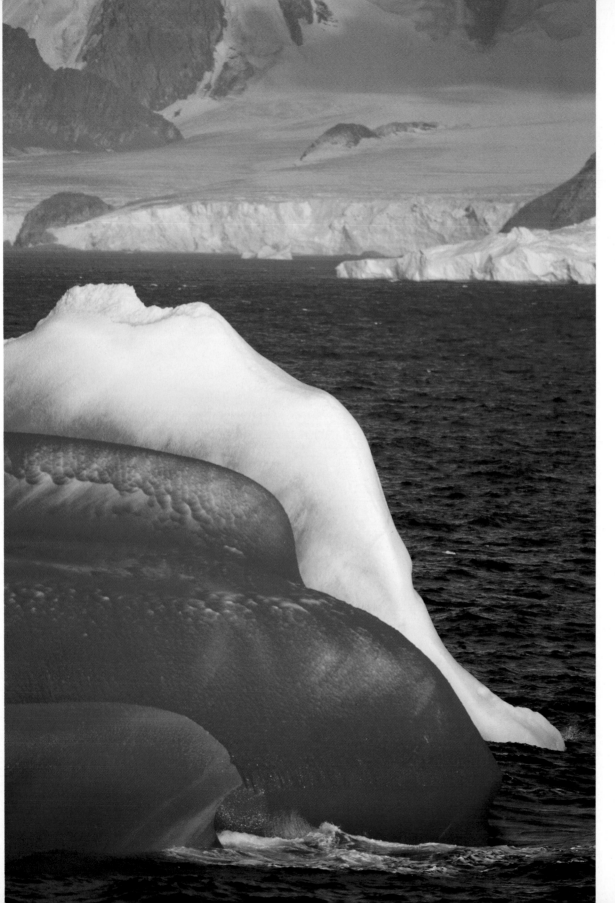

LEFT Blue ice forms when pressure squeezes air bubbles out of white ice or meltwater when it freezes.

OPPOSITE, ABOVE An aerial view of the upper reaches of an ice fjord in Greenland before the icebergs get caught by the undersea moraine as they enter the open ocean

OPPOSITE, BELOW Detail of a large iceberg floating in Franz Josef Fjord, northeast Greenland

ice crystal, which exhibits a very slippery and very thin waterlike layer even at −150° Celsius (−238° F). What is clear is that the low friction cannot be explained in every case by the presence of liquid water produced by the depression of the freezing temperature because of pressure melting. Under the weight of a skater's blade, for example, the pressure is simply too low to melt the ice.

SEASONAL SNOW COVER

In the Northern Hemisphere, seasonal snow in winter covers 45 million square kilometers (17 million sq mi), an area that shrinks in summer to only 2 million square kilometers (0.8 million sq mi); that is a reduction from nearly twice the size of North America to the size of Mexico. The snow area in the Southern Hemisphere, outside of Antarctica, is restricted to high mountain regions and the southernmost areas of South America, Australia, New Zealand, and a few southern islands, amounting to less than 10 percent of the Northern Hemisphere snow cover. The winter extent of seasonal snow cover is much larger than that of any other snow and ice component on Earth, but due to its shallow thickness, seasonal snow would hardly raise the global sea level by 1 centimeter (0.4 in) were it to melt entirely.

Seasonal snow cover directly affects water resources, particularly during the spring melt. In the Northern Hemisphere, snow cover has shrunk by more than 1 percent per decade over the last forty years. In turn, rivers controlled partially by snowmelt in North America and Eurasia are now showing peak flows that occur one to two weeks earlier than those observed sixty-five years ago. If these trends persist, water resources will be severely diminished, particularly in spring, affecting such economic activities as agriculture and hydropower generation.

Skiing also depends critically on snow cover extent. Evidence in recent decades shows reduction of snow cover in ski areas in the eastern United States, Australia, and the European Alps. In the central Andes of Chile, the snow line has risen by more than 100 meters

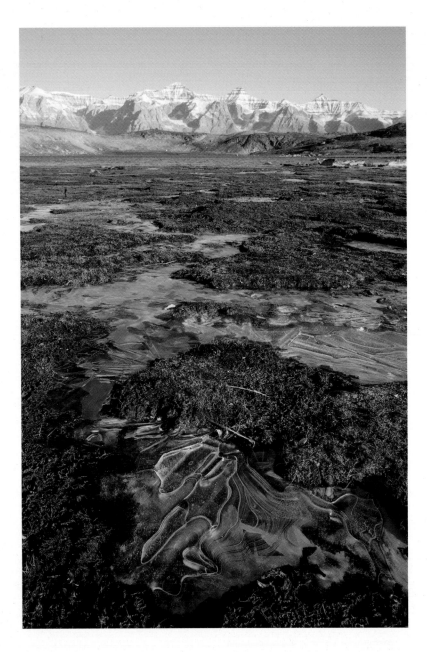

At the head of Scoresby Sound, Greenland, ice forms in puddles on the tundra at first light.

(328 ft) in winter and 200 meters (656 ft) during summer in the last thirty years. Future projections show that warming will cause snow cover to decline by 60 to 80 percent in most midlatitude areas within the next 100 years, while increases are predicted in Siberia and in the Canadian Arctic due to higher snow precipitation. Less snow will severely affect the ski industry, particularly ski areas located below elevations of 2000 meters (6562 ft).

Not least, of course, snow plays an important ecological role, controlling the growth of microorganisms, insects, birds, mammals, and vegetation. Reduction of seasonal snow cover, glaciers, frozen ground, and sea ice will affect indigenous people living in alpine areas and especially in the Arctic, who traditionally depend on snow and ice in order to live. In Greenland, warmer temperatures are already allowing the growth of potatoes, which has been unheard of since the times of the Vikings during the Medieval Warm Period, AD 800 to 1300.

FROZEN GROUND

Frozen ground includes permanently frozen ground (called permafrost), seasonally frozen ground, and ground frozen for shorter time periods. In the Northern Hemisphere, the total area covered by seasonally frozen ground varies from 6 million to 48 million square kilometers (2.3 million to 18.5 million sq mi), or twice the size of North America; permafrost amounts to 23 million square kilometers (8.9 million sq mi). In the Southern Hemisphere—outside of Antarctica—most of the permafrost is found in the Andes, with an estimated area of only 100,000 square kilometers (38,610 sq mi).

There is evidence that the temperature of permafrost has increased in the last few decades, both in the Arctic and in some mountain regions. Warming of frozen ground is resulting in devastating effects. An increase of wetlands in the Arctic and increases in lake formation followed by rapid drainage, as well as mechanical weakening of the ground, produce damages to infrastructure (roads, railroads, airfields, buildings,

pipelines), slope instability, and rockfall, such as that reported in the Alps during the exceptionally warm summer of 2003. Temperatures 6° Celsius (11° F) warmer than average caused the deaths of nearly 15,000 people in France and about another 35,000 in the rest of Europe.

A particularly disturbing potential effect of future warming and increased wetlands is the release of organic carbon. The upper permafrost layers contain about 850 gigatonnes (1.9 trillion lb) of carbon, which is 10 percent more than the organic carbon found at present in our atmosphere. The partial release of this carbon amount, not to mention the carbon stored deeper in the permafrost, might severely exacerbate the greenhouse effect.

SEA ICE

Sea ice is found in the Arctic and around Antarctica. Salt depresses the freezing point of seawater to a temperature of about −1.8° Celsius (28.8° F). At first a thin sheet of surface water freezes, progressively adding ice by freezing downward in the form of vertical column–shaped crystals. During the crystallization process, sea salt is rejected and trapped in small pockets of highly concentrated brine.

After one winter, first-year ice can reach thicknesses of up to 2 meters (6.6 ft). If first-year ice does not melt entirely during the summer, it can continue to grow by regelation on the underside and by snowfall on the surface, becoming multiyear ice, which can attain thicknesses of 4 meters (13.1 ft). Multiyear ice is usually transported hundreds of miles by oceanic and atmospheric currents and can survive for more than a decade. During the summer, sea ice can melt on the surface, creating melt pools and thaw holes, and it can also melt from the underside. As surface meltwater finds its way down through the sea ice due to its increased specific weight compared to ice, which can mechanically break the ice cover and can also melt the ice, it effectively drains the salty brine, thus reducing the salinity of sea ice, which in turn mechanically strengthens the multiyear ice.

Seawater just beginning to freeze north of the Arctic Circle as late-summer temperatures drop in September

DECLINE OF MOUNTAIN GLACIERS

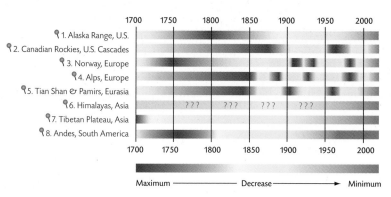

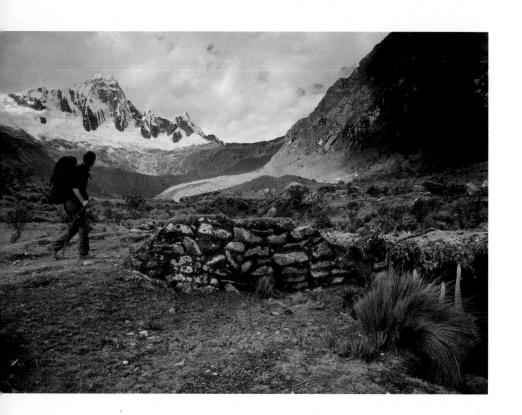

A hiker approaches a 4725-meter (15,500-ft) pass, Punta Union, on the Santa Cruz Canyon loop in Huascarán National Park, Peru, with Mount Taulliraju rising at the canyon's head in the Cordillera Blanca Andes.

Over the past hundred years, a trend of dramatic shrinking is apparent over the entire globe, especially at lower latitudes such as that of the Himalayas; increasing rates of glacier wasting occurred after 1980. *Source: Hugo Ahlenius, U.N. Environmental Programme/GRID-Arendal (http://maps.grida.no/go/ graphic/overview-on-glacier-changes-since-the-end-of-the-little-ice-age)*

Due to pressures caused by wind, sea ice can break apart into openings in the ice known as leads. If a lead refreezes and is later affected by winds, it can easily be crushed into broken blocks of ice, creating linear features in sea ice known as pressure ridges; these usually range in thickness from 10 to 30 meters (about 33 to 98 ft).

Sea ice in both polar regions covers 27 million square kilometers (10.4 million sq mi) in winter (slightly larger than the size of North America), reducing to 19 million square kilometers (7.3 million sq mi) in summer. Since it is already floating, sea ice does not contribute to raising sea level as it melts. Arctic sea ice has declined sharply over the last three decades due mainly to warming, with reductions of 9 percent per decade recorded in September of each year and 2.5 percent per decade each March. The decline is predicted to accelerate due to the ice albedo effect, or the extent to which a surface reflects light from the sun (see "Forces at Work in the Warming Arctic"). Models predict that the Arctic Ocean will become totally ice free in summer well before the end of the century. Antarctic sea ice is projected to shrink as well under progressive warming, but at a much more moderate rate than in the Arctic; this difference is at least partially due to the extensive Antarctic glacial cover and the circumpolar current, which are very effective at keeping Antarctica cold.

Although sea ice constitutes a very harsh environment, it is a unique habitat that hosts species such as seals and polar bears. The reduction of Arctic sea ice would bring many negative consequences to the web of life, including reduction or even extinction of organisms ranging from bacteria to whales and threatening indigenous peoples' traditional life-styles and cultures. Changes associated with the impacts of melting sea ice—impacts that are hard to quantify—include a potential slowdown

Tents and horses at the high camp below steep-ice-draped Mount Taulliraju, one of the most beautiful peaks in Peru's Cordillera Blanca; the rapidly melting ice in this region may disappear within a generation.

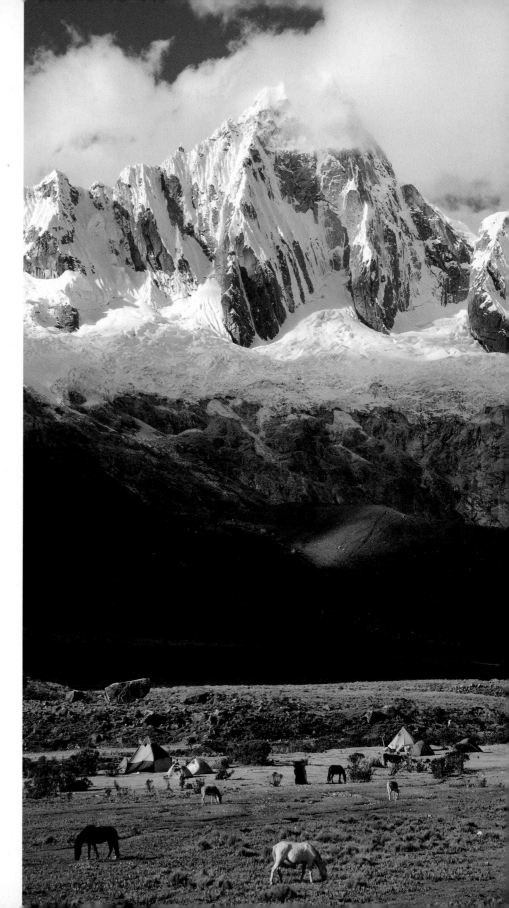

FOCUS ON ICE

HOW COLD IS "COLD AS ICE"?

Ice always seems cold if you grab some with your bare hand. The ice touching your fingers is probably at the melting point—but ice can be far colder. Mountain glaciers are often at the melting point throughout, but almost all of the ice in the great polar ice sheets is below freezing. Of great importance is the temperature at the bottom of the ice.

Anyone who has shoveled a snowy driveway knows that sometimes the snow and ice are frozen hard to the blacktop and virtually impossible to move; other times, a film of water separates the snow and ice from the blacktop, and shoveling is simple. The same is true of glaciers and ice sheets—sometimes they are frozen at the bottom and stuck tight to the rock, and other times they are thawed by the heat of the Earth and are free to slide over the materials beneath.

Melting at the bottom makes glaciers more interesting. A glacier sliding over its bed, whether lubricated by a thin film of water or by a thicker layer of water-saturated mud (called till), goes faster than a glacier frozen to the bed. In some cases, a glacier with a melted bed moves ten or even a hundred times faster than a glacier frozen to the rocks beneath. If warming were to thaw a formerly frozen bed, the pile that is the glacier or ice sheet would spread faster, moving more ice to lower elevations where melting is faster, or making icebergs faster, and thus reducing the total volume of ice. —*Richard Alley*

Chunks of ice from a serac (ice tower) fell into a crevasse in the Perito Moreno Glacier in Argentina's Perito Moreno National Park.

or even shutoff of the Gulf Stream, which brings warm waters to the North Atlantic. However, not all the impacts of global warming on sea ice are negative. A reduced sea ice cover will result in increased shipping traffic and associated economic growth, although environmental risks will increase correspondingly. Even the political world will be affected by continued warming: in view of the loss of sea ice, Arctic countries are already preparing claims for increased sovereignty in the area.

LAKE AND RIVER ICE

Lake and river ice are formed by the freezing of freshwater downward from the surface, similar to sea ice, with growth of vertical columnar crystals reaching thicknesses of 1 meter or more (3-plus ft). As in sea ice, pressure ridges may also develop, substantially increasing ice thickness. At the end of the summer, virtually all lake and river ice melt, except in remote locations at high latitudes in the polar regions.

The effect of warming is also clearly documented in Arctic freshwater ice, with a shortening of the freezing period due to earlier breakup in spring and, to a lesser extent, by a later freeze-up in autumn. Future reductions of lake and river ice are expected under continued global warming. This would bring changes in floods produced by ice jamming upstream, resulting in both fewer events in areas where reduced freezing dominates and in enhanced floods in regions that are affected by increased breakup events.

Access to communities and industrial facilities via frozen lakes and rivers will suffer if the freezing period is further reduced. Traditional activities of indigenous people, such as hunting and fishing, will also be affected, as will recreational skating on outdoor lakes and rivers. Another impact of reduced ice, which is hard to evaluate, includes changes in lake and river ecosystems.

Large blocks of ice fallen from Alberta, Canada's retreating Athabasca Glacier are protected by a covering of morainal material, which slows melting.

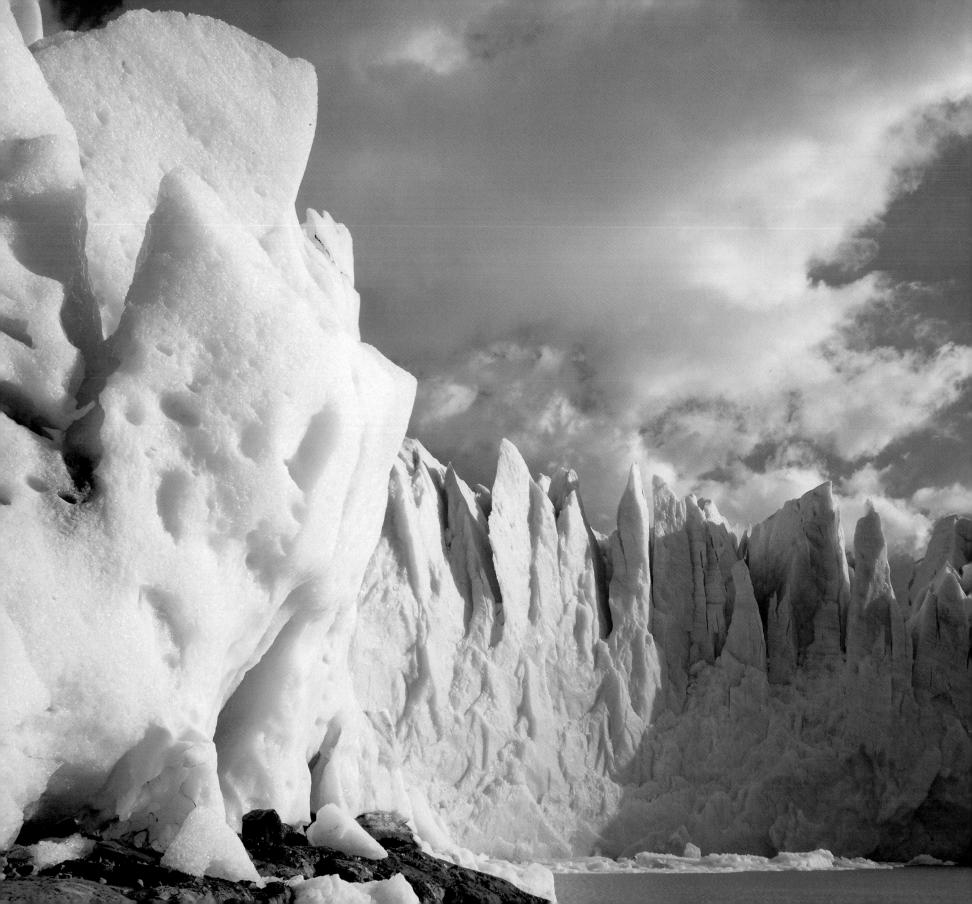

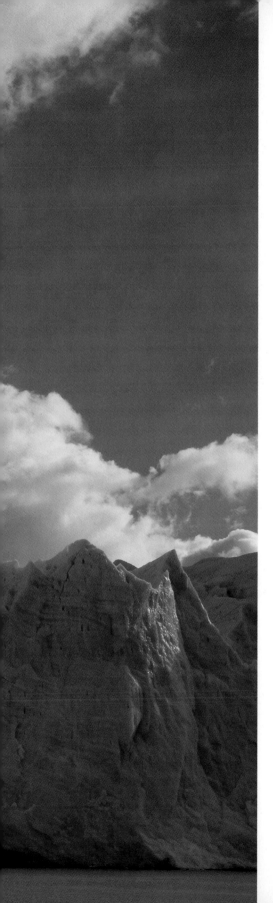

THE FORECAST OF ICE AND SNOW

If the climatic trend of the last 2 million years continues, the Earth could experience a new ice age within the next 10,000 years or so. However, some scientists believe that due to global warming, this natural cyclicity might be disrupted and the present Holocene epoch might turn into a "superinterglacial" lasting an unusually long time.

Greenhouse gas concentrations are now higher than at any time during the past 800,000 years, and it is these gases that are mainly responsible for the recent warming. In essence, we humans are responsible for this unprecedented change.

What can we do to avoid the meltdown of snow and ice due to the increased concentration of greenhouse gases produced by human activities?

Essentially, we must reduce the generation of greenhouse gases. Some of the concrete actions we can begin with include employing cleaner technologies and promoting sequestration of carbon—the latter can be achieved by preserving and growing forests and also by capturing carbon from the atmosphere and, for example, injecting it into deep wells. Goals far stricter than those agreed to as part of the Kyoto Protocol are needed in order to lower the concentration of greenhouse gases to reasonable values. And each one of us has a very relevant role in trying to accomplish that, including, for example, using clean and more efficient energy sources.

Simply put, it is urgent that we try to reduce greenhouse gases. Action now will leave our descendants a planet with a cleaner environment and better energy technologies, even if the unexpected scenario of a new ice age—instead of continued global warming—does come to pass. And we should continue to study and enjoy snow and ice as long as we can. ❋

The Perito Moreno Glacier in Argentina's Andes is fed from the Southern Patagonian Icefield; the ice sometimes blocks a channel between two lakes until sufficient pressure builds and the ice dam breaks.

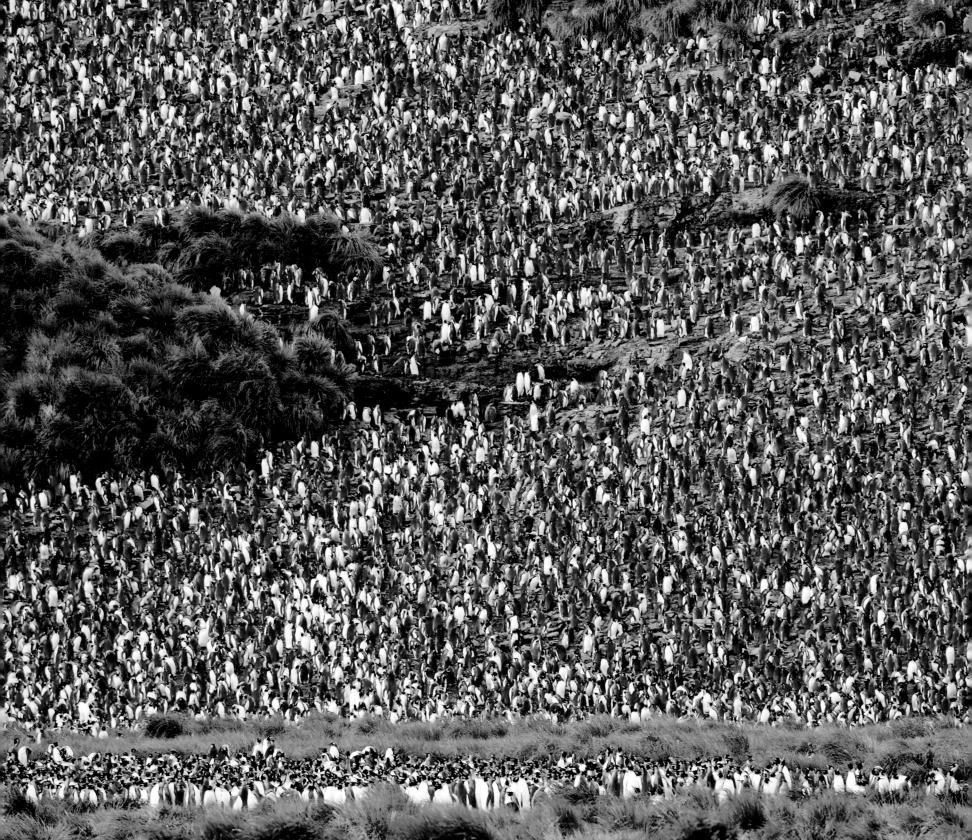

FOCUS ON ICE

THE ICE BIRDS

Antarctic penguins, like Arctic polar bears, provide compelling evidence of the impacts of climate change on their unique ecosystems. The seventeen species of penguins live only in the Southern Hemisphere, from Antarctica to more-populated colonies in South America and islands in southern oceans. Some species—like the Adélie penguin—nest on land rather than ice but except for the Galapagos penguin that lives at the equator, these marine birds like it cold.

Seven penguin species make their home in the southern polar region proper: the emperor and Adélie penguins extend the farthest south around the Antarctic coast, while the chinstrap, gentoo, king, macaroni, and rockhopper penguins live on the northern Antarctic Peninsula and on subantarctic islands.

Emperor penguins are the largest, at 20–40 kilograms (44–80 lb), according to Dr. Dee Boersma at the University of Washington. They live only where the ocean freezes at least part of the year. They begin breeding in April, when Antarctic sea ice is extensive, and because they can't climb, they nest on flat sea ice, which remains stable until the end of December. If the ice is too thin or breaks up too soon, the chicks are lost at sea before they're independent. At the northern edge of their habitat, the Point Géologie colony has not recovered from warming winter temperatures since the mid-1970s, when the population dropped from about 6000 breeding pairs to about 3000, according to research at www.penguinscience.com.

Chinstrap penguins on Zavodowski Island in the South Sandwich Islands

Since penguins can't fly, they depend on a stable food supply in predictable locations. Human exploitation of fisheries has affected their food web, as have warming temperatures. For the tiny Adélie penguins, less sea ice can mean more *polynyas,* open areas in otherwise dense pack ice where these penguins can feed. Receding Antarctic glaciers can also reveal moraines of rocks where the 4- to 6-kilogram (8- to 13-lb) Adélies can nest.

But the warmer temperatures also mean competition from other penguin species. Since the 1940s, the western Antarctic Peninsula has experienced the largest temperature increase on Earth, rising 0.5° Celsius (0.9° F) each decade. Gentoo and chinstrap penguins' southward expansion on the peninsula during that time confirms that sea ice is disappearing, and the Adélie colonies with it. In the early 1970s there were about 15,000 breeding pairs here, and in 2000 there were only 4000. Chinstrap penguins, which aren't as dependent on very cold conditions, may begin to displace the Adélies.

This will become part of the long history of Adélie penguin colonies—these seabirds have left 35,000 years' worth of bones and eggshells, a record of the past that helps us see what might happen to Adélies and their cousins in the future. *–Kris Fulsaas*

Nesting king penguins on South Georgia, the largest of the Antarctic islands

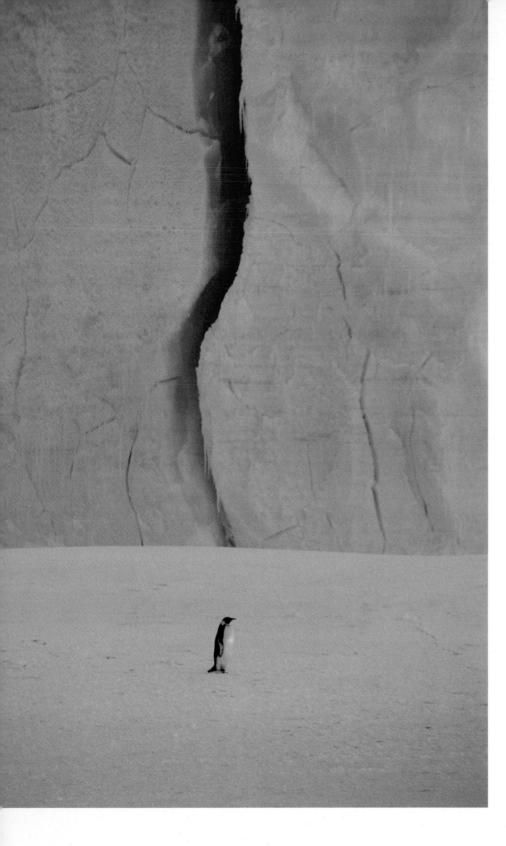

LEFT A lone emperor penguin walks the frozen Weddell Sea, Antarctica.

RIGHT Emperor penguins, the only large animal that winters on the Antarctic continent, form a colony near a large grounded iceberg on the Weddell Sea.

FOLLOWING PAGES, LEFT The exceedingly small feathers of a king penguin form a dense coat of more than 100 feathers per square centimeter, which provides protection against cold air and frigid waters.

FOLLOWING PAGES, RIGHT A rainbow bathes a large king penguin colony with color on St. Andrews Beach on South Georgia Island.

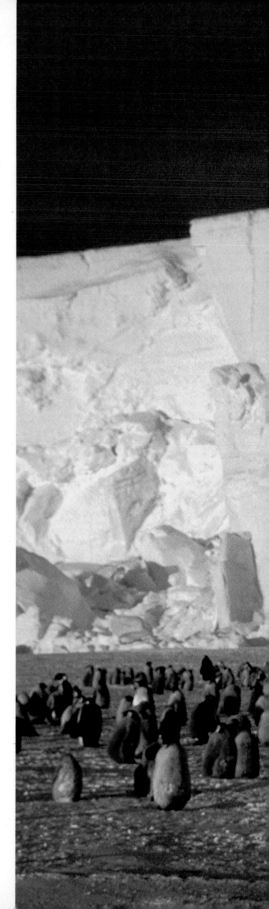

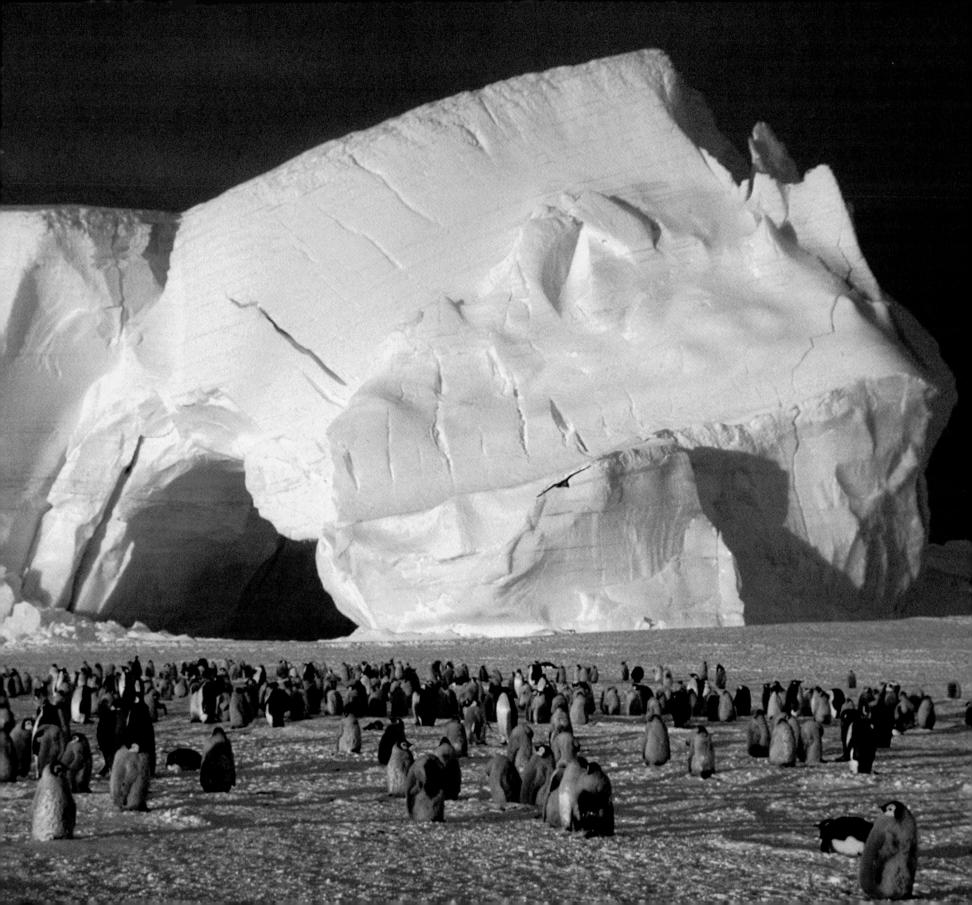

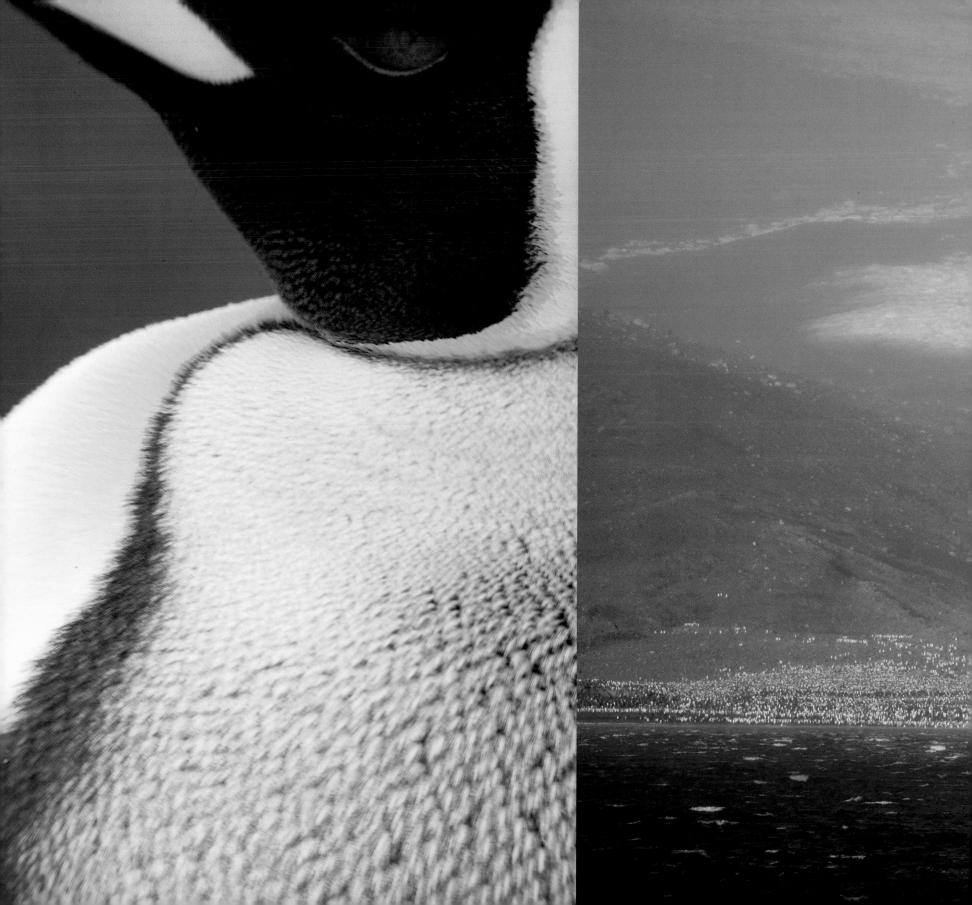

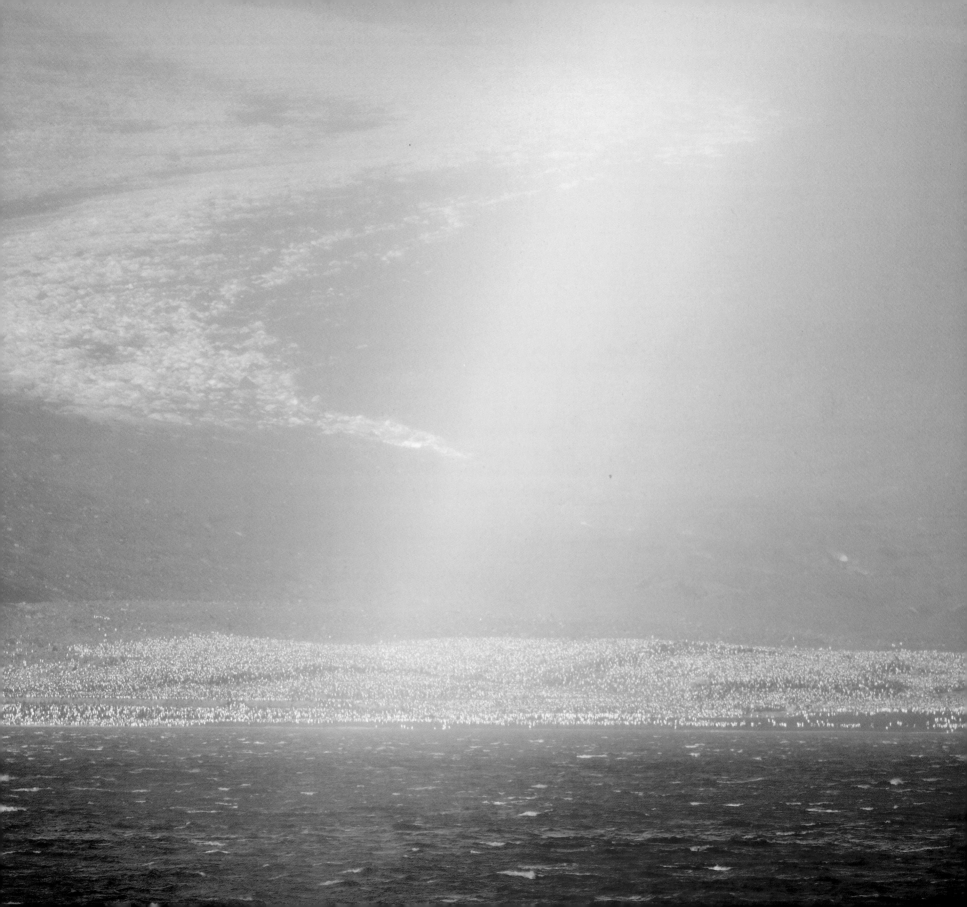

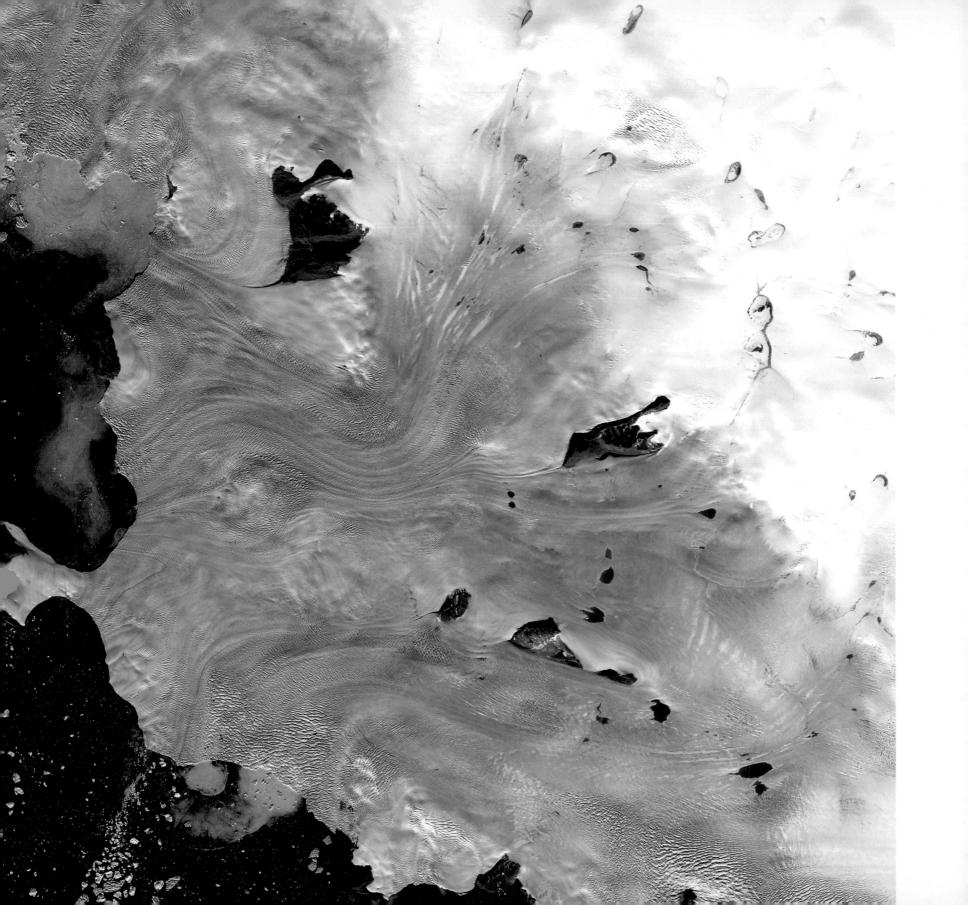

WHY ICE MATTERS
A LENS INTO
CLIMATE CHANGE

Richard Alley

RICHARD ALLEY is Evan Pugh Professor of Geosciences at Pennsylvania State University. He is a member of the National Academy of Sciences and chaired their Panel on Abrupt Climate Change. He participated in the Intergovernmental Panel on Climate Change, which was co-recipient with Al Gore of the 2007 Nobel Peace Prize, and has advised upper-level U.S. government officials in numerous administrations. He has published more than 175 peer-reviewed papers, and his popular account of climate change and ice cores, *The Two-Mile Time Machine,* was chosen science book of the year by Phi Beta Kappa in 2001. *Photograph courtesy of British Broadcasting Corporation*

A satellite image of Greenland's west coast *(image courtesy of USGS NASA Landsat 7 Data Collection)*

The great ice began with a single snowflake. Each delicate flake that survived summer's heat was pressed by the weight of more snow into the growing layers of gleaming glacier ice, which carved the high peaks, and the vast ice sheets piled at the poles.

Slow changes in the planet amassed the ice over millions of years. The snow that covered the polar lands started as water evaporated from the ocean, lowering sea level to expose the coastal regions, where humans settled. And as the snow fell and was compressed to ice, it trapped bubbles of air and bits of dust, layer upon layer, recording the history of the changes in the Earth's climate that have affected humanity—and the reasons for those changes.

Reading that record tells a sobering tale: although nature has changed climate and the ice over time, humans are now pushing harder and faster than nature, with no sign that nature can push back hard enough. Our decisions about burning oil, coal, and natural gas will determine whether future warming becomes great enough to melt much of the world's ice, flooding our coastal settlements with the liquid remnants of the beautiful polar historical records. How do we read the clues in the ice, determine that they are reliable, and learn what they mean for the future?

THE MYSTERY IN THE ICE

One-tenth of the land on Earth is buried by permanent ice. The deepest ice is found in Antarctica and Greenland, and ice cores more than 3 kilometers (2 mi) long have been drilled from these two immense ice sheets. Like a written history, the story that unfolds through the depths of the ice is told over time in layers—in this case, layers you can actually see.

The easiest way to look at layers in snow is in a snow pit. If you're lucky enough to live in a climate where it snows, get a shovel and dig in! Digging really deep is hard, but almost anyone can get 2 meters (6 ft) down in an afternoon. To see things clearly, dig two pits next to each other, separated by a wall just a foot or so thick. Lay boards over one pit, while the sun shines into the other. Crawl beneath the boards, and pause for a very long moment. The sun shining through the thin wall is the most ethereal, beautiful blue imaginable.

After admiring the blue, notice the layers. A storm leaves a hard-packed deposit, with slanting lines marking the growth of a snowdrift. A sunny week doesn't melt the coldest parts of the ice, but the sun's energy changes the structure of the snow from packed-in to light and airy. The next storm scours the top of the sun-cooked layer before putting down a new drift. Where snow survives the summer, what we see is storm and calm, summer and winter, year by year, written in the pit walls.

Some people were once concerned that the snow falling on Greenland and Antarctica would build up and build up until the world became top-heavy and rolled over. Don't worry! The pile that is the Greenland Ice Sheet spreads in all directions under its own weight, becoming wider and thinner. If the climate is unchanging, a balance will be reached in which the thinning causes the surface to move downward as rapidly as new snow accumulates. There is no magic here, just simple physics. If the surface moved down slowly and snow fell rapidly, the pile would get higher, but higher piles spread faster and so the surface moves down faster—and a balance is achieved.

Broken ice stranded by waves lines the beach on Paulet Island off the northeast end of the Antarctic Peninsula.

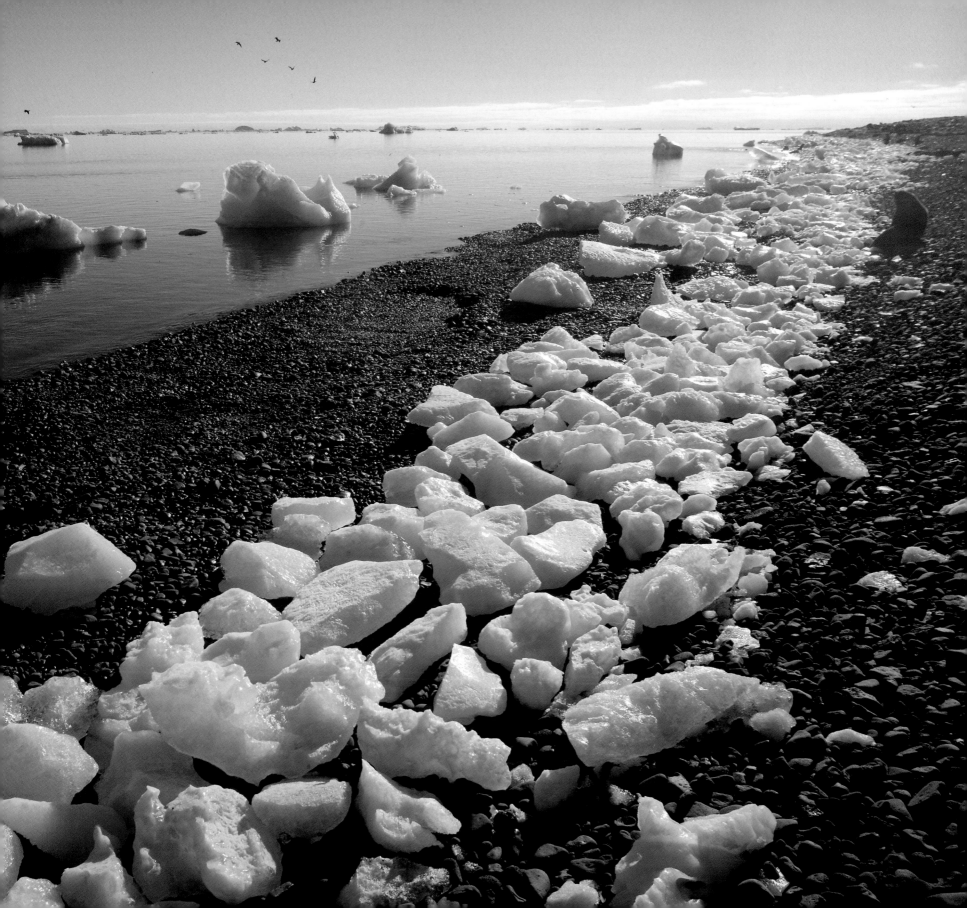

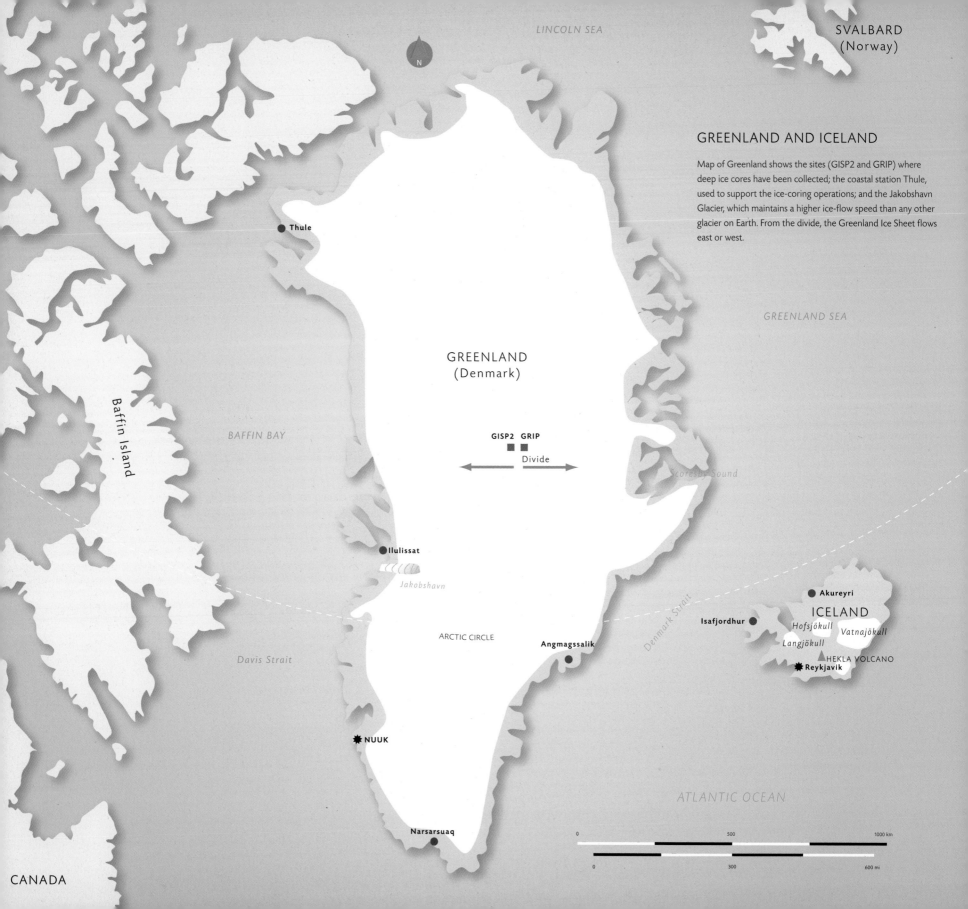

LINCOLN SEA

SVALBARD
(Norway)

N

GREENLAND AND ICELAND

Map of Greenland shows the sites (GISP2 and GRIP) where
deep ice cores have been collected; the coastal station Thule,
used to support the ice-coring operations; and the Jakobshavn
Glacier, which maintains a higher ice-flow speed than any other
glacier on Earth. From the divide, the Greenland Ice Sheet flows
east or west.

Thule

GREENLAND SEA

GREENLAND
(Denmark)

BAFFIN BAY

Baffin Island

GISP2 GRIP

Divide

Scoresby Sound

Ilulissat

Jakobshavn

Akureyri

ICELAND

Isafjordhur

Hofsjökull Vatnajökull

Langjökull

ARCTIC CIRCLE

Denmark Strait

HEKLA VOLCANO

Reykjavik

Davis Strait

Angmagssalik

NUUK

ATLANTIC OCEAN

Narsarsuaq

0		500		1000 km

0		300		600 mi

CANADA

All of the layers in an ice sheet are spreading and thinning. The older layers, toward the bottom, have been spreading and thinning for a long while and are now very thin—a layer that was initially a foot thick reduced to less than an inch. (You also have to allow for the squeezing of the snow into ice under the weight of more snow, but the calculation is not very difficult.) Wherever an ice layer is, it will be thinned by about half in the time it takes to move half of the distance to the bed at the base of the ice. This means that a core sample of ice from near the bottom of a glacier will contain a whole lot more years of history than one from the snow pit at the top.

The chemistry of the atmosphere is different in the warmer, sunny summer than in the colder, dark winter, so the chemicals that fall with the snow and are trapped in the ice vary by season. These and other indicators allow the counting of annual layers in those places such as central Greenland where snow accumulates fast enough so that single snowdrifts don't interfere with interpreting a whole year of snowfall.

This counting can be confirmed in many ways. For example, a really big volcanic eruption spreads ash around the whole world, and the composition of the ash is characteristic of each individual volcano. As far back as historical records of volcanic eruptions are available, the chemically fingerprinted ash of the eruptions provides time lines in ice cores and other sediment cores, and these show that annual-layer counting in ice cores can be really accurate. And if you know the age of ice, then the thickness of an annual layer gives the snowfall rate

ABOVE Alternating white and blue-green layers on an iceberg in the South Orkney Islands, part of the British Antarctic Territories but also claimed by Argentina; blue ice occurs when air bubbles are compressed out of the ice or when meltwater seeps into cracks.

BELOW Open water in the pack ice off the coast of northern Greenland freezes at night in mid-September.

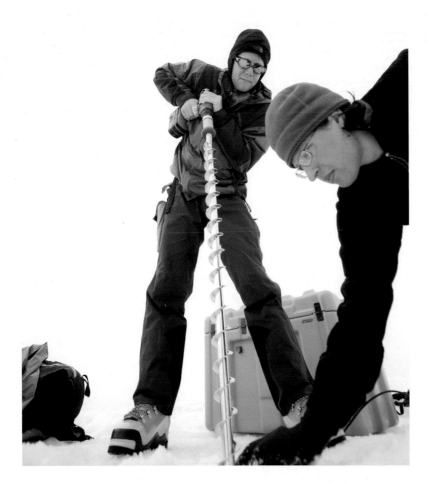

Scientists from the Woods Hole Oceanographic Institute set up a seismic monitoring station to record the effects of rapid surface-lake draining on the Greenland Ice Sheet.

when it fell, after correction for the thinning from ice flow.

Anything blowing around in the air—sea salt, soot, pollen, odd isotopes made by cosmic rays, micrometeorites, or whatever—will fall on the ice sheet and be included in the snow. You can get a dirtier layer if more dirt falls or if less snow falls to dilute the dirt, but once you know the snowfall rate, the dirtiness of the ice tells you how much stuff was blowing around in the air and reaching the ice sheet.

Ice sheets have several indicators of past temperatures. All of these *paleothermometers,* which require a little explaining, provide useful results. For example, a storm picks up water from the ocean and carries it up over the ice sheet, snowing on the way. The water naturally comes in both "normal" and "heavy" forms, with maybe one molecule in 500 having an extra neutron or two in at least one of its atoms. Not surprisingly, this heavier water falls out more easily. As the storm moves inland, cooling causes water vapor to condense and fall as snow, removing the heavy water from the air. The colder a site is, then the more water vapor has been removed before the storm arrives, the more the remaining vapor has been depleted in the heavy water, and the more depleted in heavy water is the snowfall at the site. So isotopic ratios of ice provide a paleothermometer.

Another paleothermometer is related to the physical temperature of the ice. Just as a frozen turkey placed in a hot oven takes a long while to warm up in the center, the ice in the center of the ice sheet has not finished warming from the cold of the ice age. The temperature of the deep ice today reveals much information about the history of temperature at the surface of the ice sheet—the history of the warmth of the climate. And combining this temperature information with the other measurements allows the ice to tell a whole lot about past climate.

CHANGING ICE

Changing ice matters in many ways. Mountain glaciers are reservoirs, holding the water of winter snow and releasing it in summer when it

is needed by salmon and farmers; imagine what might happen if this were to change. If the ice melts, we won't be able to read the history of climate in the ice. Also if a lot of the ice is melting, we won't be able to sail from the current ports to study the changes, because the current ports will be underwater.

The ice in glaciers and ice sheets is made of water that evaporated from the oceans and that hasn't made it back yet. If glaciers grow, the ocean falls—when the ice of the Pleistocene ice age was rumbling across what is now Chicago, New York, and Boston, the oceans were more than 100 meters (nearly 400 ft) lower than today because the water in the ice in the ice sheets had evaporated from the oceans. If glaciers shrink, the ocean rises.

If all the thousands of mountain glaciers were to melt, the world's oceans would rise a foot or two. But if the Greenland Ice Sheet melted, the sea would rise more than 7 meters (23 ft). In Antarctica, the ice is split into two pieces by the Transantarctic Mountains. The Western Hemisphere part, cleverly named the West Antarctic Ice Sheet, has almost 6 meters (20 ft) more of sea level, and the huge Eastern Hemisphere part, cleverly named the East Antarctic Ice Sheet, has about 50 meters (more than 160 ft) of sea level, for a total between Greenland and Antarctica of more than 60 meters (200 ft) of sea level locked up in ice. (These numbers are already corrected for the fact that some of the ice is below sea level or floating just above sea level, and so would not raise sea level if melted—West Antarctica has more ice than Greenland, but more of West Antarctica's ice is below sea level than is Greenland's, so melting Greenland would raise sea level more.)

The world has been warming over the last century, and especially over the last few decades. In response, the mountain glaciers are melting rapidly, as expected. Any given glacier may do crazy things for a little while, surging or otherwise marching to its own drummer. But averaged over decades, the huge majority of glaciers have lost mass, even those getting more snowfall. By estimating the sensitivity of

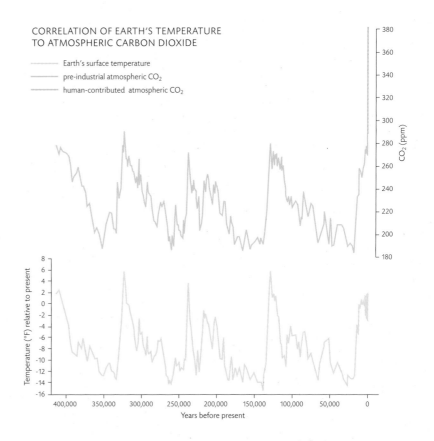

CORRELATION OF EARTH'S TEMPERATURE TO ATMOSPHERIC CARBON DIOXIDE

— Earth's surface temperature
— pre-industrial atmospheric CO_2
— human-contributed atmospheric CO_2

A compelling relationship between carbon dioxide and the Earth's temperature emerges when paleoclimate (past climate) is reconstructed from proxy measurements such as ice cores. *Source: International Panel on Climate Change, Third Assessment Report, 2001*

glaciers to changing climate and observing the changes in glacier size, we can even estimate the warming that has occurred, and this agrees with independent estimates from thermometers.

The Greenland Ice Sheet is losing mass too. Snowfall has increased in cold central regions, but melting has increased more. Perhaps more importantly, the flow of the ice sheet has also accelerated. Some of this acceleration may be due to the excess meltwater reaching the ice sheet's bed and lubricating the flow. But most of the acceleration is probably

LEFT Cryoconites form where bits of dust absorb more heat than the surrounding reflective ice; as they melt, exposing dust trapped in the ice and growing faster, they meld with surrounding cryoconites. These cryoconites were flooded by rising waters of a surface lake on the Greenland Ice Sheet.

RIGHT Icebergs from the Antarctic Peninsula drift northeast toward the South Orkney Islands, where many bergs are caught in the shallows.

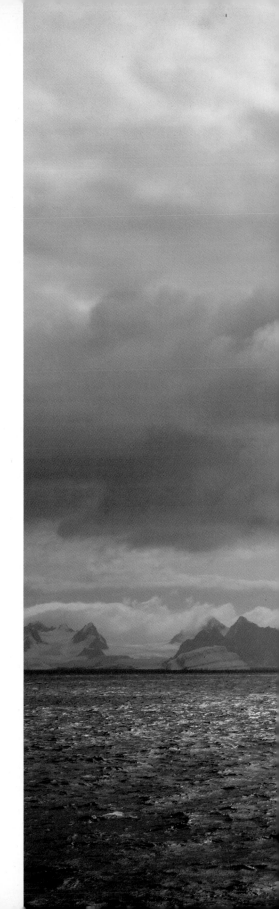

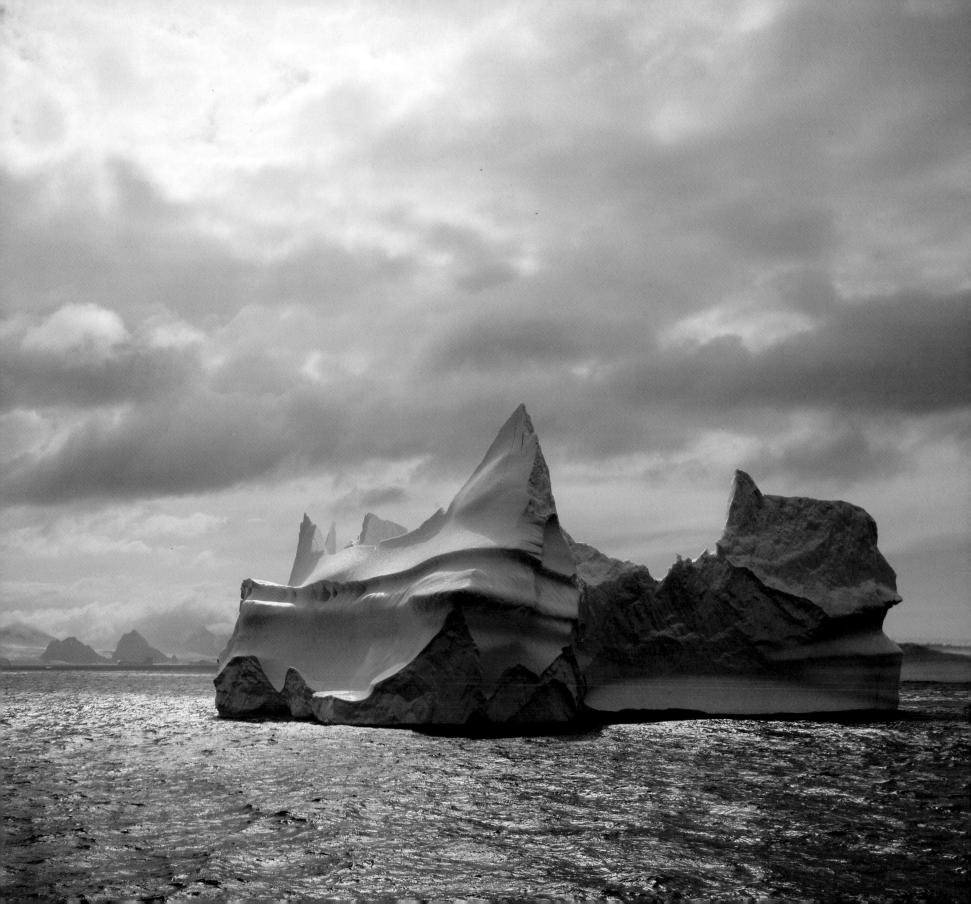

View of Greenland's Ilulissat village from its cemetery by Disko Bay; the Inuit live on the edge of one of the Earth's two largest ice sheets.

related to something that is also going on in Antarctica.

Remarkably, Antarctica seems to be losing mass overall, despite having almost no melting on its surface, and despite the expectation that warming would actually cause Antarctica to grow (see "The More It Snows, the More Ice Melts"). What is happening?

The ice in Antarctica, and in parts of Greenland, flows down to the sea to make icebergs. But the icebergs don't form the moment the ice starts to float in the surrounding sea. Instead, the floating ice remains attached as an ice shelf hundreds of feet thick, with ocean water beneath. These ice shelves scrape past the rocky sides of fjords or run aground on high spots in the seafloor before eventually breaking off icebergs at their ends.

Recall that all piles tend to spread under their own weight. The early Gothic cathedral builders discovered this—the soaring heights of the cathedrals tended to spread, the roof sagging down as the walls bulged out. How to protect the cathedral? Flying buttresses were the answer—great extensions to push back against the cathedral, defeating the spreading tendency with friction from the ground far beyond the stained-glass-enhanced walls. The ice shelves are the flying buttresses of the ice sheet, resisting some of the spreading tendency of the ice sheet through friction with the seabed or the fjord walls.

The surface of the ice sheet is cold, but the base of the ice shelf is at the melting point and is in contact with the water. Warm the water by 1° Celsius (1.8° F), and you'll increase melting from the ice-shelf bottom by about 10 meters (30 ft) per year, reducing friction with the seabed or the fjord walls and allowing faster flow. In Greenland, ice-shelf thinning and loss have been accompanied by near doubling in flow speed of parts of the ice sheet that had been perhaps the fastest moving on the planet. In Antarctica, meanwhile, loss of one ice shelf allowed a tributary glacier to speed up eightfold. The Antarctic Ice Sheet is behaving like other ice—melting with warming.

The ice records the history of climate, the ice changes when the

climate causes it to, and the ice even amplifies the climate changes—as warming melts ice, exposing soil, the darker ground soaks up more sun and causes more warming. As science has sorted out all of these interwoven strands, it has become clearer and clearer that humans now control the climate, and the ice, much more than does nature. But to see why, we need to take a trip back into history.

NATURE AND CLIMATE CHANGE

Ice cores provide tremendous detail about climate change on the ice sheets. Ice cores also give some information about climate changes elsewhere and some information about causes of climate changes. Meanwhile, moraines and other features left by former glaciers tell how the ice responded to the climate changes.

These records show that the climate has changed greatly throughout history—but usually slowly. Although some fascinating and scary strangeness has occurred, the climate has usually been well behaved. Let's look at the big, and not so big, causes of climate changes, what they might mean, and what they tell us about the recent past and the near future. The sun, cosmic rays, volcanoes, the Earth's magnetic field, space dust, jumps in the temperature of the North Atlantic, and wiggles in the Earth's orbit are all involved, and it has taken decades of serious research to learn what they do and don't do. The more we learn about the climate and about all the natural things that have happened over the millennia, the more we know that humans are responsible for the recent changes and that we are the primary drivers for future changes. So let's start with the sun.

If the sun changed much, we'd know it immediately. But we're lucky—the sun is a faithful furnace, and as far back as we can see, it just hasn't changed very much or very rapidly. As the world warmed late in the twentieth century, the satellites watched the sun and saw that it had not brightened—the sun simply cannot be responsible for what is happening. But the satellites have seen the sun's brightness

ICE SHEET DYNAMICS

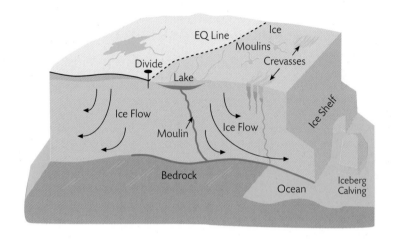

From an ice sheet's equilibrium (EQ) line—the boundary between accumulation from snowfall and ablation from melting snow or ice—the ice flows in opposite directions toward the ocean, where ice shelves form and icebergs calve. Moulins (vertical meltwater tunnels) and surface lakes—and even rivers—form in the EQ and ablation zones. *Sources: "Surface Melt-Induced Acceleration of Greenland Ice Sheet Flow," by H. Jay Zwally, et al., NASA Goddard Space Flight Center ; U.S. Geological Survey*

wobble a bit with the eleven-year sunspot cycle, going up and down and up and down without getting anywhere. Humans have observed sunspots for centuries, so we know that back a century and more, there were sunspot cycles with very few sunspots. The quiet sun gave slightly colder conditions at those times, contributing a bit to the cool of the Little Ice Age, the slightly cool period that peaked in the 1700s and 1800s, for example. We can look back even further than sunspot records, because changes in sunspots correlate with changes in the solar wind that helps protect us from the cosmic rays that break molecules in the air to make beryllium-10 and other chemicals.

Production of beryllium-10 also responds to changes in the

magnetic field that helps shield us from the cosmic rays, but careful work allows separation of the effects of the sun and the magnetic field, so that beryllium-10 can be used to estimate past variations in the sun. Again, when the sun changed a bit, the climate did too, but the sun has changed little, and almost all of the climate changes have other causes. (Looking back hundreds of millions of years, we have to rely on the physicists who study the sun and who tell us that it has been getting brighter very, very slowly, far too slowly to cause noticeable climate change over mere millions of years.)

Big volcanic eruptions throw up particles that block the sun and cause a degree or two of cooling for a year or two. If volcanoes could get organized, they could control the climate—but they can't get organized, so they're just noisemakers, complicating things without accomplishing much.

The Earth's magnetic field nearly went away for a millennium about 40,000 years ago. We can see this because during this interval the little "magnets" in minerals in lava flows were not lined up by the magnetic field before freezing into position, as normally happens. The weak magnetic field allowed cosmic rays to stream in, and the resulting spike in beryllium-10 in ice cores and sediment cores is huge. But the climate didn't follow the pattern of change in beryllium-10, so cosmic rays cannot matter much to climate. Recently, our instruments have shown that cosmic rays aren't changing anyway, except for wiggles that correspond to the sunspot cycle.

Only a tiny bit of the dust in the ice came from space, and the amount of space dust hasn't changed significantly. Even if space dust were common enough to matter, its lack of change means that space dust is not important in the story of the climate. (Much, much, much further back in time, the immense amount of dust from the giant meteorite that killed the dinosaurs did matter for a little while.)

Occasionally, huge and abrupt climate jumps have occurred, affecting much of the planet. As the last ice age was ending about 12,500 years ago, the Younger Dryas cold event pushed temperatures around the North Atlantic back almost to ice-age values for a millennium. In Greenland, the warming that ended the Younger Dryas was about 10° Celsius (18° F) in roughly a decade or even less. While Greenland was cold during the Younger Dryas, rainfall was reduced in many areas, including monsoonal regions of Asia, where lots and lots of people now live. Many similar climate jumps punctuated the most recent ice age, with the jumps ending as the ice age ended, just as humanity figured out agriculture and cities. (Some people think that this timing is not a coincidence!)

Evidence from the oceans confirms that these climate jumps were related to changes in ocean currents. Today, the waters of the far northern Atlantic sink before they freeze during wintertime, keeping wintertime air temperatures near or above freezing. But during the Younger Dryas and other cold times, the waters of the northern Atlantic froze before sinking, isolating the air from the warm ocean below and allowing wintertime air temperatures to plummet.

When scientists first began to understand these events a decade or two ago, we were worried that future melting of the Greenland Ice Sheet could make the surrounding waters fresh enough for wintertime freezing in the near future, but we are now cautiously optimistic that we will miss such an event. Interestingly, these abrupt climate changes did not affect the planet's average temperature very much, with cold in the north bringing warmth in the south as the rearrangement of ocean currents also rearranged heat around the planet.

ORBITING THE CLIMATE

The biggest signal in the ice-core history involves long, slow, but very large changes in climate over tens of thousands of years or longer,

Glaciers cover almost all of the Antarctic Peninsula, even near its warmer northern tip.

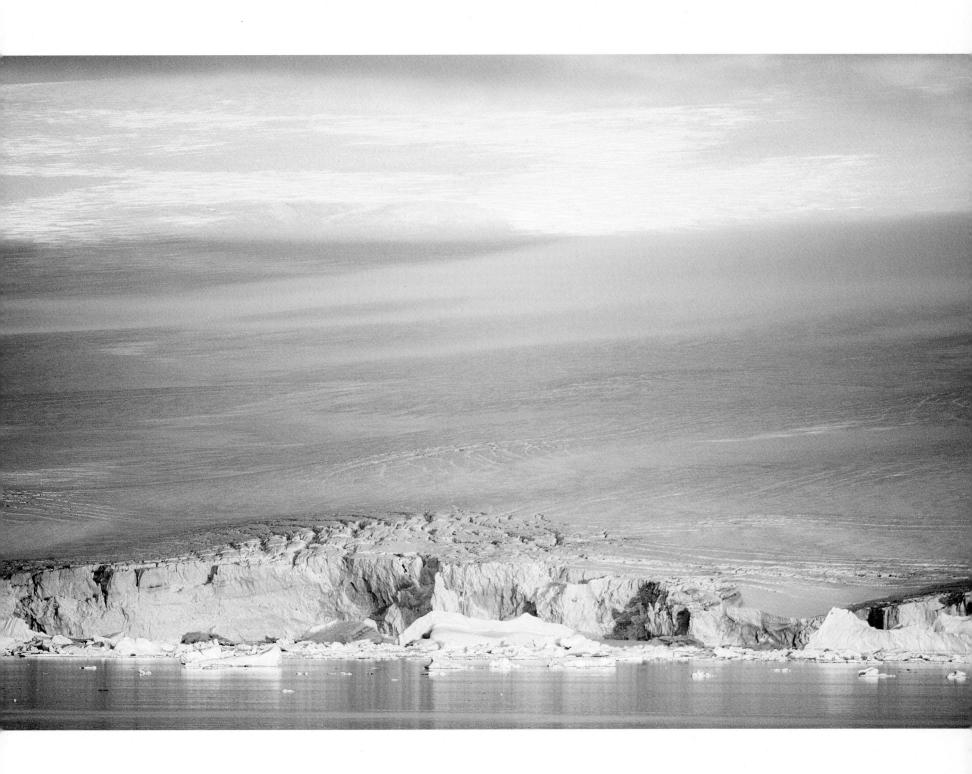

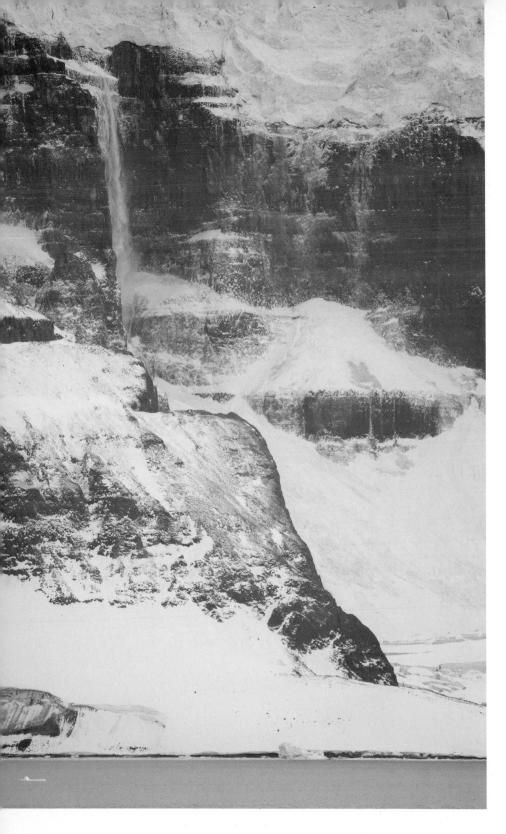

switching from the cold, low-precipitation, dusty conditions of ice ages to the warmer, more-precipitation, less-dusty times of interglacial intervals and back. Ice sheets expanded greatly when the climate was cold, and records from elsewhere on land and in the ocean show that the temperature changes were global. The spacings between warm and cold times indicate cycles of about 100,000 years, 41,000 years, 23,000 years, and 19,000 years, linked to the ice ages.

These ice-age cycles were predicted long before they were observed, because they are the cycles of Earth's orbit. Imagine that your head is the Earth. Touch the top of your head with your finger—that's your North Pole. Now, stare at a lamp—that's the sun. If you are staring right at the sun, you'll never get a sunburn at your North Pole even if you have a bald spot, because the sun is barely grazing your North Pole. Now nod a little, and the sun can hit your North Pole, while your equatorial nose gets slightly less sun. The Earth's North Pole doesn't stick straight up but has nodded a little, and the nod increases and decreases with a 41,000-year cycle. As the nod increases, the poles warm, and as the nod decreases, the poles cool. The poles also wobble, making a loop every 19,000 or 23,000 years. And the out-of-roundness (*eccentricity*) of the Earth's orbit about the sun changes over the course of 100,000 years.

These wobbles do very little to the total sunshine hitting the planet, instead serving primarily to move the sunshine around, from summer to winter, north to south, pole to equator. Whenever there has been little summer sunshine in the north, the ice has grown. The growing ice reflects the sun and grinds up rock, which makes dust that blocks the sun, causing some more cooling. In the south, the land in Antarctica has remained ice covered, and there isn't much land nearby on which to grow ice, so the north has been more important to study.

A waterfall streams from the ice cap above east Greenland's Scoresby Sound, the largest fjord in the world.

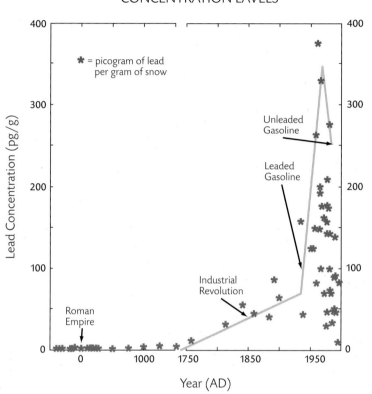

CHANGES IN ATMOSPHERIC LEAD CONCENTRATION LAVELS

✳ = picogram of lead per gram of snow

Unleaded Gasoline

Leaded Gasoline

Industrial Revolution

Roman Empire

Year (AD)

Greenland ice cores reveal the history of atmospheric lead concentration levels: the huge rise in lead after World War II is from leaded automobile fuels; when unleaded fuels and other changes intended to clean up the environment were made in the 1970s, lead levels fell precipitously, providing a hopeful example for current proposals to curb greenhouse gases and slow the effects of global climate change. *Source: Hong et al., 1994, 1996 and Candelone et al., 1995, in Newsletter of International Global Atmospheric Chemistry, NOAA, 1998*

But the cooling effects of the reflective ice and the dust aren't enough to explain the amount of the worldwide ice-age cooling. Here again, the ice cores help. The bubbles in the ice show that the cooling

and ice growth were accompanied by a drop in the greenhouse gases carbon dioxide, methane, and nitrous oxide. Warming and melting of ice brought increases in these gases. Many processes contributed to the changes in the greenhouse gases. For example, the ice-age drying of some regions that helped create dust also helped reduce wetlands that produce methane.

The changes in orbit caused changes in temperature, which caused changes in ice (among other things), which caused changes in greenhouse gases, which caused more changes in temperature and ice and other things. It is a little bit like overspending your credit card: you go into debt, then the interest payments kick in and put you deeper in debt. The cause of your debt is overspending, but you can't explain the size of your debt unless you include the effects of the interest payments. The cause of the climate change is the orbits, which affected the ice and dust, but you still can't explain the size of the temperature changes without including the effects of the greenhouse gases, and especially carbon dioxide.

PEOPLE AND CLIMATE CHANGE

All of this may sound a bit complex and daunting—and it is. Climate scientists have spent a lot of decades, and a lot of money (primarily on satellites), to understand all of this and a lot more as well. Now we see that warming is occurring. Thermometers show warming, including thermometers in the air far from cities, thermometers in the ocean and the ground, and thermometers looking down from space. (The warming is "bumpy"—changing climate does not make weather go away, and occasionally a bit of cooling occurs before more warming—but the temperature trend is clearly upward.) Things such as the Earth's changing orbit are far too slow to explain what is occurring; the sun isn't changing measurably, the cosmic rays and space dust aren't changing, the volcanoes are just making noise. Because heat is going into the oceans and the land from the air, the warming of the air can't be caused

by the oceans or land. If we consider just the natural causes of climate change over the last century, we can't explain what has happened. If we include what humans have done, we can explain quite well what has happened. Climate scientists have been making projections for the last couple of decades—"If we keep doing what we've been doing, then this much warming will occur." We haven't changed our behavior, and the warming has occurred, as expected—climate science is successful at predicting as well as explaining.

So what have humans done to change the climate? We have cut down dark trees and replaced them with more-reflective crops. Our chimneys have thrown dark soot on bright snow. Our rice paddies, cattle, and sheep have put methane into the air. The acid rain from our smokestacks has helped the volcanoes block the sun. And we have made other changes. But our biggest influence is the burning of coal, oil, and gas, which increases carbon dioxide in the atmosphere.

The basic physics are unassailable—"more carbon dioxide has a warming effect" is almost as simple as "a rock dropped in midair falls down, not up." Carbon dioxide acts as a greenhouse gas, blocking some of the energy the Earth sends back to space, and this makes the planet warmer than it would be without the carbon dioxide. The focus on carbon dioxide might at first seem strange, because water vapor is actually a somewhat more important greenhouse gas. But a lot of the carbon dioxide we put into the air will be there in centuries or even millennia, whereas most of the water vapor we put into the air rains or snows out in a week or two. The only way we know to change water vapor a lot is to change the air temperature—warmer air picks up more water vapor from the vast ocean, amplifying the warming. And the easiest way we know of to change air temperature is to raise carbon dioxide.

Looking to the future, if we continue to burn fossil fuels rapidly, the increase in greenhouse-gas concentrations in the atmosphere is expected to bring warming. Because the carbon dioxide accumulates up there, whereas the water vapor and acid rain and even the methane

fall or break down much more rapidly, it is easier to predict the future than it is to explain the past—we have high scientific confidence that if we keep filling the air with carbon dioxide from our fossil fuels, the planet will warm.

THE FUTURE OF ICE

Climate scientists have demonstrated their ability to predict many changes in the Earth's systems, not just to explain them. Much remains to be done, but progress has been remarkable. However, the recent changes in ice flow were not predicted, and only partial explanations are available. Thus, important uncertainties remain in predicting the future of the world's ice sheets.

Predicting the fate of mountain glaciers is comparatively easier—too warm, and the ice melts, with little hope of increased snowfall offsetting this for most of the world's glaciers. The same is true for the Greenland Ice Sheet, although changes in flow of the ice sheet complicate the picture. And for Antarctica, where we don't expect a whole lot of melting on top of the ice sheet unless the climate gets really hot, and thus where changes will depend on ice flow, we are especially uncertain.

We don't believe that an ice sheet can collapse in mere decades, instead requiring centuries at least. But because of human contributions to climate change, the Earth might reach temperatures within the next decades that will trigger the changes that will destroy one or more of the ice sheets over centuries, raising sea level much faster than is now occurring.

Glaciers and ice sheets are fascinating pieces of the planet, telling the history they helped create. We humans will decide whether they continue their ancient role. ❋

Chinstrap penguins laboriously climb a snow slope on one of the volcanic South Sandwich Islands in the South Atlantic.

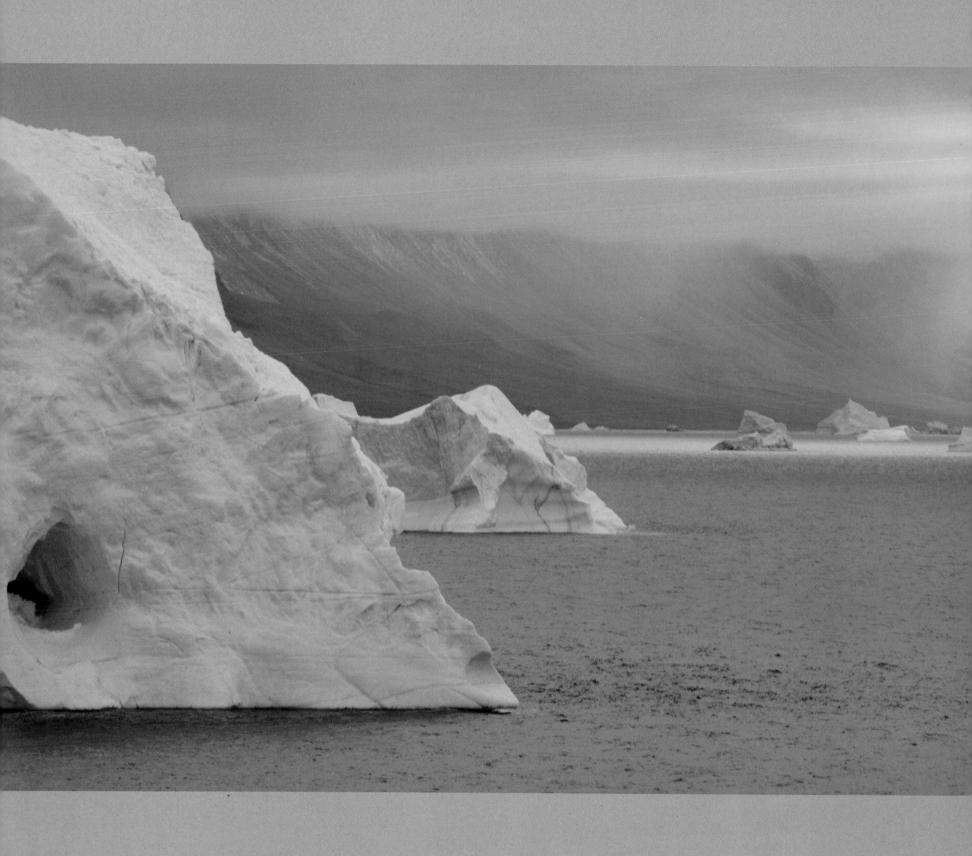

FOCUS ON ICE

THE MORE IT SNOWS, THE MORE ICE MELTS

If the climate doesn't change for a long time, a glacier or an ice sheet tends to reach a balance. Ice is added by snowfall in higher, colder regions, and ice is removed just as rapidly by melting or iceberg calving in lower, warmer regions. A few glaciers may oscillate, building up excess ice in cold places and then moving it rapidly to warmer places in a dramatic, fast-flowing "surge," then repeating this cycle. But even these surging glaciers reach a sort of balance if you average over a few oscillations.

After balance is reached, a glacier will grow if the climate changes to provide more snowfall or less melting. Not surprisingly, the glacier will shrink if it receives less snowfall or more melting. Warming increases melting. But because warmer air can carry more moisture, warming often increases snowfall, if not too much of the falling snow switches to rain. At first, this might seem confusing--will warming cause glaciers to grow or shrink?

A careful look gives a clear answer. Raise the temperature a little bit over a glacier ending on land, and the increase in melting will be about five times larger than the increase in snowfall from the ability of warmer air to carry more water. Occasionally, a climate change will have a large enough effect on where storms go, or on how strong they are, that it is possible for warming to be accompanied by growth of mountain glaciers, but this is rare. (And it usually involves shifting

In eastern Greenland, a procession of icebergs moves down a fjord toward the sea.

An unusual formation on an iceberg at the terminus of the ice fjord at Ilulissat, Greenland

storms away from somewhere else, causing any glaciers there to shrink really rapidly.) Much more commonly, a glacier grows with cooling and shrinks with warming. Thus, a glacier is often biggest when snowfall is lowest, and the glacier shrinks as snowfall increases.

Some glaciers and ice sheets in really cold climates have little or no melting and lose mass mostly by iceberg calving. For these ice masses, warming typically causes a larger increase in snowfall than in melting. One might think that these ice masses would grow with warming. However, this doesn't work very often (see "Changing Ice" in "Why Ice Matters")--warming usually melts ice. –Richard Alley

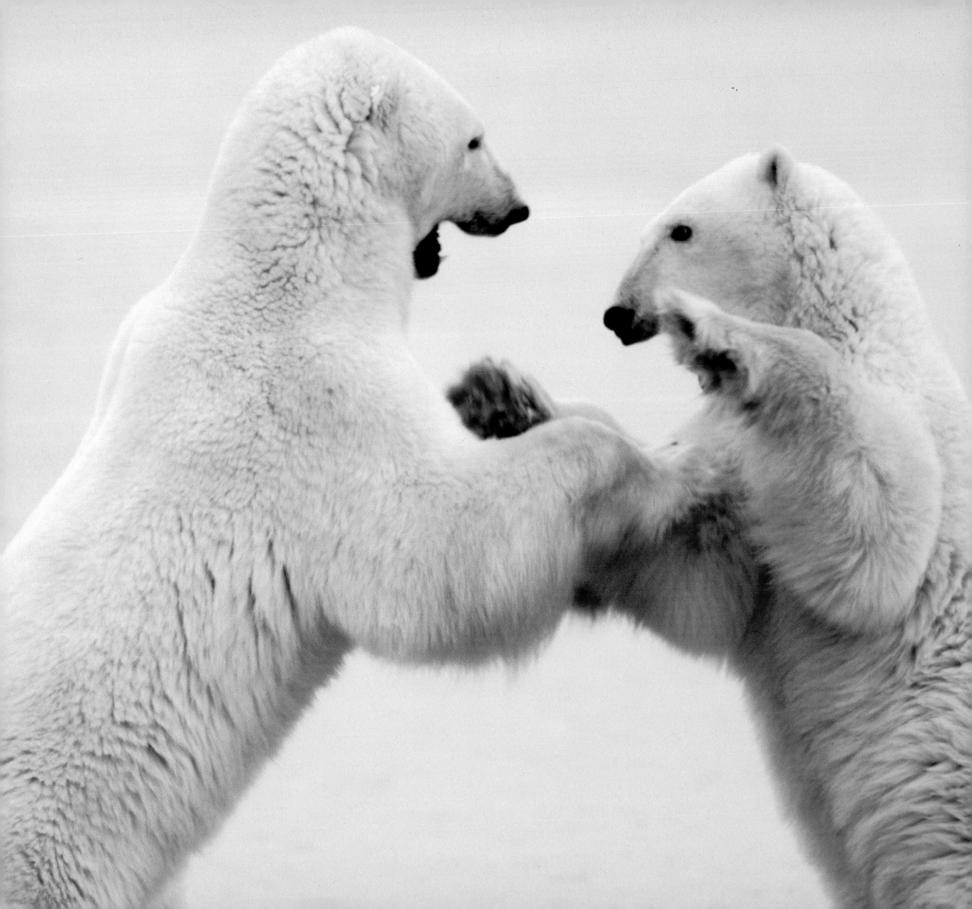

THE ICE BEAR
ICON OF THE ARCTIC

Ian Stirling

IAN STIRLING is an emeritus scientist with Environment Canada and an adjunct professor at the University of Alberta. He has studied polar bears for thirty-eight years and polar seals (Arctic and Antarctic) for forty-three years. His particular interests include ecology, behavior, relationships between predators and prey species, and conservation of polar marine mammals and ecosystems. He participates in a number of national and international committees on polar bears and marine mammals. He has authored or coauthored more than 200 scientific articles and three books on bears, including *Polar Bears*. He has received the Canadian Northern Science Award and has been made an officer in the Order of Canada and a Fellow of the Royal Society of Canada. *Photograph courtesy of Ian Stirling*

Young male polar bears engage in play fights before the ice forms near Churchill, Manitoba, on Hudson Bay.

Polar bears and ice go together in our minds as automatically as salt and pepper. The largest of the terrestrial carnivores, polar bears are uniquely adapted to live on Arctic sea ice. The significance of that relationship can be expressed quite simply: polar bears came into existence in the first place because of sea ice—if the ice disappears, so will the polar bears.

Less than a million or so years ago—a blink of an eye in evolutionary time—the barren-ground grizzly bears roamed the coast of the Arctic mainland, adjacent to a vast new habitat: sea ice. And the ice was home to an unexploited abundance of prey: seals. At some point, grizzlies ventured out onto the sea ice and, as they learned to prey upon the ice-breeding ringed seals, they rapidly evolved into the present-day polar bears.

For undisturbed millennia, the sea ice was not a harsh place for the newly evolved polar bear, but simply home—and a very comfortable home at that. More recently, however, because of rapid climate warming in the Arctic, sea ice is disappearing at an alarming rate. In some areas, there are also significant trends toward earlier breakup in spring and later freeze-up in fall. As a result, the long-term survival of the polar bear now appears uncertain. Over the next few decades, the prospects for its future will become clearer and will almost certainly depend

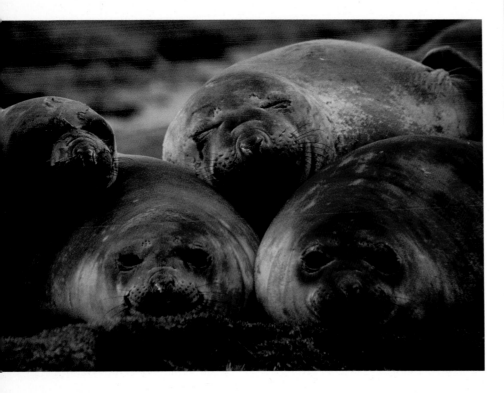

ABOVE Female elephant seals on
a South Georgia Island beach; they
hunt as deep as 610 meters (2000 ft)
below the water's surface.

RIGHT A polar bear sow leads her
cubs along the shore of Hudson Bay
near Churchill, Manitoba, Canada;
each year the sea ice melts sooner
and forms later, reducing the amount
of time the mother can hunt to feed
herself and her cubs.

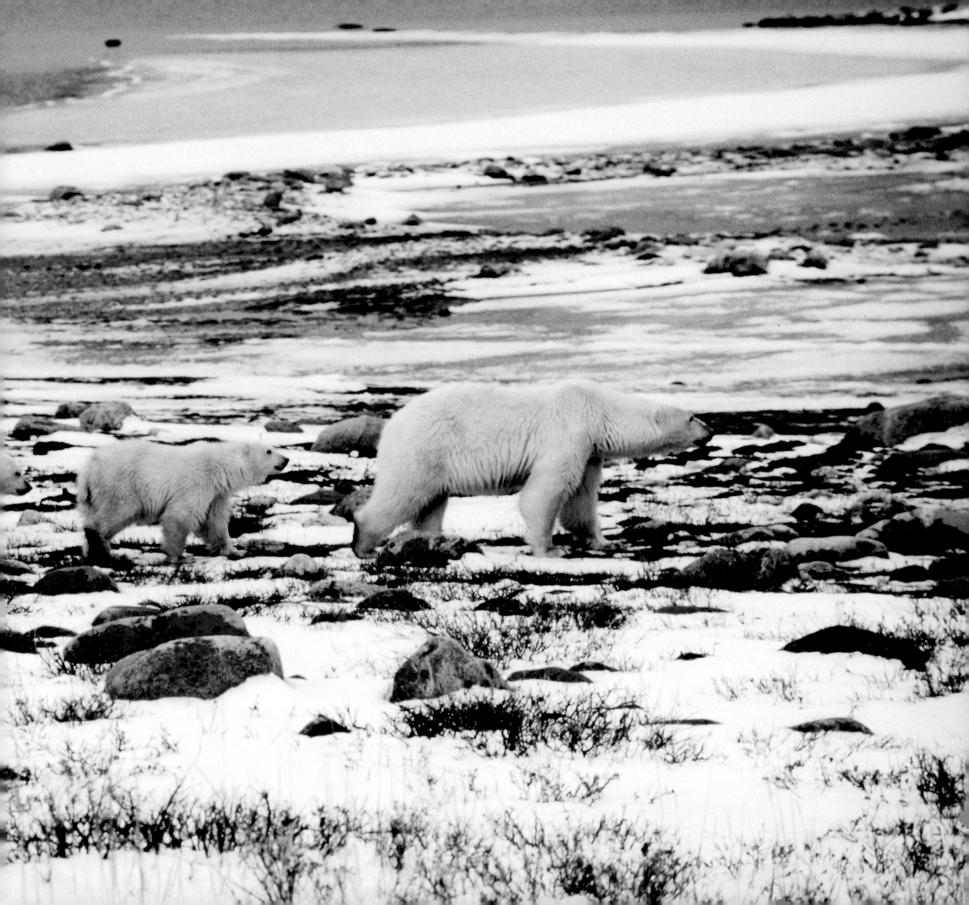

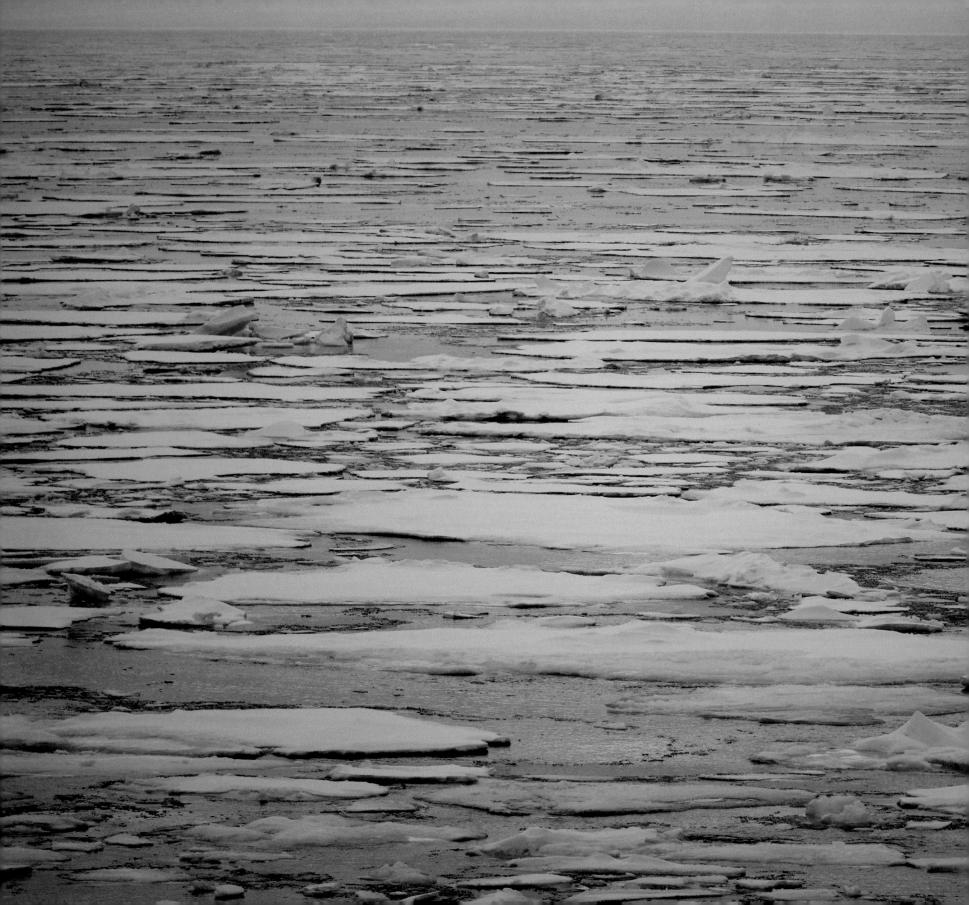

on our collective ability to stabilize and then reduce our production of greenhouse gases.

HOME OF THE ICE BEAR

I have paused to marvel at the very existence of the polar bear countless times and in many places in the Arctic: while standing on annual ice several feet thick, at the edge of an ice floe, beside an open lead (a crack in the ice with water in it), or on a vast, unbroken expanse of frozen ice. In early April, there is nothing living in sight. In fact, there is not much of anything at all in sight but ice, snow, sometimes a bit of ice-cold blue water between nearby floes, or a few wisps of mist rising up from a lead. The ice occasionally cracks and creaks beneath your feet as the currents or winds make it shift slightly, possibly causing floes to grind against each other. The temperature may be –30° Celsius (–22° F), sometimes with a wind of 30–50 kilometers an hour (19–31 mph) with drifting snow.

In these conditions, the dry snow squeaks with even the slightest movement of your mukluks, as if you were walking over hundreds of mice with each step. Gusts of wind may batter you back and forth as you stand there. For as far as you can see, everything is white until the white eventually blends with the blue sky on a distant horizon. If you climb to the top of a pressure ridge of buckled ice, you can see slightly farther, but the view is the same.

At such special moments, I am often overwhelmed by several things, but especially by how tiny and ineffectual my presence is in the vastness of the frozen Arctic Ocean. While I watch a distant polar bear striding purposefully across the sea ice in such circumstances, oblivious to me or anything else, it is easy to understand why it became the powerful iconic animal of the Arctic sea ice in the first place, yet it is difficult even now to comprehend its vulnerability.

Midway up the east coast of Greenland, discontinuous pack ice presents a challenge for polar bears, which, in order to conserve energy, prefer to walk on ice rather than swim.

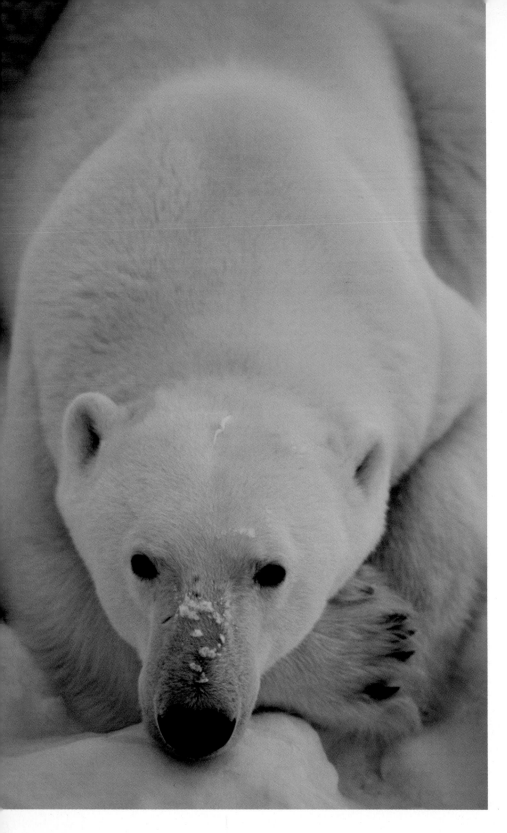

THE ECOLOGY OF SEA ICE

Arctic sea ice is a tough environment for any animal to survive in, let alone prosper. The enormous variability, both predictable and unpredictable, in the distribution and abundance of the ice itself requires animals living there to be able to make large adjustments to their movements on a regular basis. The extent of the ice cover or the distribution of leads and pressure ridges may vary enormously between seasons or years. On a large scale, in the Beaufort or Chukchi Sea adjacent to northern and western Alaska, respectively, an individual ice floe may move hundreds of miles in various directions throughout the year in response to wind and currents. A polar bear that goes into a maternity den on the drifting ice in November may exit several hundred miles away only a few months later. On a smaller scale, ice may be absent or abundant through summer or fall, sometimes changing overnight because of wind or currents. When the ice is relatively thin during freeze-up, a fall storm may compress 80 or more square kilometers (50-plus sq mi) into a virtually impassable rubble field. The location of the best habitat for overwintering seals, or the reproductive productivity of the seals themselves, may vary greatly between years for reasons that are not currently understood.

Such extreme variability exists in few other habitats and is the reason why polar bears, unlike the terrestrial bears, are not territorial. Resources that black or grizzly bears depend on, such as berry bushes or salmon streams, will be in the same place every year. In contrast, the availability of prey or the location of the best sea-ice habitat can fluctuate so much between years that it doesn't make sense to try to defend a territory.

Both the surface and the underside of sea ice are vital to polar bears. The surface provides the critical platform on which the bears

Polar bears' elongated neck and short, blunt claws are adaptations that allow them to hunt and travel in their icy environment.

travel and from which they are able to hunt seals. Less apparent, on the underside of the ice is a unique and biologically rich, if transient, seasonal community of algae and marine organisms. This is the *epontic*, or "under-ice," community. In response to the sunlight penetrating the ice in spring, a flourishing community of algae and single-cell organisms becomes established on the underside and within the ice itself. The rapid increase in day length and intensity of sunlight in spring stimulates a bloom in phytoplankton (plant cells) that supports small invertebrates, which in turn are fed upon by larger invertebrates and small fish that live in cracks and on the underside of the ice, thus providing food for the ringed seals.

It has been estimated that in some areas up to a third of the primary productivity of the ocean in ice-covered waters over the continental shelf is produced on the underside of the sea ice. Most important, because the epontic community is anchored in and beneath the ice, its biomass remains near the surface for several months until the ice eventually melts, after which most of the biomass sinks to the seafloor. It is the retention of an abundant and accessible food source on the underside of the ice that both attracts seals and keeps them there.

The seals hunted from the ice by polar bears are mammals, so they must breathe air. Thus, they breathe at open cracks in the ice or in breathing holes they maintain by abrading the ever-freezing ice with the heavy claws on their foreflippers. However, when they surface to breathe, they are vulnerable to capture by the bears. When summer comes, the most important polar bear habitat—the annual ice over the continental shelf—simply disappears. At this point, the bears must either retreat onto land and survive on their stored fat reserves or migrate north into the multiyear ice of the central Arctic Ocean, where they probably also mainly live on their fat but are still able to hunt a

A disintegrating glacier wall on the Flade Isblink Peninsula at Antarctic Bight, northern Greenland

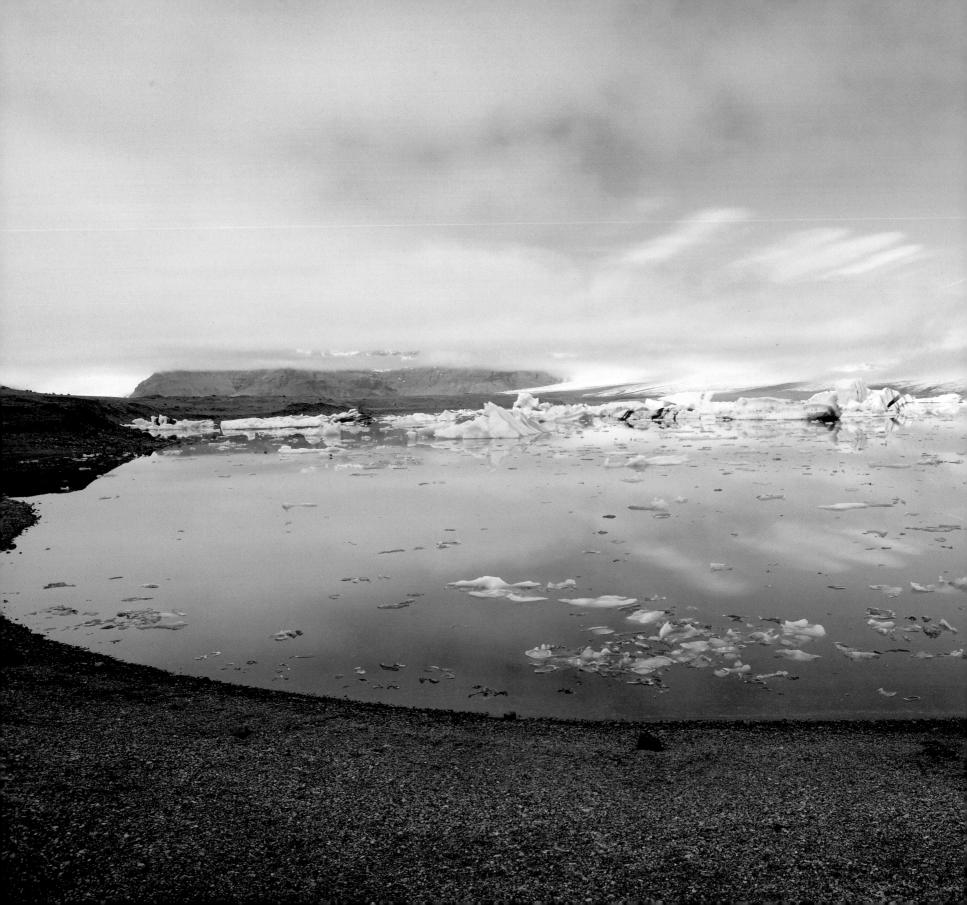

certain amount while they await freeze-up over the continental shelf again in the fall.

TYPES OF SEA ICE

To the uninitiated observer looking down from an airplane, the seemingly endless sea ice on the Arctic Ocean may appear much the same. However, there is as much variety in types of ice and the relative abundance of associated life as there might be if you were to compare a coastal Douglas fir forest with the tundra. Not surprisingly, some types of ice are more important to polar bears than are others.

Two kinds of sea ice have the greatest influence on the ecology of polar bears, mainly because of how they influence the abundance and accessibility of the ringed seals that primarily sustain the bears. *Multiyear ice* may be several years old, partially melting in summer, but refreezing and replacing the melted portion through the winter. It may be 3–5 meters (10–15 ft) thick and snow-covered, thus allowing a limited amount of sunlight to pass through it and stimulate biological productivity. Multiyear ice is predominantly found in the middle of the Arctic Ocean, lying over very deep and generally unproductive water with low densities of seals.

Annual ice forms in winter, melts completely in summer, and occurs mainly along the southern coastlines of the Arctic Ocean, in channels between islands, and in more southerly areas such as Hudson Bay in Canada. Annual ice rarely exceeds about 2 meters (6.5 ft) in thickness and is more easily penetrated by sunlight in the spring. Most annual ice lies over the shallower and more biologically productive waters of the continental shelf where seal densities are highest. Consequently, that is where polar bears do most of their hunting.

Within the annual ice, there are two main categories: *landfast ice*, as the name suggests, is attached to the land; *pack ice* is made up of moving ice floes that are not attached to land. Within these categories are several subcategories of ice types, but three are of greatest

The recent retreat of glaciers from Iceland's Vatnajökull ice cap has revealed the Jökulsárlón (glacier lagoon) that the glaciers had excavated; the area of the lake has doubled in recent decades.

ESTIMATED POLAR BEAR RANGES & POPULATIONS

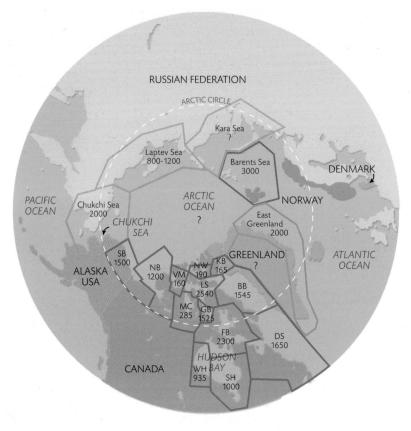

Polar bears, which occur in nineteen subpopulations unevenly distributed throughout the Arctic, are estimated to have numbered 20,000 to 25,000 in 2005; they are well-studied in Canada, though they are less studied in the Russian Arctic. *Source: International Union for Conservation of Nature and Natural Resources / Species Survival Commission, Polar Bear Specialist Group, 2006*

importance for seals, and thus for the bears that hunt them: stable land-fast areas with snow drifts deep enough for seals to make their birth lairs (usually in bays or near the coast); the floe edge, which is the outer edge of the landfast ice, with associated leads; and drifting pack ice dense enough to cover 75 percent or more of the surface of the ocean.

The preferred breeding habitat of ringed seals is the stable landfast ice. There, territorial adults maintain breathing holes in the ice beneath snow drifts deep enough for making haul-out lairs. Their breathing holes are distributed at fairly low densities, which makes them difficult for the bears to find. Meanwhile, the subadult and nonbreeding ringed seals are most abundant along the floe edge and in the drifting pack ice. Bearded seals also prefer areas along the floe edge and in the moving pack ice, where it is easier to find natural openings in the ice to breathe. (Although bearded seals are capable of maintaining breathing holes with the claws on their foreflippers, as ringed seals do, they tend not to.) Adult bearded seals are several times larger than ringed seals and consequently are mainly killed by adult male polar bears.

The preferred hunting habitat of polar bears of most ages and both sexes is along the floe edge or on the drifting pack ice where seals are more abundant and accessible, where there is more likely to be carrion to scavenge on, and where seal breathing holes are likely to be less protected by consolidated snow drifts. In late March or early April, when female bears exit their dens with three- to four-month-old cubs, they hunt at first mainly in the stable ice areas closer to the coast and away from the floe edge. The hunting may be more difficult there, but adult males, which are known to kill and eat cubs if they have a chance, are also encountered less frequently.

MOVING ONTO THE ICE

The simple existence of a vast expanse of Arctic sea ice, home to millions of seals but unoccupied by a large surface predator, made it possible in the first place for the polar bear to evolve from the land-dwelling grizzly bear. The ecological circumstances that originally gave rise to the polar bear were probably not very different from what we see today along the southern coast of the Beaufort Sea in northern Alaska and northwestern Canada.

There, barren-ground grizzly bears den on land, sometimes as

close as a few miles from the coast and the adjacent sea ice. In spring, when the grizzlies first emerge from their dens, hungry after a winter of existing only on their stored fat reserves, it is often difficult to find the vegetation they seek at first because the ground is still covered with snow. For years, it has been well known to the local Inuvialuit hunters, who live along the coast of the Beaufort Sea in Canada, that some of the first grizzlies to leave their dens go out onto the sea ice either to scavenge on the remains of seals killed by polar bears or possibly to prey on seals themselves. The grizzlies have been seen feeding on seal carcasses, but whether they kill them themselves or are simply scavenging is uncertain. What is known, however, is that some bears do this every spring and probably have for a long time.

There is a lot of variation in coat color of the barren-ground grizzlies, from dark brown or black to a light brown trending to almost blond. It is not hard to imagine that the lighter-colored bears might have been slightly less noticeable to the initially naive seals than their dark-colored brethren and so were more successful at stalking and killing seals that had hauled out to rest on the ice near their breathing holes. Those bears that were more successful at killing seals would have survived better, produced more cubs, passed on the genes for lighter coat color, and gradually turned white, to become the polar bears of today. However, polar bears adapted in many more ways than just coat color.

ADAPTATIONS TO THE ICE

As polar bears adapted to life on the ice, their morphology changed quickly from that of their stocky, mainly dark-colored, long-clawed grizzly bear ancestors with a distinctive shoulder hump. In only a little over a million years, polar bears have become sufficiently distinct from grizzlies to be instantly recognizable. The skull became less heavily

This well-fed polar bear was wandering on the sea ice 65 kilometers (40 mi) off the coast of northern Greenland at about 80 degrees north latitude.

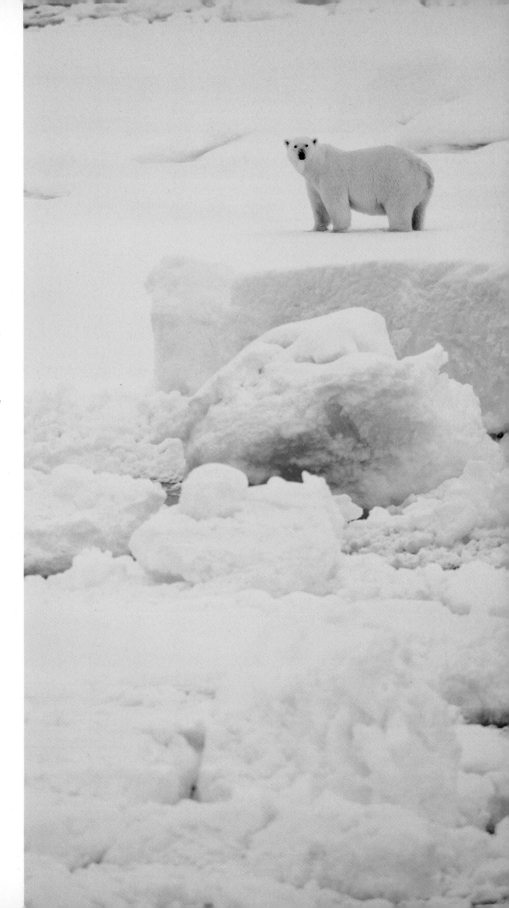

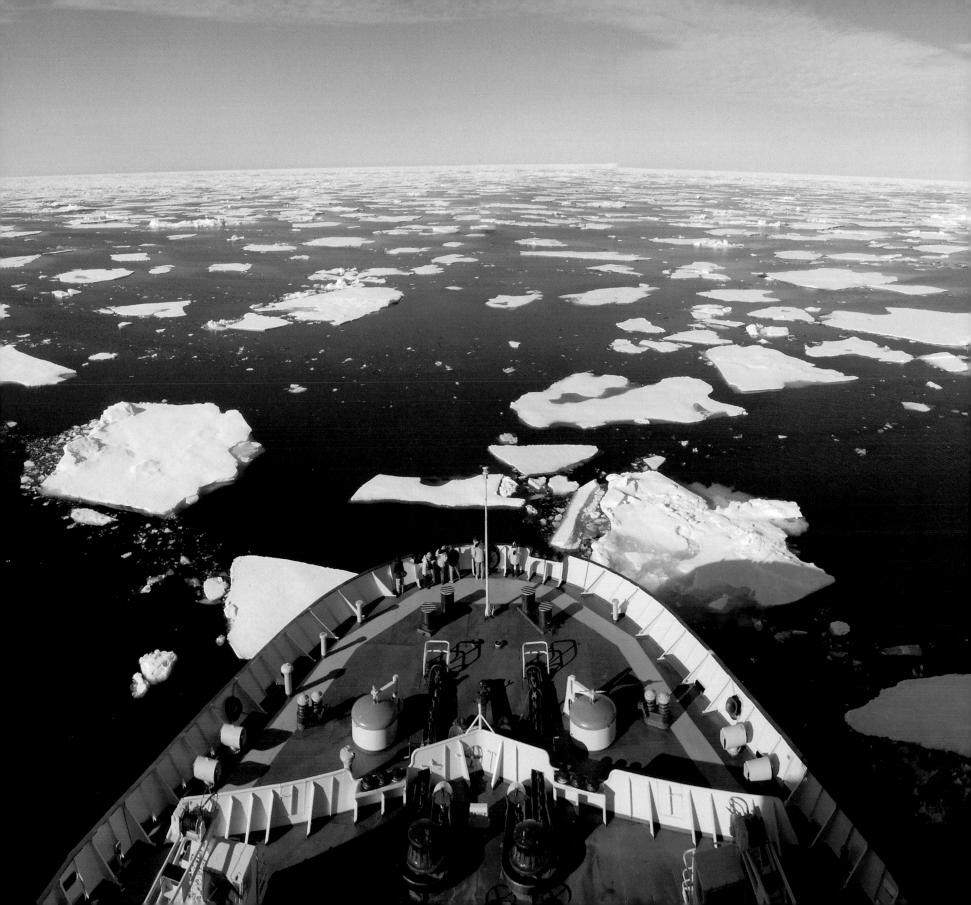

boned than a grizzly's and more elongated, as did the neck, which may be an adaptation enabling a polar bear to lunge farther into a breathing hole in the ice when trying to capture an escaping seal. During winter, rock-hard, windblown snow drifts form over seal breathing holes. Ringed seals come up through their breathing holes and scoop out small haul-out lairs in the overlying drifts where they can rest. In spring, pregnant females give birth to their pups in such lairs. When bears detect a seal in a lair below a drift, they may smash on the top with their forepaws or dig furiously to create a hole large enough to quickly reach down through and attempt to capture the occupant.

Compared to the long claws on the forepaws of the grizzly, polar bear claws are short, stubby, and sharp-pointed, probably for maintaining a firm grip on the ice. Long hair rooted between the toes extends beneath the bare pads, giving added traction when the bears walk on ice. Interestingly, the large hairless pads on polar bears' feet also have small vacuoles on the surface that may function like tiny suction cups to give additional traction on the ice, although this is only speculative. What is not speculative is that, compared to the feet of grizzlies or black bears, polar bear feet are much bigger relative to the rest of the body. These large, paddlelike feet are remarkably effective for swimming but also act like snowshoes for walking across freshly forming ice without breaking through. Since ringed seals also like these areas of newly forming thin ice—in part possibly because they are more difficult for polar bears to reach—it seems clear the polar bears' large feet increase their access to seals.

Lastly, when thinking about how polar bears evolved to a life of hunting seals on the sea ice of the Arctic, the question of the Antarctic sometimes comes up. After all, there are many seals of several species there and a lot of ice, so why aren't there polar bears or a similar surface predator there as well? The answer is quite straightforward. The

The bow of an icebreaker plows through broken-up pack ice.

gap of cold, stormy, inhospitable ocean between the southern tip of South America (the closest continental land mass to the Antarctic) and the continent itself is simply too wide for terrestrial predators of any species to be able to cross. But that doesn't mean there is no predator of seals to fill the ecological niche of the polar bear. That role is very successfully shared by leopard seals and killer whales, the top-level marine predators.

LIVING ON THE ICE

Polar bears depend on sea ice for everything that matters to their survival, including hunting, seasonal movements, finding mates and breeding, and, in some areas, even digging maternity dens in snow drifts by ice ridges and giving birth to their cubs far from land. Polar bears' most important prey species, the ringed seal, is distributed at low densities over huge areas of sea ice, as well as being almost absent in others, for reasons that are not well understood. For polar bears, the most essential aspect of a frozen polar sea is that it provides the substrate over which they move in search of seals, as well as the essential platform from which to hunt. Although a few bears have been known to kill seals in open water near the shoreline, the number of successful open-water hunts is likely tiny relative to the success of hunting on the sea ice. Furthermore, extensive swimming in cold water to hunt would be energetically inefficient compared to walking on ice.

To appreciate how important it is to have access to a huge area of ice habitat and be able to travel easily over it in search of prey, consider that the average polar bear requires approximately forty-five ringed seals (or ringed seal equivalents) per year to survive. Limited hunting of other species reduces the number of ringed seals needed, to some degree. However, in crude numbers, the currently estimated 20,000 to 25,000 polar bears worldwide would require more than a million ringed seals (or ringed seal equivalents) annually. There is no other marine mammal in the Arctic that could replace ringed

seals for sustaining the majority of the world's polar bears.

The high degree of variability in the distribution and abundance of sea ice between seasons and years presents serious problems for the bears, not the least of which is navigation in an environment with few visual clues. Regardless, it has been well demonstrated by tracking adult female polar bears with satellite radio collars, and recapturing of tagged animals of all ages and sex classes, that they do not move at random. Nor do they just drift passively in the direction that wind or currents may take the ice if that is not where they want to go. Instead, many studies have shown that individual bears return predictably to the same areas at the same seasons, such as to those used for spring hunting, maternity denning, or summer sanctuary during the open-water period.

For example, some bears that spend most of their time along the southern coast of Baffin Island, Canada, walk several hundred miles south over the drifting ice of the Labrador Sea each spring to feast on abundant, unwary harp seal pups near the coast of Newfoundland. After a few weeks of active feeding, the bears walk back north to Baffin Island against the current on a treadmill of ice floes that are steadily moving south before disappearing altogether in the North Atlantic Ocean.

EFFECTS OF CHANGING ICE CONDITIONS ON POLAR BEARS

At first glance, the status of polar bears might appear secure. They are widely distributed throughout the seemingly unlimited, ice-covered seas of the circumpolar Arctic. They still inhabit the majority of their original habitat, and their worldwide abundance, in nineteen subpopulations, was estimated by the Polar Bear Specialist Group of the International Union for Conservation of Nature to exceed 20,000 in 2005.

However, the incredible success of the polar bear in adapting to life on the sea ice is also its greatest vulnerability. A large carnivorous specialist such as the polar bear has few options if its habitat disappears. It cannot revert to a terrestrial life and eat berries or other vegetation. By feeding captive grizzlies, researchers have confirmed that

their large size cannot be attained solely by eating vegetation. Achieving their massive body mass is dependent on animal matter (salmon) in the diet. Similarly, polar bears are large animals, and they got that way by eating seals, not vegetation. Consequently, their survival in anything like today's numbers requires large and accessible seal populations and huge areas of ice from which to hunt.

Aboriginal hunters throughout the Arctic and polar scientists alike agree that climate warming is having a significant negative impact on sea ice. Especially worrisome is the conclusion of scientists at NASA and elsewhere that the total amount of ice still present in the polar basin at the end of summer has been declining at a rate of 9 percent or more each decade since satellite monitoring became possible in 1979. In September 2007, the minimum ice extent of the Arctic Ocean in the polar basin reached a much lower-than-predicted all-time low and in 2008 fell to the second-smallest minimum area. The possibility of a totally ice-free Arctic Ocean, in summer at least, has been predicted to be possible in less than forty years. In 2006, NASA also reported that the total amount of ice in the Arctic was declining during winter as well as at the end of summer. These changes, and the speed with which they are happening, exceed the worst scenarios that any of us studying polar bears could have imagined twenty, or even ten, years ago.

We are facing the previously unthinkable—the loss of summer sea ice in the Arctic in the foreseeable future—mainly because of human-induced climate warming. During our thirty-year study of polar bears on the western coast of Canada's Hudson Bay, we have seen things I can still hardly believe possible in a period as short as a human's working lifetime. Hudson Bay is completely covered through the winter by annual ice that, until recently, melted completely by about mid-July. Open water prevailed for about four months through the summer

Eroded ice catches the midnight sun on the Greenland Ice Sheet shortly after a surface lake has drained.

THEN & NOW

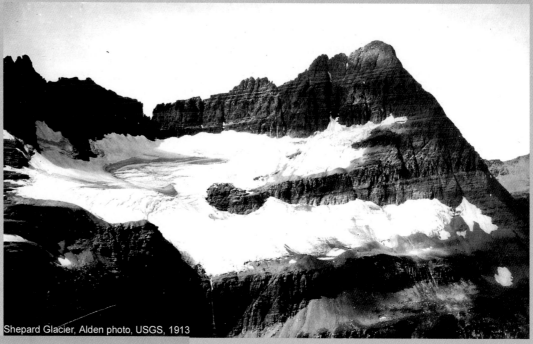

Shepard Glacier, Alden photo, USGS, 1913

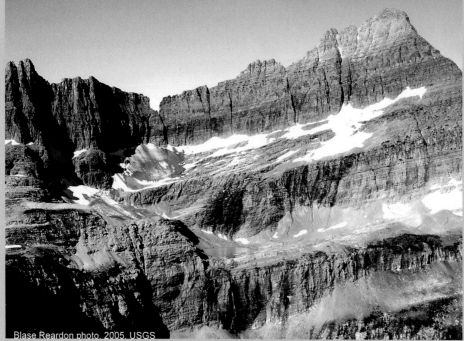

Blase Reardon photo, 2005, USGS

ABOVE **Shepard Glacier from Pyramid Peak, Glacier National Park, Montana, 1913.** *W. C. Alden photograph, USGS, 1913*

LEFT **Shepard Glacier from Pyramid Peak, Glacier National Park, Montana, 2005.** *Blase Reardon photograph, USGS, 2005*

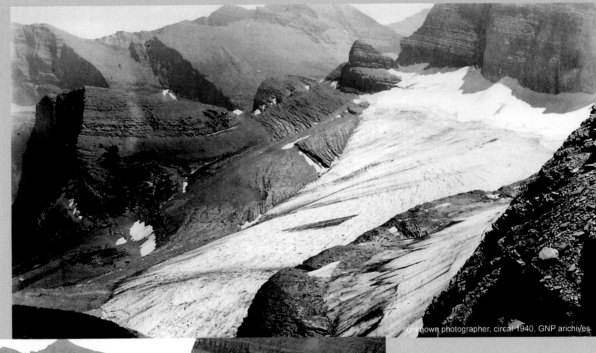

unknown photographer, circal 1940, GNP arichives

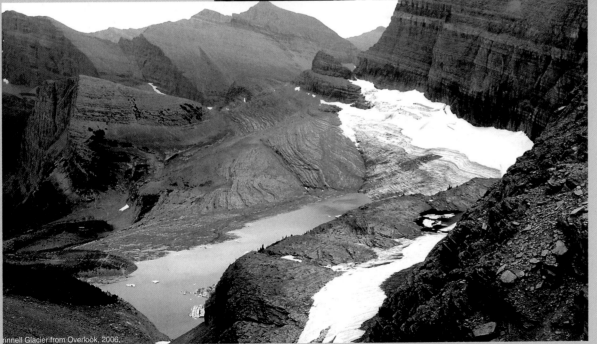

rinnell Glacier from Overlook, 2006,

ABOVE **Grinnell Glacier from the Grinnell Glacier Overlook off the Highline Trail, Glacier National Park, Montana, circa 1940.** *Photographer unknown, courtesy of Glacier National Park Archives, circa 1940*

LEFT **Grinnell Glacier from the Grinnell Glacier Overlook off the Highline Trail, Glacier National Park, Montana, 2006.** *Karen Holzer photograph, USGS, 2006*

and fall. However, the average date of breakup of the sea ice is now a full three weeks earlier than it was only thirty years ago! Freeze-up is slowly getting later as well.

This extraordinarily rapid change has had immediate and severe consequences for polar bears. The most critical time for polar bears to feed on ringed seals is from late spring to breakup, when newly weaned ringed seal pups are abundant, their body composition is up to 50 percent fat, and they are still naive about predators. In fact, during the spring and early summer feeding period, the polar bears of western Hudson Bay probably accumulate 70 percent or more of the energy they survive on for the entire year. Thus, over the last thirty years, the polar bears in western Hudson Bay have been forced to abandon hunting seals on the sea ice for progressively longer periods because they lose their essential hunting platform (ice) *at the single most important time of year*. The earlier breakup occurs, the poorer the condition of the bears when they come ashore to fast through the open-water period.

As a consequence of steadily declining body condition, the average weight of lone (and suspected pregnant) adult female polar bears in the fall has declined from approximately 290 kilograms (640 lb) in 1980 to about 230 kilograms (507 lb) in 2004. Our past records indicate that no female polar bear weighing less than about 190 kilograms (420 lb) in the fall has been recorded with cubs the following year, suggesting that although females below that weight can survive, they don't reproduce. At the present rate of decline in their fall weights, it seems likely that in a few decades, few adult females will be capable of reproducing in western Hudson Bay.

The decline in the annual survival rate of cubs, subadults, and the oldest bears is also significantly related to timing of breakup: the earlier

At 6194 meters (20,320 ft), Denali, seen here from Wonder Lake, is Alaska's—and North America's—highest peak.

the breakup, the poorer the survival of bears of those ages. Thus, the negative effects of progressively earlier breakup of sea ice in western Hudson Bay on reproduction and survival probably caused the polar bear population in western Hudson Bay to begin to decline and then ensured that the decline continued. In the northern half of western Hudson Bay, which is part of Nunavut (the northernmost territory in Canada), hunting of an annual sustainable quota of polar bears by Inuit is legal. However, after the western Hudson Bay population of polar bears began to decline, the former annual quota was no longer sustainable, resulting in a continued trend of overharvesting that, when added to the negative effects of climate warming, helped to cause that population to decline from about 1200 animals in 1987 to 935 in 2004.

New research in southern Hudson Bay has confirmed that the ice is breaking up earlier than it used to and that there has been a corresponding decline in the condition of polar bears of all ages and both sexes, between the mid-1980s and 2005. The similarity of these trends to those in western Hudson Bay suggests that a decline in the polar bear population in southern Hudson Bay will follow, if it has not already started.

In the Chukchi, southern Beaufort, Laptev, and Barents Seas—some of the Arctic Ocean's circumpolar seas—breakup is also occurring earlier, while freeze-up is later. Thus, both the extent and duration of open water north of the coast through summer and fall are increasing. Consequently, more bears from those areas are now spending extended periods on land. At the same time, the southern edge of the offshore pack ice, where the rest of the bears from those regions spend the summer, now lies over deep, unproductive water far from the coast, where there are fewer seals to hunt.

In the southern Beaufort Sea, the polar bear population shared by northern Alaska and northwestern Canada appears to have declined from about 1800 in the 1980s to about 1500 in 2006. The major known ecological change during that period is that the southern edge of the

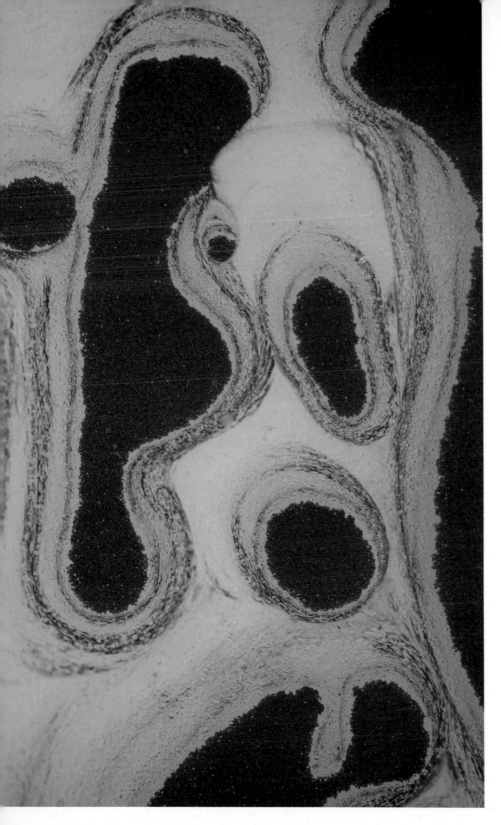

remaining ice in summer now retreats farther to the north, away from the productive continental shelf area along the coast where seals are more abundant, and the ice remains farther north for longer periods than it used to. In 2001 and 2002, the ice-free period was relatively short (a mean of 92 days), and the annual survival of adult female polar bears was approximately 99 percent. In 2004 and 2005, however, because of unusually warm summers, the ice-free period averaged 135 days, and survival of adult female polar bears was only about 77 percent.

Further evidence of nutritional stress in the southern Beaufort Sea, coinciding with years of extended open water, includes several instances of starvation, cannibalism, and bears desperate enough for seals that they clawed through solid ice in vain attempts to capture seals that might have breathing holes below. As noted earlier, 2007 set a new record for retreat of the ice, which likely had further negative effects on the bears. If the Arctic continues to warm, we can probably expect to lose ice at a rapid rate.

SEA ICE AND POLAR BEARS IN THE FUTURE

The Fourth Assessment Report of the Intergovernmental Panel on Climate Change of the United Nations, published in January 2007, came to the "unequivocal" conclusion that the world's climate is warming rapidly and that the primary cause is human activity. What this means for polar bears is that large-scale loss of ice will continue, with severe negative impacts on the bears' survival, reproduction, and population size. The effects of climate warming will vary in timing and rate of change in different regions, but over the long term, the effects will be negative.

Ice is also home to very small life forms. Cryoconites, formed where bits of dust absorb more heat than the surrounding reflective ice, are home to a microecosystem of bacteria and algae that feed minuscule nematodes and rotifers, all preyed upon by carnivorous tardigrades ("water bears").

In Hudson Bay–Foxe Basin and in the eastern Canadian Arctic (Baffin Bay and Davis Strait–Labrador Sea), the sea ice melts completely each summer. Since the most important feeding period for bears there is from mid-April until breakup, they are already among the first populations to be negatively affected by climate warming. Bears there survive the summer mainly on their stored fat, although they scavenge opportunistically, sometimes feed on vegetation, and may attempt to hunt other marine mammals. However, polar bears obtain almost all their annual energy requirements by hunting seals from the sea ice surface, not from other sources. Speculation that polar bears might sustain themselves from alternate food sources on land is fanciful.

The main area where multiyear ice presently remains in late summer and fall, and will in the future, is along the coastline and between some of the northernmost islands of Canada and Greenland. If the relatively unproductive multiyear ice there is replaced by annual ice, over the continental shelf at least, it is possible that the biological productivity, and its suitability for seals and polar bears, may increase, at least in the short-term. However, if the climate continues to warm unchecked, as is currently predicted, this possible respite may be brief.

Despite the enormous changes in the Arctic that have already been documented, humans still can and must respond. It will likely be several decades before the most negative predictions are realized. Thus, time is critical for both polar bears and the sea ice that dominates the Arctic's marine ecosystem. Polar bears evolved into existence because of a large, productive habitat unoccupied by a terrestrial predator. As that habitat disappears, so will the bears that live and depend on it. It is vital that all humans use whatever time remains to reduce greenhouse-gas emissions sufficiently for sea ice and polar bears to persist for our children and grandchildren to marvel at. Nothing less is defensible. ❀

Thick ice caps a 1600-meter-high (mile-high) red rock wall in Franz Josef Fjord, northeast Greenland.

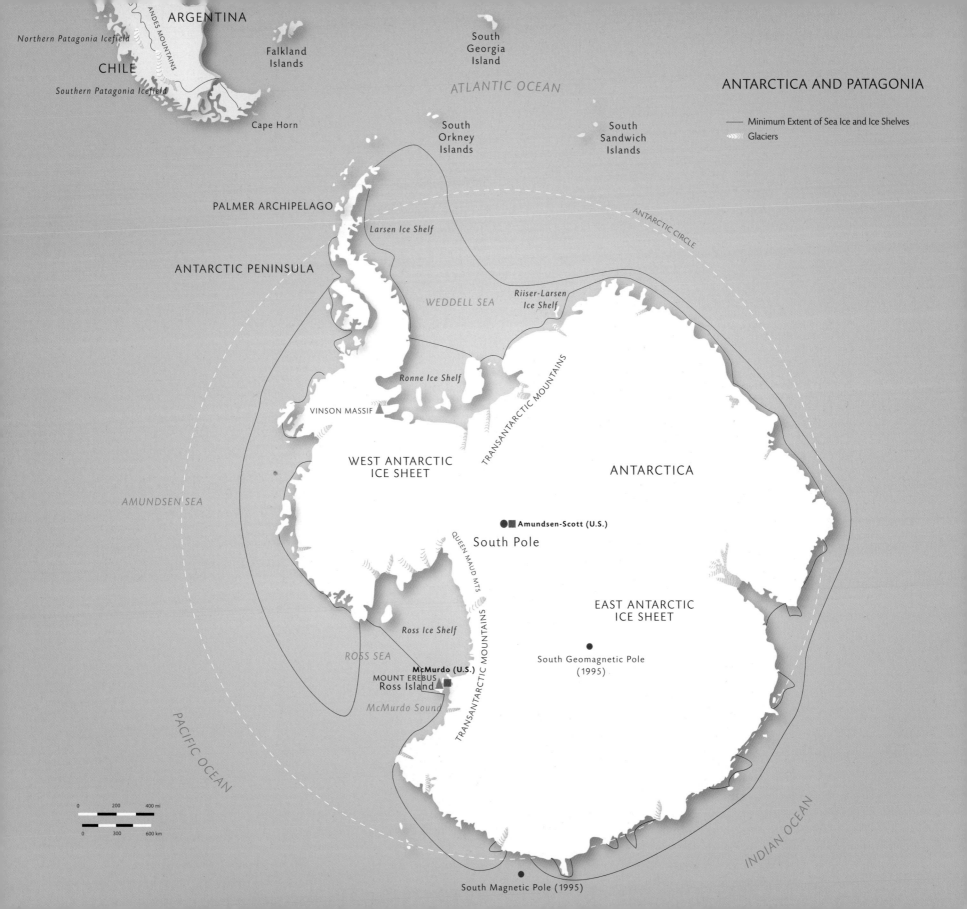

ARGENTINA

Northern Patagonia Icefield

CHILE

ANDES MOUNTAINS

Falkland
Islands

South
Georgia
Island

Southern Patagonia Icefield

ATLANTIC OCEAN

ANTARCTICA AND PATAGONIA

Cape Horn

—— Minimum Extent of Sea Ice and Ice Shelves
〰〰 Glaciers

South
Orkney
Islands

South
Sandwich
Islands

PALMER ARCHIPELAGO

Larsen Ice Shelf

ANTARCTIC CIRCLE

ANTARCTIC PENINSULA

*Riiser-Larsen
Ice Shelf*

WEDDELL SEA

Ronne Ice Shelf

TRANSANTARCTIC MOUNTAINS

VINSON MASSIF ▲

WEST ANTARCTIC
ICE SHEET

ANTARCTICA

AMUNDSEN SEA

● ■ **Amundsen-Scott (U.S.)**

South Pole

QUEEN MAUD MTS

EAST ANTARCTIC
ICE SHEET

Ross Ice Shelf

● South Geomagnetic Pole
(1995)

ROSS SEA

TRANSANTARCTIC MOUNTAINS

McMurdo (U.S.)
MOUNT EREBUS ▲ ■
Ross Island

McMurdo Sound

PACIFIC OCEAN

0 200 400 mi
0 300 600 km

INDIAN OCEAN

● South Magnetic Pole (1995)

FOCUS ON ICE

EARTH'S GREAT ICE SHEETS: ANTARCTICA AND GREENLAND

Only Antarctica and Greenland remain of the vast, continent-sized ice sheets that spread from the poles and higher mountain regions of Earth 21,500 years ago.

With your feet astride the hydrographic center of the Antarctic Ice Sheet—an almost limitless expanse actually made up of the West and East Antarctic Ice Sheets, divided by the Transantarctic Mountains—you stand on a dome of ice more than 3 kilometers (1.9 mi) thick. The atmosphere at the poles is thinner than at the equator, so you gasp for air as if you had climbed thousands of feet higher. In the dark of winter, temperatures can drop more than 38° Celsius (100° F) below freezing as the Aurora Australis blazes overhead. There is only one permanent human encampment for thousands of miles in every direction.

The White Lantern, so named by astronauts viewing Antarctica from space, is a realm of wonders. Ice covers 98 percent of the continent, and the Antarctic Ice Sheet and its glaciers comprise more than 90 percent of the planet's ice: more freshwater than double all the lakes and rivers in the world. If all of Antarctica's ice melted, sea level would rise more than 61 meters (200 ft).

Antarctica's 12,000-year-old ice shelves are in fact experiencing significant disintegration; in summer, meltwater threads through them until they break apart in chunks the size of small states. In the summer of 2002, 3250 square kilometers (1255 sq mi) of the Larsen B Ice Shelf rapidly collapsed, littering the Weddell Sea with thousands of icebergs. The home of this ice shelf, the western Antarctic Peninsula, has seen a temperature increase of 0.5° Celsius (0.9° F) each decade since the late 1940s, the biggest temperature increase on Earth.

But a total melt of the continent is highly unlikely for several reasons, not least because Antarctica is on average still very cold: from about 0° Celsius (32° F) on the coast to between −20° and −35° Celsius (−4° and −31° F) in the interior. A cold-water current also rings the continent, flowing between it and the southern tips of South America and Africa as the prevailing winds spin over the same regions, blocking warm-water currents and winds of the sort that accelerate ice loss on the world's other remaining ice sheet, Greenland.

Greenland, part of Denmark, is the largest island in the world, an area roughly twice the size of Texas situated mostly above the Arctic Circle. The Greenland Ice Sheet, up to 3 kilometers (1.9 mi) thick, covers 90 percent of the island. It flows to the east and west from a longitudinal spine, the second-largest expanse of ice after Antarctica.

Greenlanders have a front-row seat on climate change. The Jakobshavn Glacier near Ilulissat moves 35 meters (115 ft) a day while retreating even faster, depositing massive amounts of ice in a long fjord. In winter, Greenlanders in the area used to visit neighboring islands by dogsled until the 1980s when the sea stopped freezing..

Paleoclimatologists prize the Greenland Ice Sheet as the clearest repository of climate data on Earth. Along the continent's spine, the ice layers have moved little, so scientists have a year-by-year record of more than 100,000 years. What the ice tells us about the past may help us understand the future of ice on Earth. —*James Martin*

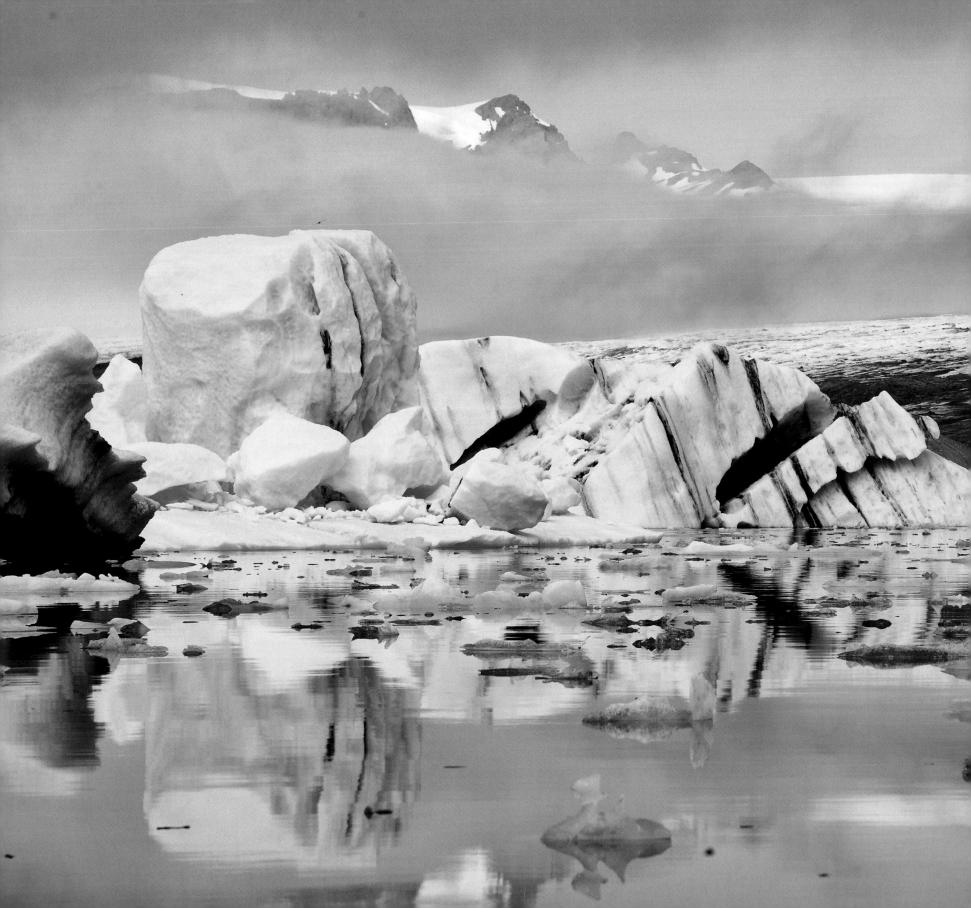

PEOPLE OF THE ICE
WHAT IS AN ESKIMO WITHOUT ICE?

Nick Jans

NICK JANS is a longtime contributing editor to *Alaska* magazine and a member of *USA Today*'s board of editorial contributors. He has written seven books, including *A Place Beyond: Finding Home in Arctic Alaska, Tracks of the Unseen,* and *The Grizzly Maze: Timothy Treadwell's Fatal Obsession with Alaska's Bears.* He has published many magazine articles and has won a number of literary awards, most recently the 2006 and 2007 Ben Franklin Awards. He is also a professional photographer who specializes in wildlife and bush Alaska. Jans travels widely in Alaska, including the Arctic, where he lived for twenty years in Iñupiaq villages. He currently makes his home in Juneau with his wife, Sherrie. *Photograph courtesy of Nick Jans*

Large glaciers flowing from the Vatnajökull ice cap in Iceland calve into the Jökulsárlón (glacier lagoon), filling it with icebergs.

"No more 40 and 50 below!" laughs seventy-seven-year-old Daniel Agoochuk. "Hunt in T-shirt! Pretty soon summertime year-round!" But concern leaks through his smile as he looks out over a gray, heaving expanse of water. The Beaufort Sea pack ice on which this Iñupiaq Eskimo has hunted all his life has again receded far beyond the northern horizon, taking the seals with it and stranding dozens of polar bears on offshore barrier islands.

Daniel and fellow elders across the northern Alaska coast note other troubling changes to their once-stable environment. With far less ice cover, seas are rougher. New species of birds are showing up, and others are behaving unpredictably. The autumn freeze-up over the past two decades has been setting one to three months late. To be sure, there's still an Arctic winter each year, but periods of deep cold are less frequent, thaws increasingly so, and the spring melt comes early. As a result, the pack ice itself is unstable and far thinner, the pressure ridges more jumbled, travel more difficult.

Global warming naysayers would find a disappointing reception among Alaska's Iñupiat. The People, as they call themselves, are beyond discussing climate change; they've been living it for the past two decades. Like the whales, seals, birds, fish, and land mammals on which they depend, these hunter-gatherers evolved over millennia in a

THE ARCTIC

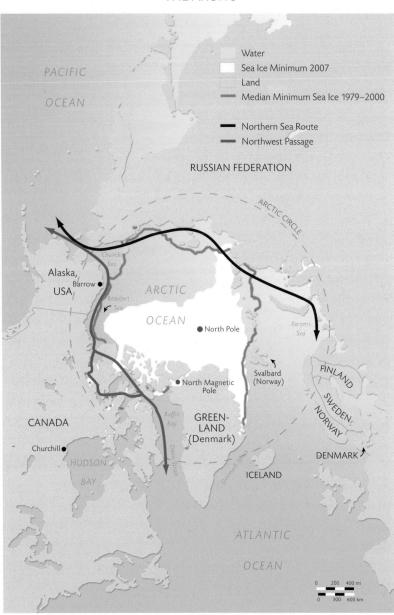

Water
Sea Ice Minimum 2007
Land
Median Minimum Sea Ice 1979–2000

Northern Sea Route
Northwest Passage

SOURCES: F. FETTERER, K. KNOWLES, AND STAFF, NATIONAL SNOW AND ICE DATA CENTER, NOAA; HUGO AHLENIUS, UNEP/GRID-ARENDAL (HTTP://MAPS.GRIDA.NO/GO/GRAPHIC/ARCTIC-SEA-ROUTES-NORTHERN-SEA-ROUTE-AND-NORTHWEST-PASSAGE)

world defined by ice—an ever-shifting, harsh, yet life-sustaining matrix that dictated the shape of their existence: what they wore and lived in; how, where, and when they traveled or hunted; the songs they sang; the shapes they carved in bone. Faced with one of the most brutal environments on Earth, they did more than survive. They prospered.

Now the very source of the People's identity is melting away, at a pace that just a generation ago seemed impossible—even in the stylized, magical realm of Iñupiaq storytelling, where practically anything might happen. But the elders have no tales hinting at a time when ice, and the creatures that live on its face, would simply cease to be.

CLIMATE CHANGE IS CULTURE CHANGE

Portents loom from afar as well. From the Bering Strait west to the Russian Far East, and northeast across the Chukchi Sea to Alaska's Arctic coast, into the Canadian Archipelago and beyond, the stories travel among the Iñupiat and other circumpolar indigenous peoples— passed on by relatives, trading partners, the Internet, television, and radio. The Alaska villages of Shishmaref and Kivalina are so threatened by coastal erosion and worsening storms that relocating or abandoning both settlements seems inevitable within a decade. Experienced hunters, men with an encyclopedic knowledge of sea ice, go missing in what should be optimal conditions. Hordes of walruses haul out on the Russian coast, attempting to use dry land to replace ice floes that no longer exist, and thousands are crushed in panic-induced stampedes. In 2007, a polar bear and—even more remarkable—a lone walrus traveled miles inland up the Kobuk River in Alaska, where neither species has ever been seen, apparently unable to find food in their normal sea ice habitat. From Greenland come reports of alarming melt-offs and similar anomalies.

Polar bear biologists describe the relationship between the white bears and sea ice as *obligate*—which means the bears can survive over time only if that ice, and the resources it provides, is available. Already

struggling to retain language and tradition in an onrushing world, the People now face this penultimate crisis as well. What, indeed, is an Eskimo without ice? The Iñupiat and their circumpolar brethren (the majority of them collectively known as Inuit) share that obligate bond. For a people born of ice, intimately connected to its cold essence, climate change is culture change, and both are bearing down on them with startling speed.

"This environment is their whole world," says Geoff Carroll, long-time Barrow, Alaska, resident and biologist for the Alaska Department of Fish and Game, who is married into an Iñupiaq family. "This is their whole life."

North Slope Borough mayor Edward Itta shakes his head and observes, "We have no power to control what's occurring in our own backyard, and this could be the end of who we are."

The perspective offered by western science on Arctic warming and sea ice loss is, if anything, bleaker still. Satellite imagery and other data compiled by the National Snow and Ice Data Center (NSIDC) confirms a pattern of widespread loss of Arctic Ocean ice since 1979, which has accelerated sharply since the mid-1990s. The polar ice pack reached an all-time record low during the melt season of 2005, only to surpass that record in 2007 by an area roughly equivalent to Texas and Alaska combined—a staggering transformation, even for such a vast, dynamic region.

The polar ice not only covered far less surface area at its low point that summer; its thickness and density decreased dramatically as water temperatures rose—a trend that seems to be long-term and ongoing. Multiyear ice, some of it decades old and tens of feet thick, has "essentially disappeared," NSIDC researcher Jim Maslanik reported

Hikers pause to admire small icebergs flowing quickly past gigantic icebergs in an ice fjord off southwestern Greenland.

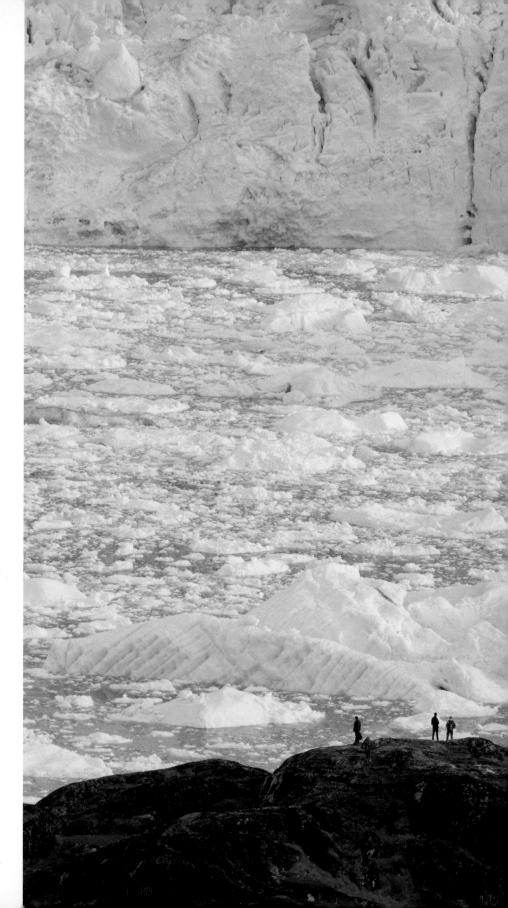

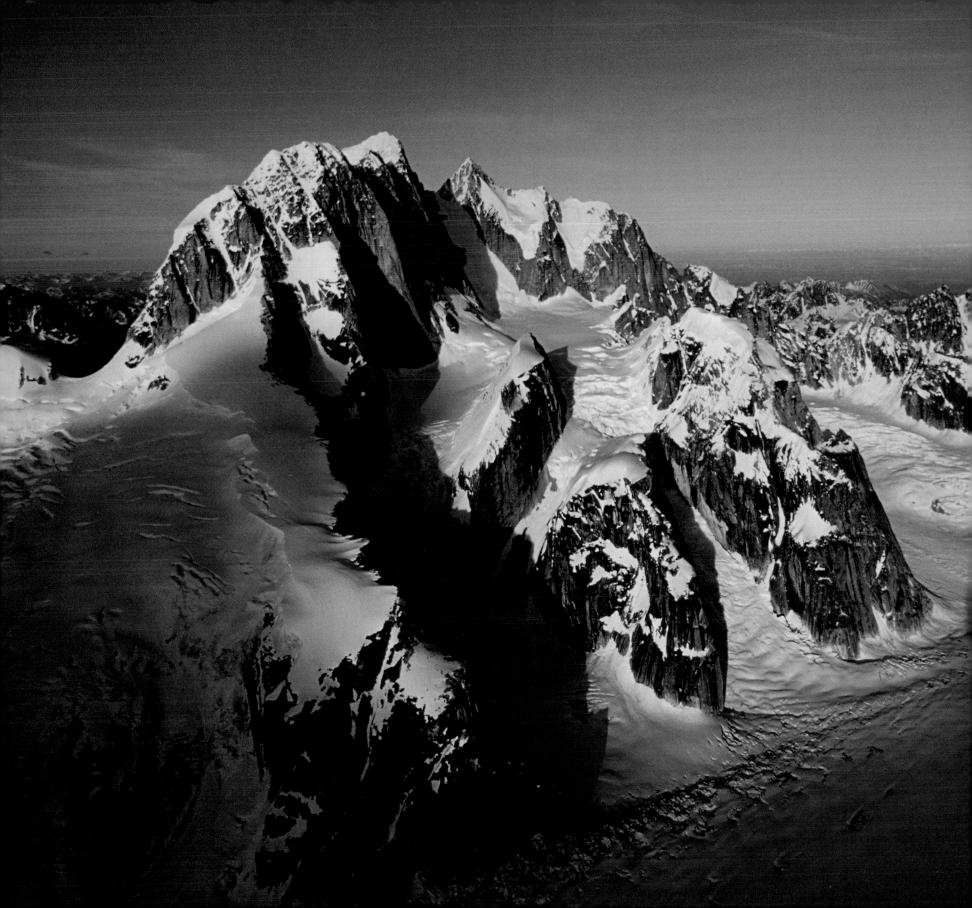

In Alaska, the Moose's Tooth is one of the grandest mountains rising above Denali National Park's ice-carved Ruth Gorge; the walls of the gorge are 1600 meters (1 mi) high, and the glacier ice is 1158 meters (3800 ft) thick, enough ice to bury Yosemite's El Capitan, which rises 1098 meters (3604 ft) above California's Merced Valley floor.

to the American Geophysical Union. Just between 2004 and 2007, the total volume of ice in the polar basin decreased by 50 percent. Mainstream climatologists, men and women bound by the dispassionate language of science and conservative by nature, fall back on words like "alarming," "astonishing," and "incredible" to describe the findings, as quantifiable as the gradations on a thermometer.

NSIDC senior climatologist Mark Serreze, who labels himself a moderate on the issue of climate shift and cataclysmic polar ice loss, predicts a seasonally ice-free Arctic Ocean by 2030—far sooner than he would have believed possible just a half-dozen years ago. "The overall rate of ice loss clearly exceeds our most aggressive [computer] models," he says. "Climate change is coming at us a whole lot faster than we expected, perhaps faster than we can deal with…It's the rate of change that I find most worrisome."

A multinational team of scientists, including Wieslaw Maslowski of the Naval Postgraduate School in Monterey, California, and NASA climatologists, predicts an even more abrupt melt-off, resulting in a seasonally iceless Arctic Ocean by 2013. A more cautious forecast comes from the Intergovernmental Panel on Climate Change, which posits the total loss of summer ice around the turn of the next century. Colleagues debate the exact timing; even though knowledge of the forcing mechanisms (see "Forces at Work in the Warming Arctic") and their interactions continues to expand, the variables and their interactions are complex. However, virtually everyone at the leading edge of peer-reviewed Arctic climatology believes a total summer melt of the polar ice pack lies in the foreseeable future. As Serreze says, "The debate is over."

Scientists also agree that the rate of warming and melt-off is most pronounced in the western Arctic, which includes northern Alaska as well as portions of Russia and northwestern Canada. Furthermore, this region is heating up faster than any other part of the planet. Through some dark irony, one of the peoples least culturally equipped to cope

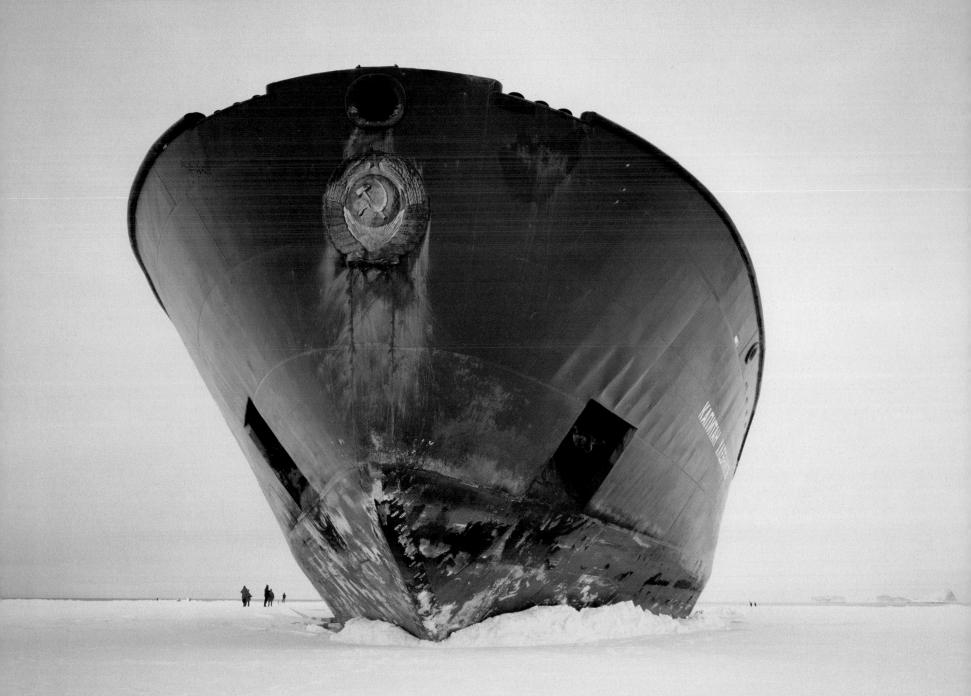

with global warming find themselves at its epicenter. Considering that the Arctic is widely considered by climatologists to be a major factor in regulating global weather (it acts as a reflective, cooling thermostat and drives key wind and ocean currents), what's true for the Iñupiat today may be our reality tomorrow.

The loss of ice means the utter disintegration—an optimist might say "transformation"—of the polar ice ecosystem. Of course, other life forms would expand or take hold, even prosper. But whatever the shape of the new food web, it would bear little resemblance to that which evolved in the nurturing shadow of polar ice. The U.S. Geological Survey has already forecast the certain extirpation of polar bears in Alaska and Russia by midcentury. Ribbon and ringed seals, as well as walruses, must have ice—for hauling out, as well as for raising pups. What other forms of marine life, from microscopic to leviathan, depend on ice, either directly or in ways science hasn't yet guessed? Are we teetering on the brink of a multispecies, multitiered trophic cascade toward extinction? What, then, will the People hunt, and how? What will they become? The questions gape like the dark, spreading chasms between floes.

STAKING CLAIMS TO BOUNDARIES AND RESOURCES

Meanwhile, a high-stakes political and economic shell game continues to unfold—as beyond the control of the Iñupiat as the ongoing thinning of the polar ice pack. The significance of a seasonally ice-free Arctic is hardly lost on multinational corporations or governments, both of which are shaping policy to take advantage of a warming polar region. The USGS estimates that up to a quarter of the world's undiscovered oil and natural gas lies beneath the polar seabed; recent lease sales off the Alaska coast and major, established discoveries in Canada's Mackenzie River delta serve as harbingers of a boom to come. Onshore, large-scale deposits of copper, zinc, silver, and diamonds beckon, with the promise of more discoveries ahead. An ice-free Arctic Ocean will also certainly lead to development of rich, untapped fisheries.

ABOVE Glaciers fed by the Vatnajökull ice cap calve icebergs into a lake near the famous Jökulsárlón, the best-known of Iceland's glacier lakes.

OPPOSITE The Russian icebreaker *Kapitan Khlebnikov* is one of only three icebreakers that civilians can book passage on.

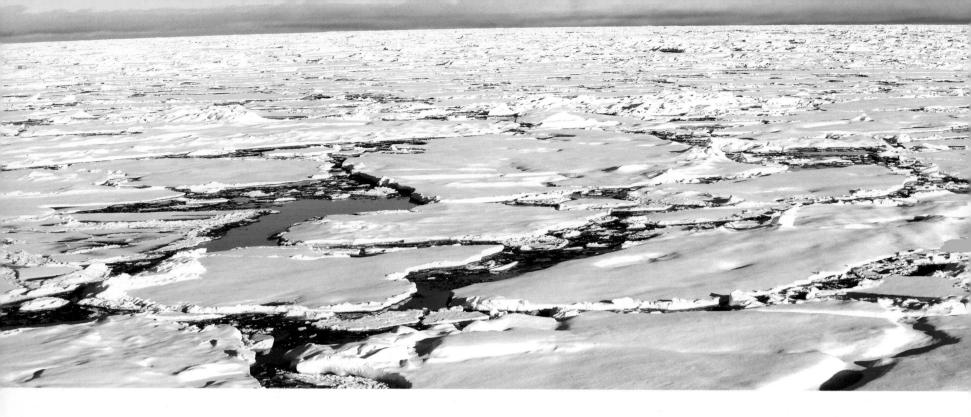

Pack ice 160 kilometers (100 mi) off
the northeast coast of Greenland far
north of the Arctic Circle

While some of these resources lie within recognized political boundaries, others don't. Eight nations—Russia, the United States, Canada, Finland, Denmark (whose Arctic turf is Greenland), Norway, Sweden, and Iceland—have laid historical claims to portions of the Arctic Basin, and disputes are heating up along with the climate. For example, Russia, Canada, and Denmark all assert ownership of the geographic North Pole, which lies not on solid land but on sea ice. In 2007, scientists aboard a Russian nuclear submarine made an emphatic gesture by planting their national flag on the ocean floor beneath the North Pole and proclaiming Russian sovereignty. Canadian prime minister Stephen Harper responded by announcing a tenfold increased military presence in the high Arctic to bolster Canadian claims—to the pole and across the region. The Danes, with few sabers to rattle, sternly urged caution. A number of less theatrical but no less real disputes involve polar islands and portions of the seafloor. Some, like "the wedge" (a submerged tract on the Alaska-Canada border), hold the potential for sizable petroleum reserves.

But the wrangling isn't limited to resources. For three centuries

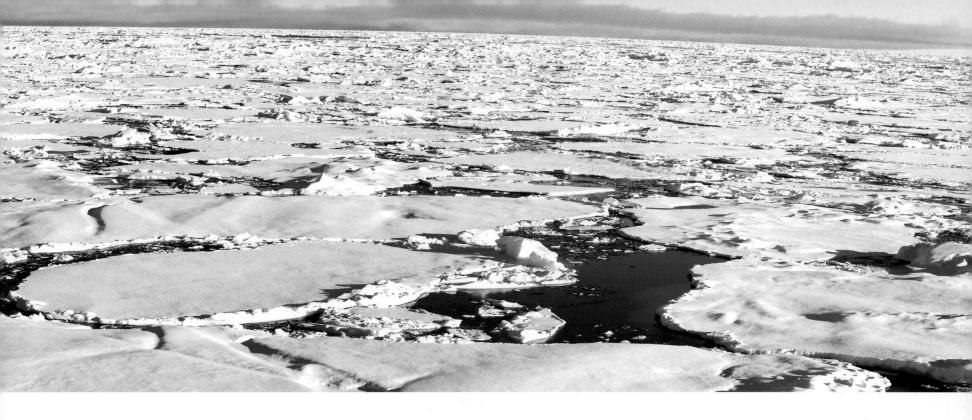

the vision of a navigable Northwest Passage, connecting Europe and Asia across the top of North America, served as a grail for explorers intent on fortune and glory. The impassive, sometimes brutal force of ice shrugged off all advances until the early twentieth century. Though modern steel icebreakers proved the viability of various routes (most spectacularly in 1969, when a Canadian icebreaker escorted the U.S. supertanker SS *Manhattan* safely through), the Northwest Passage was judged too risky and ephemeral for large-scale shipping.

All that changed in 2007, when satellite images showed the entire route to be navigable for the first time without icebreaker escort. Though no strings of freighters or tankers steered north, the commercial and military implications were obvious—a route connecting the Atlantic and Pacific that would cut in half the sailing distance between Asia and Europe. President George W. Bush joined Japan and members of the European Union in declaring the passage an international waterway, a claim the Canadian government has hotly disputed. And, partly in response to the Canadians, partly to the Russians and all other comers, the United States stepped up its already pointed military presence, as well as science-related expeditions, in the Arctic Basin. The U.S. Coast Guard is conducting ongoing, well-publicized exercises. And, reminiscent of the cold war (more literal this time around), Russian and U.S. jets are once more engaging in games of supersonic tag miles above the polar frontiers of both nations.

HARSH IMPACT ON A FRAGILE ENVIRONMENT

While the backdrop of international tension provides sound bites, the greatest threat to the Arctic will no doubt stem from burgeoning industrial development and related impacts. Drilling pads, pipelines, seismic grids, roads, mines, dumps, exploration camps, airports, and other infrastructure sprout from the tundra as the rush north accelerates. The harsh Arctic environment, with its short growing season and austere conditions, has proven remarkably fragile. Willows 5 centimeters (2 in) high may be a century old. Bulldozer tracks on wet tundra last for decades.

The offshore polar-ice biome poses special concerns. Increased ship activity, whether scientific, military, or commercial, will accelerate

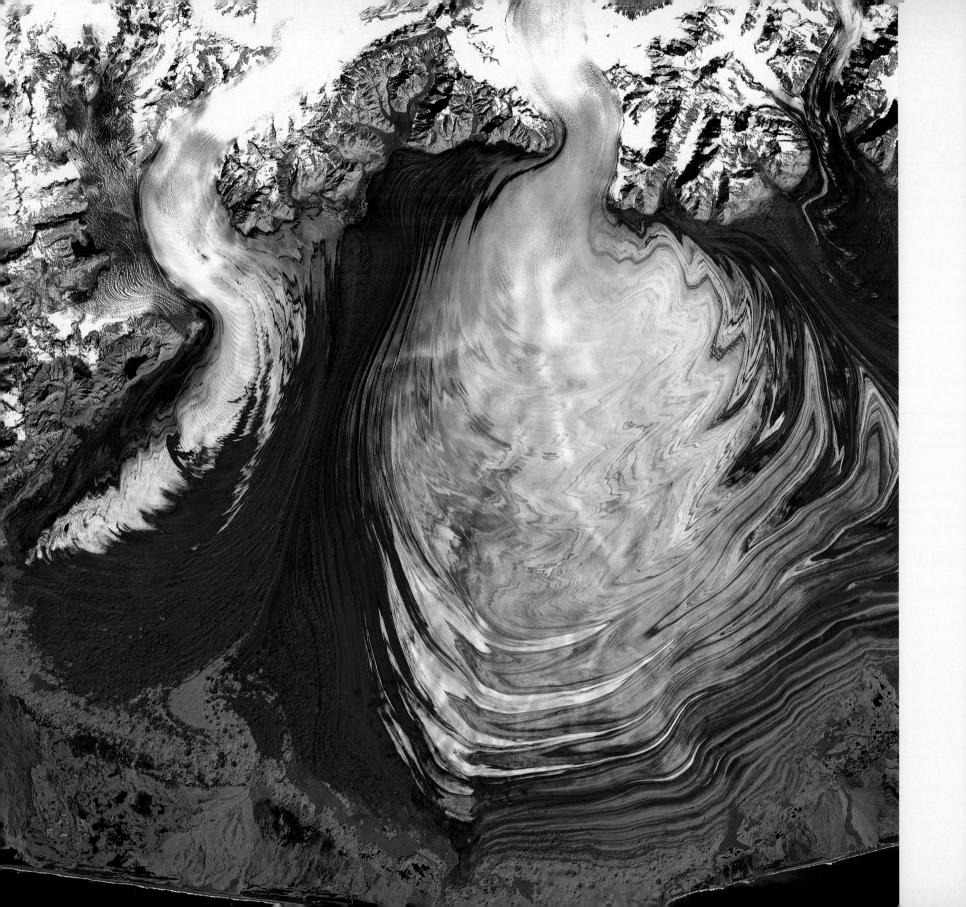

SHAPED BY ICE

This meltwater lake is on the Greenland Ice Sheet at 1000 meters (3281 ft) elevation.

This surface river is on the Greenland Ice Sheet.

▲ ICE SHEET LAKES

Although some of the water under an ice sheet is produced by heat from the Earth or from the friction of moving ice, summertime melting on top of the ice sheet in relatively warm places generates water much more rapidly. But how does water get from the upper surface through a thick ice mass to the bed? Where glacier flow is partly blocked by hills beneath the ice, hollows may develop in the surface and fill with water to form lakes. When a lake gets deep enough, the water pressure will wedge open crevasses that reach to the bottom. In exceptional cases, the lake may drain into the glacier as rapidly as water flows over Niagara Falls! *–Richard Alley*

A satellite image of the Malaspina Glacier, in Alaska's Wrangell–St. Elias National Park and Preserve *(image courtesy of USGS NASA Landsat 7 Data Collection)*

▲ ICE SHEET RIVERS

The wider parts of a water-filled crevasse that connects to the bottom of an ice sheet carry more water, and the heat generated by turbulence in the flowing water will melt the walls and enlarge the crevasse further. Eventually, the thinner parts of a crack through an ice sheet will freeze or squeeze closed, with the flow plummeting down a hole called a *moulin* (French for "mill," as the water mills around on its way down). This flow connects to subglacial rivers. During winter, the deeper parts of such moulin systems partially squeeze closed under the weight of the overlying ice. In the spring, melting resumes on the surface, feeding rivers on the ice, which flow into moulins or into lakes that open into crevasses to form new moulins, and so feed the subglacial rivers. *–Richard Alley*

the breakup of already thinning ice and will disrupt feeding, breeding, and resting wildlife that can ill afford further stress. A large-scale oil spill in winter sea ice looms as a worst-case scenario; there's no proven way to contain or clean up oil in shifting ice. The only spill drills ever conducted by a U.S. company, ConocoPhillips, ended in total failure—ironically called off due to dangerous weather and ice, the precise conditions in which an accident is most likely to occur. And the newly opened lease areas offshore in the Beaufort and Chukchi Seas (especially in the latter, which is characterized by dynamic currents and large-scale ice movement) offer challenges unlike any the industry has ever encountered. A spill on the magnitude of the *Exxon Valdez* is unthinkable but entirely possible. In water just above freezing, congealed oil sludge would linger not for decades but for centuries.

There's no doubt that the Arctic Basin teeters on the cusp of sweeping, inevitable change. One wonders if the People, transported a century into the future, would even recognize their home. Of course, no more than token effort has been made to include Alaska's Iñupiat and their circumpolar brethren in the discussion, though they collectively hold the most legitimate claim to the region, by simple fact of occupancy that predates the governments that now speak for them. Imagining these people as powerless innocents, though, is an oversimplification. In some cases, they're as much participants as victims. Well-positioned Native-owned (and -led) corporations have already reaped huge profits from resource development, with even greater opportunities ahead. Economic success, though, offers no guarantee of cultural stability or well-being.

The People are powerless to flee the multiple tsunamis—cultural, climatic, ecological, economic, political—that are bearing down. We might hope that the Iñupiat, among the most innovative, tough, and self-reliant people on Earth, will find a way to endure, as they always have. One further hope: that we find the will and means to save the Arctic ice—and perhaps ourselves. ❋

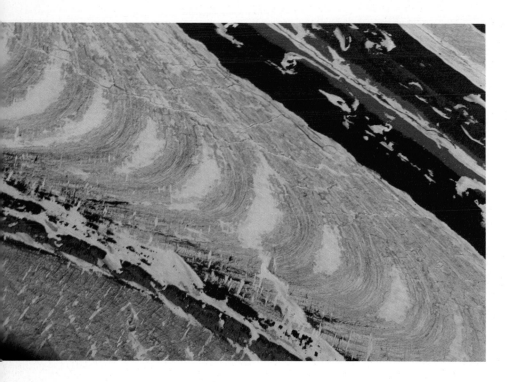

An aerial view of the Kahiltna Glacier in Alaska's Denali National Park shows surge patterns called ogives, which indicate that the center ice is moving faster than the ice on the sides; the parallel lines show where two glaciers merged.

FOCUS ON ICE

FORCES AT WORK IN THE WARMING ARCTIC

The following forcing mechanisms—identified forces and phenomena that cause change—are involved in the ongoing Arctic warming trend and the thinning of the polar ice pack.

Solar radiation and cloud cover Less cloud cover during the melt season (roughly mid-March through mid-September), when the sun is above the horizon for most or all of the day, results in a more rapid melting of ice. Far more clear days than usual were a major contributing factor to record melts in 2005 and 2007.

Greenhouse gases Probably the best-known forcing mechanism effecting climate change, greenhouse gases slow the loss of solar radiation into space. Carbon dioxide (CO_2) and methane are the two dominant greenhouse gases. Current atmospheric levels of CO_2 are higher than at any time in the past 600,000 years, as documented by fossil ice cores. Climatologists have attributed this rise directly to human activity.

The Arctic Oscillation This periodic and naturally occurring atmospheric pattern results in winds that tend to flush ice, especially thicker, older ice, into the North Atlantic Ocean. During the winter of 2007–2008, the oscillation was in positive mode, which points toward increased flushing. The flushing leads to warmer water being drawn north into the Arctic Ocean via the Bering Strait in the North Pacific and a general warming of polar basin waters. While the Arctic Oscillation is a natural phenomenon, studies are underway to determine to what extent it is influenced or enhanced by human-caused warming.

Less cloud cover results in more rapid melting of ice; as ice melts, more open water leads to more ice melting at an ever increasing rate.

The ice albedo effect This feedback loop plays a major role in the decline of polar ice. White snow and ice reflect far more solar radiation than does darker, open water. As ice melts, more water is exposed, leading to more heating, which leads to more ice melting at an even faster rate as more and more water is exposed. As the overall composition of polar ice becomes thinner and more subject to sudden, total melting over wide areas, the feedback loop's power intensifies. In short, melting results in even more melting, at an accelerating rate.

Warming ocean currents Arctic Ocean surface temperatures in 2007 were the highest ever recorded: up to 5° Celsius (9° F) above normal. Warming of deeper water as well suggests the trend is ongoing. A new model offered by NASA and others suggests that as polar ice thins, the decrease in volume creates a vacuum (oceanic advection), drawing more warm water northward to replace the lost volume of ice. Proponents of the model say that overestimates of ice thickness, and subsequent underestimates of the rate of oceanic advection, may explain why warming has been accelerating faster than predicted. –*Nick Jans*

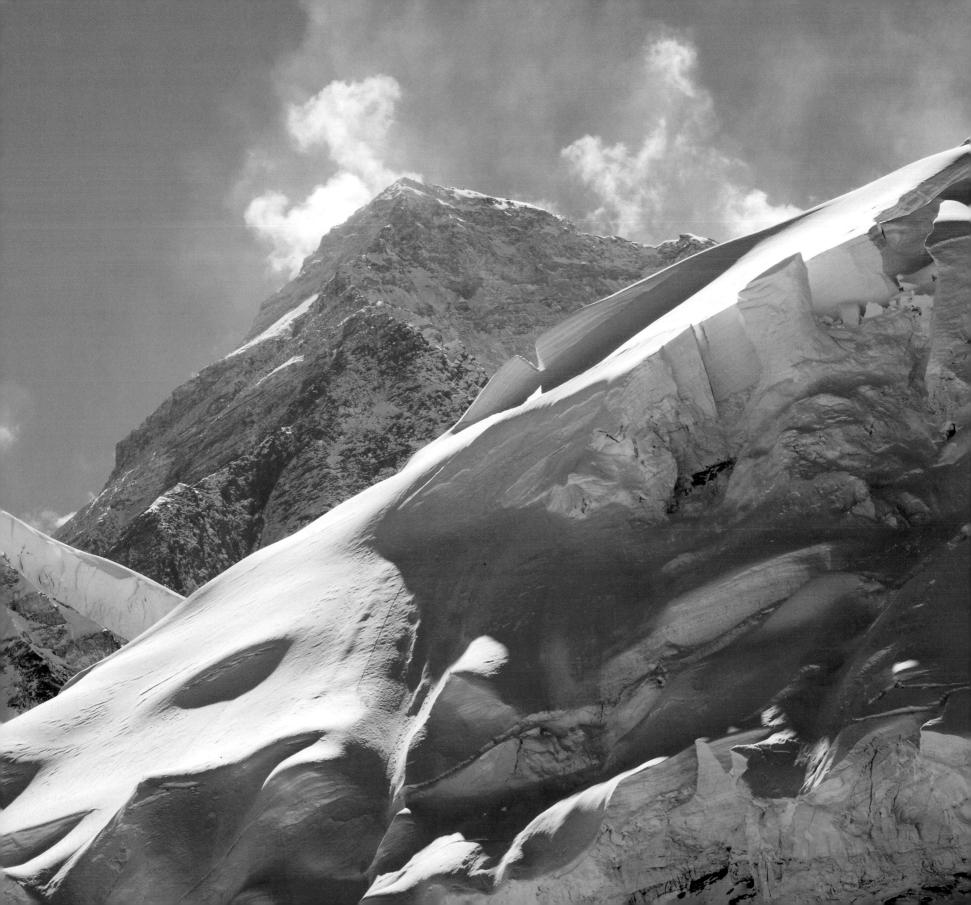

THE THIRD POLE
THE HIMALAYAS' GLACIERS

Broughton Coburn

BROUGHTON COBURN, of Wilson, Wyoming, has worked on environmental conservation and development projects in Nepal, Tibet, and India for two of the past three decades. He has written, edited, or collaborated on seven books, including *Aama in America: A Pilgrimage of the Heart* and two national bestsellers, *Everest: Mountain Without Mercy* and a collaboration with Jamling Tenzing Norgay, *Touching My Father's Soul: A Sherpa's Journey to the Top of Everest*. In 2008 he led a research and filming project that explored several human-excavated cave sytems in the restricted area of Mustang, Nepal. *Photograph by Didi Thunder*

From Nepal's trail to Everest Base Camp at 5182 meters (17,000 ft), the summit of Mount Everest rises more than 3220 meters (2 vertical mi).

The icy outline of the 7925-meter (26,000-ft) Lhotse-Nuptse wall seems to vibrate against an indigo sky. With each deep breath I take, the crystalline air stings my nostrils. Directly south of Mount Everest, at 4572 meters (15,000 ft) in the Khumbu region of the Himalayas, I hike a rocky glacial moraine toward the head of the Imja Khola valley. A rising sense of dread accompanies me: the lower mile of the Imja Glacier, which in the mid-1950s threatened to bulge up and over its retaining walls of rubble, is simply no longer there. It has been replaced by a glacial lake, 61 meters (200 ft) below the precipitous, unstable rim of the moraine. The placid waters pour over the immense lake's western end.

The scene isn't as serene as it appears. Like scores of other glacial lakes across the Great Himalayas range, the Imja Lake is expanding at an accelerating rate; in 2007 it grew by 74 meters (243 ft). Scientists and local Sherpa villagers offer a variety of theories about the mechanics of what could happen here, and they start by invoking 1985, the year a massive block of ice crashed into the Dig Tsho, a glacial lake 32 kilometers (20 mi) to the west. The ice collapse generated a tidal wave that easily overtopped the end moraine that formed the lake's natural dam, triggering a wholesale failure—and a deluge of biblical proportions. The resulting flood drowned four people, washed several hamlets

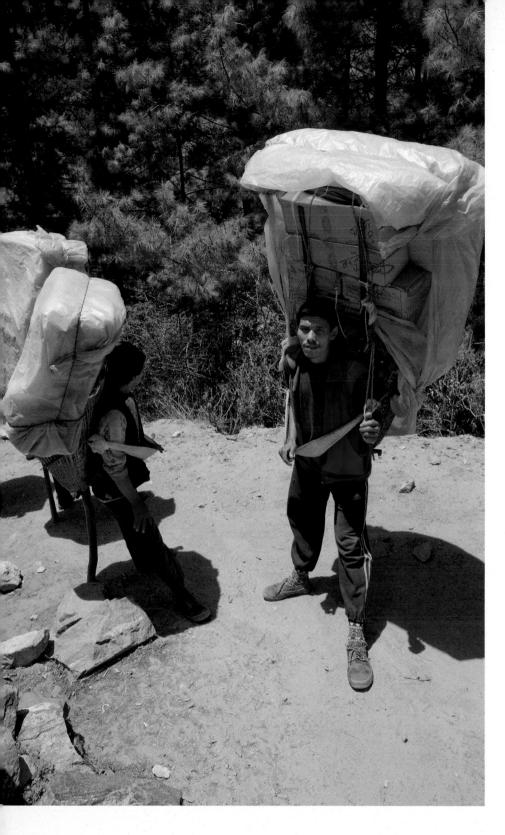

into the riverbed, and swept away twenty-three footbridges before surging over the Indian border. For months, this remote area was isolated from the outside world.

The glaciers of the Himalayas are receding, and as their remnant glacial lakes swell, they can burst with terrifying power. But these events occur in remote, sparsely populated areas, visited by few Asians (including those in villages only a few miles from the glaciated peaks), so that most Asians have never had direct contact with snow. Hiking toward the Imja Glacier and having lived and worked in Asia for over two decades, I am aware of the near-countless threats to the region's environment—and of the raft of agencies addressing them. It seems fair enough to ask how severe, in human terms, the problem really is.

NATURE'S "WATER TOWERS" RUNNING LOW

The Himalayas and the Tibetan Plateau contain the greatest concentration of snow and ice outside of the polar regions, earning this lofty realm the informal title of "the Third Pole." Western China and Tibet are home to more than 46,000 glaciers, and another several thousand are strung like necklace beads across the 1600-kilometer (1000-mi) arc of the Himalayas and Hindu Kush, traversing Pakistan, India, Nepal, and Bhutan.

Yet this region is warming by 0.3° Celsius (0.5° F) each decade (more than twice the average warming of the Northern Hemisphere's midlatitudes), and its glaciers are shrinking faster than those in any other mountain region. This is withering news, considering that—through complex meteorological processes that are magnified by the

Porters on the steep climb to Namche Bazaar, Nepal, carry enormous loads with assistance from tump lines (the wide white straps they hold in their hands during a break) on their foreheads. When they stop to rest, they balance the weight on T-shaped poles, as the two porters on the left are doing.

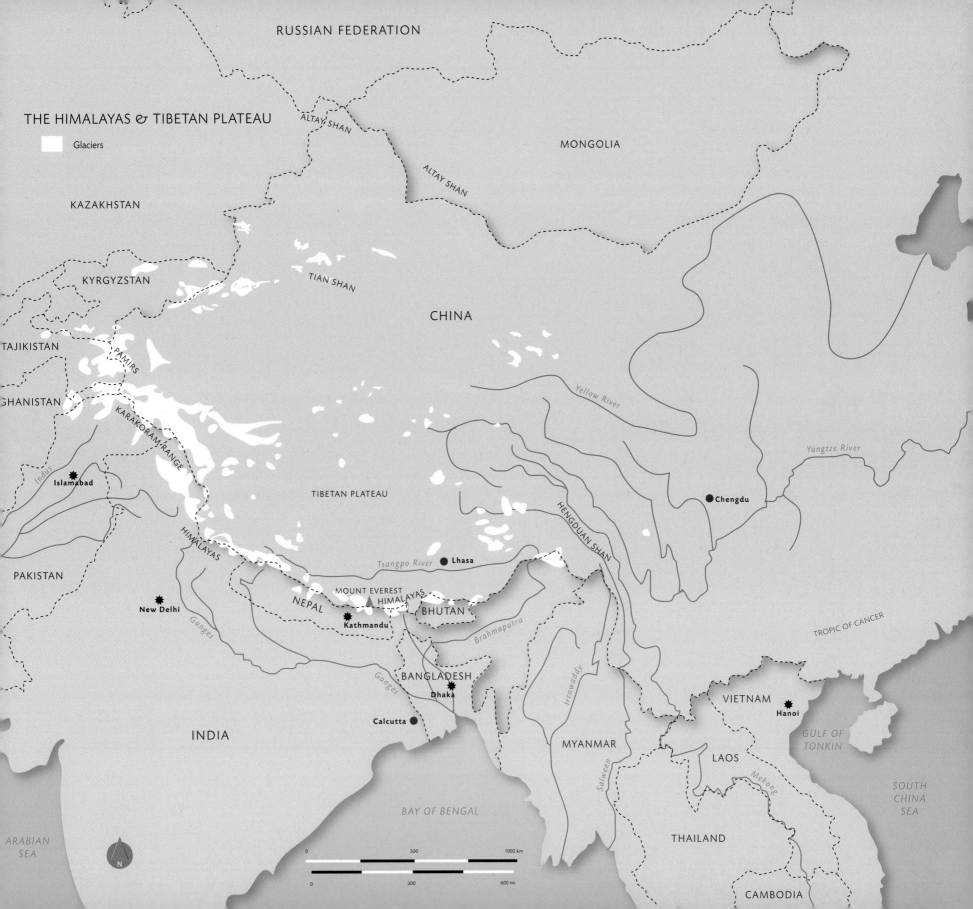

THE HIMALAYAS & TIBETAN PLATEAU

Glaciers

RUSSIAN FEDERATION

ALTAY SHAN

ALTAY SHAN

MONGOLIA

KAZAKHSTAN

KYRGYZSTAN

TIAN SHAN

CHINA

TAJIKISTAN

PAMIRS

Yellow River

GHANISTAN

KARAKORAM RANGE

Yangtze River

Indus

Islamabad

TIBETAN PLATEAU

Chengdu

PAKISTAN

HENGDUAN SHAN

HIMALAYAS

Tsangpo River

Lhasa

NEPAL

MOUNT EVEREST

HIMALAYAS

New Delhi

Kathmandu

BHUTAN

Ganges

Brahmaputra

TROPIC OF CANCER

BANGLADESH

Irrawaddy

VIETNAM

Dhaka

Hanoi

Ganges

Calcutta

GULF OF
TONKIN

INDIA

MYANMAR

LAOS

Saleen

Mekong

BAY OF BENGAL

SOUTH
CHINA
SEA

ARABIAN
SEA

THAILAND

N

0 500 1000 km

0 300 600 mi

CAMBODIA

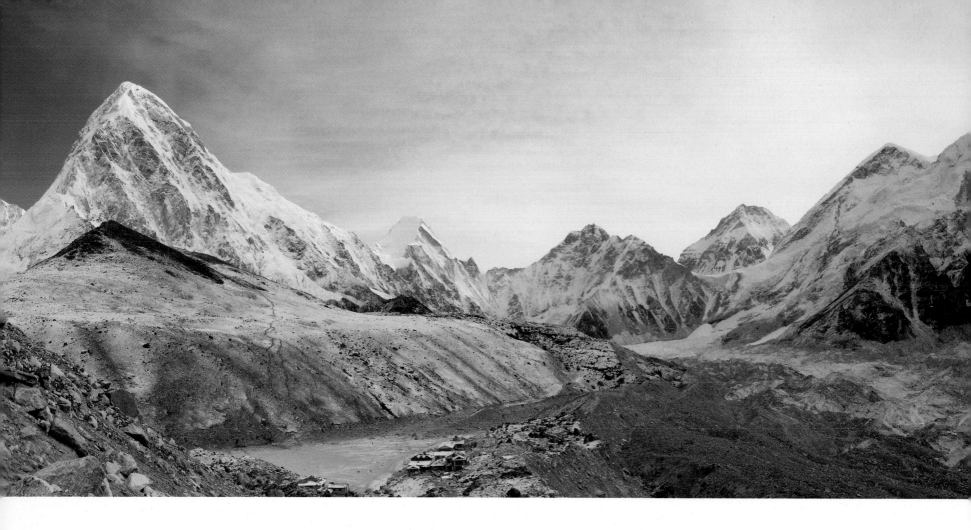

Pumori and Nuptse dominate the head of the Khumbu valley in Nepal, blocking views of Mount Everest.

dramatic topography—the Tibetan Plateau is believed to influence the climate and wind patterns of the entire globe.

The Himalayas are located only a few degrees north of the Tropic of Cancer—at the same latitude as Florida—which means that seasonal variations in temperature, day length, and climate are not as pronounced as they are nearer to the "other" poles. But for humans, the aggregated impacts of these subtle changes are profound. More than a billion people live in Himalayan river drainages, and they are nourished by its liquid lifelines: the Indus, Ganges, Brahmaputra, Salween, Mekong, Yangtze, and Yellow Rivers. Without this drip-feed irrigation from melting glacial snow, where will this expanding population get its water?

"I like to think of glaciers as nature's water towers," Lonnie Thompson told me. Thompson is a renowned paleoglaciologist known

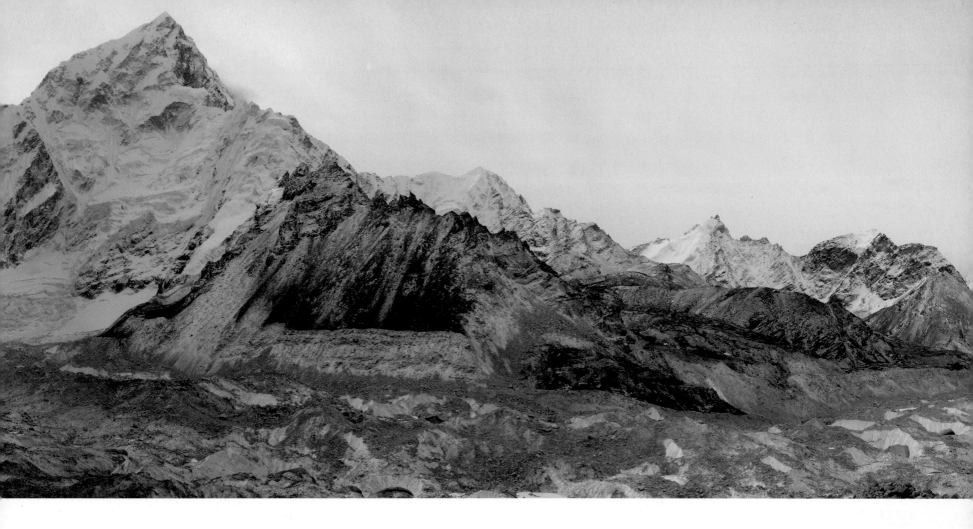

at Ohio State University as Mr. Ice. "Glaciers store water in the wet season, which in the Himalayas falls during the summer monsoon, and then release it during the dry season or during periods of drought. So it is the seasonality of water discharge that will likely be most impacted by glacial loss. This can have important impacts on hydroelectric power production, as glaciers serve to balance water flow over the whole year. In Burang, a 1500-year-old city in far western Tibet, 85 percent of their water comes from melting glaciers."

Thompson is also an expert in the study of paleoclimates, which he and others are reconstructing from ice cores drilled in the Himalayan and Tibetan Plateau glaciers. They have found that dry periods, especially, match the (sparse) historical and archaeological records of migration and local population changes.

Looking back over a few decades, conclusive data on Himalayan climate change are scarce and localized, but villagers are beginning to detect consistent shifts in the timing of monsoon rains, characterized by longer dry periods, delayed onset, and higher-intensity rainfall occurring over fewer rainy days. The intensity presents the biggest problem, because flowing water's sediment-carrying capacity—its destructive power, essentially—increases geometrically with its velocity. Big storms, which occur normally, are inconvenient. Really big storms, however, can be devastating. Increasingly, news accounts describe entire mountainside hamlets carried away by summer floods or buried in mudflows and landslides.

In a warming climate, these severe rainfall events are amplified by a simple rule of physics: warm air holds significantly more moisture

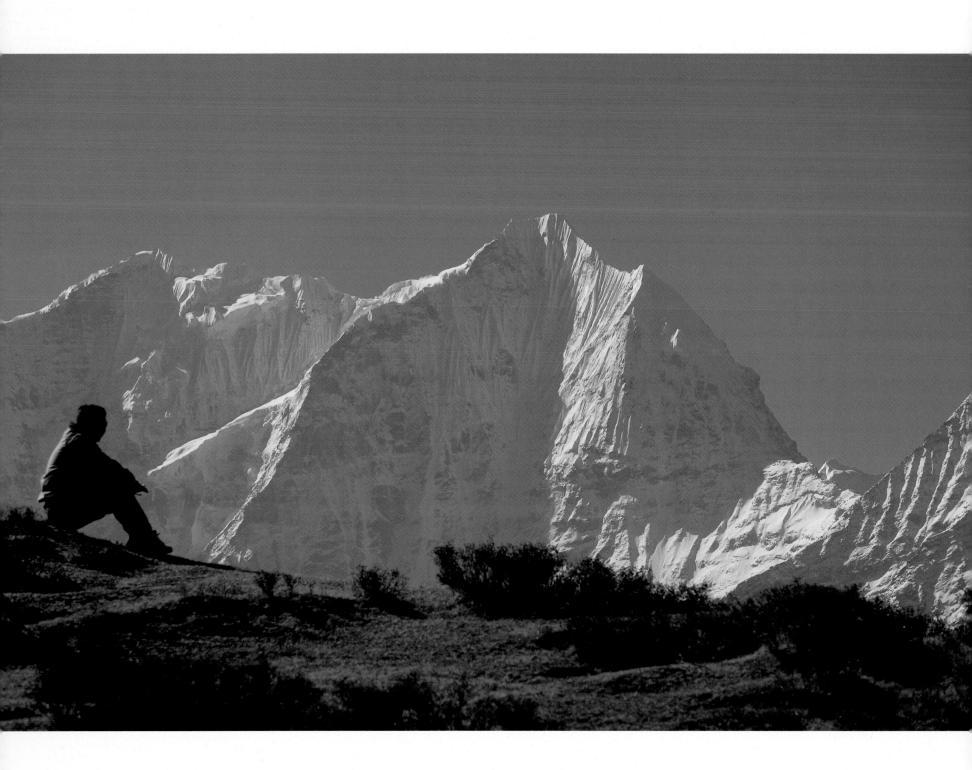

than cool air, meaning that added moisture is conveyed aloft before condensing among the high, cool peaks.

"There is evidence for increasing quantities of water vapor in the tropical atmosphere," Thompson adds. "Water vapor is our most important greenhouse gas, and it could lead to warmer temperatures at higher elevations."

This water-vapor effect is heightened, in turn, by the "Asian Brown Cloud" of pollution that floats, most every winter, above northern India. Generated by smoke from wood fires and emissions from industry and motor vehicles, this persistent high-altitude veil of haze blocks the sun sufficiently to cause a decrease in average temperatures at sea level. Until recently, this was thought to be a fortuituous, if inadvertent, offset to global warming. But recent data collected from aerosol-sampling unmanned aircraft have shown that the particles of pollution high in the atmosphere absorb substantial quantities of heat from the sun. This has caused a net warming effect on the region and is a suspected contributor to glacial retreat.

Further, when the aerosol soot and dust (and sometimes algae) collect on "clean" glaciers—which normally reflect most of the sun's energy—their dark color absorbs heat and transfers it to the snow, expediting melting.

A handful of glaciers are sheltered from these effects. Layers of rocky debris and sediment that collect atop "dirty" glaciers can partly insulate the glacier and slow melting. The Khumbu Glacier (Everest Base Camp lies along its margin) is one such dirty glacier. Constantly fed by avalanches from Mount Everest's flanks along its upper stretches, and insulated by rubble in its lower reaches, this glacier has retreated little in the past fifty years, though melting and evaporation have reduced its overall volume.

A trekker admires the icy peaks of Nepal's Himalayas.

In the Hindu Kush, strangely, some of the Karakorum's largest glaciers are advancing in sudden surges of a mile or more that occur over a period of a few weeks. It's likely, however, that this is an idiosyncratic consequence of warming, as the glaciers slide on meltwater that has begun to flow beneath them, greasing their undersides. These glaciers are heavier, too: seasonal weather systems converge in the Karakorum, delivering above-average dumps of snow to the high slopes that feed the glaciers, and under a new regime of heavier cloud cover brought by global warming, snow remains longer without melting.

SEA LEVEL ON THE RISE

A few anomalies aside, melting is the new norm, though the science is inexact and expert opinion varies. The normally cautious World Bank calculates that during this century, as all this melted ice flows toward the ocean, it will raise the level of the sea between 1 and 5 meters (3.3 and 16.4 ft). Toward the upper end of this prediction, widespread environmental and economic damage would result, as well as hundreds of millions of people being displaced, mainly in poorer nations. The World Bank's forecast is sobering: "These results are not speculative… Even if greenhouse gas emissions were stabilized in the near future, thermal expansion and deglaciation would continue to raise the sea level for many decades."

The low-elevation island state of the Maldives, in the Indian Ocean, is especially vulnerable, and east of the Philippines, Micronesia is beginning to feel the heat. As they battle rising salt water, the islands of Micronesia are suffering shortages of freshwater falling from above—much needed for cultivating rice and other thirsty subtropical crops. Indonesia could lose more than 400 million square kilometers (155 million sq mi), or an eighth of its landmass, by the year 2080, including about 10 percent of its province of Papua, the western half of the world's second-largest island, New Guinea. Dhaka, the capital of Bangladesh, is already swelling with "climate refugees," driven there by the rising sea.

ABOVE **Prayer wheels at Tengboche Monastery high on a hill above Nepal's Khumbu valley**

OPPOSITE **Moonrise over the Nepal Himalayas**

When climate starts to change, the historical record shows that the pace of that change quickens. It might take a few thousand years, but if all the world's glaciers and ice sheets were to dissolve, the injection of water into the oceans (along with eustatic expansion, from water's increase in volume as it warms) would elevate sea level by 65 meters (213 ft)—inundating Florida, Bangladesh, and much of the populated world.

IMPACTS ON THE RURAL POOR

Lonnie Thompson emphasizes that the effects of climate change won't be uniform—particularly regarding who is most likely to be affected. "The loss of glaciers will impact different parts of the world differently," he wrote me, following an expedition to collect ice-core samples on the Tibetan Plateau. "Unfortunately, it will be those who are least responsible and least able to adapt to change who will pay the greatest price. In many parts of the world, the role of the glaciers in moderating water flow in streams and rivers could be replaced by dams, but this will require monies and resources which simply do not exist in many parts of the world. As water seasonally becomes less abundant, sandstorms could become more frequent. In the foothills of Gurla Mandhata, in western Tibet, great fields of sand dunes exist in and among villages. Should these become more active, they would immediately impact these people's ability to survive and raise their livestock."

In addition to enduring hotter heat waves and more destructive floods, the rural poor of the Himalayas are also battling the growth of insect- and waterborne diseases. Liver fluke (a flatworm that infects the liver and other organs) is common in water buffalo kept in lowland areas, but it has begun infecting these livestock at higher elevations. Pressure to join the cash economy has led rural farmers to plant fewer crops, and as the seed industry is increasingly globalized, fewer varieties of those few crops are being planted. Just when subsistence farmers most need the rich agricultural biodiversity that gives their crops the resilience to adapt to diseases and climate change, they are losing it.

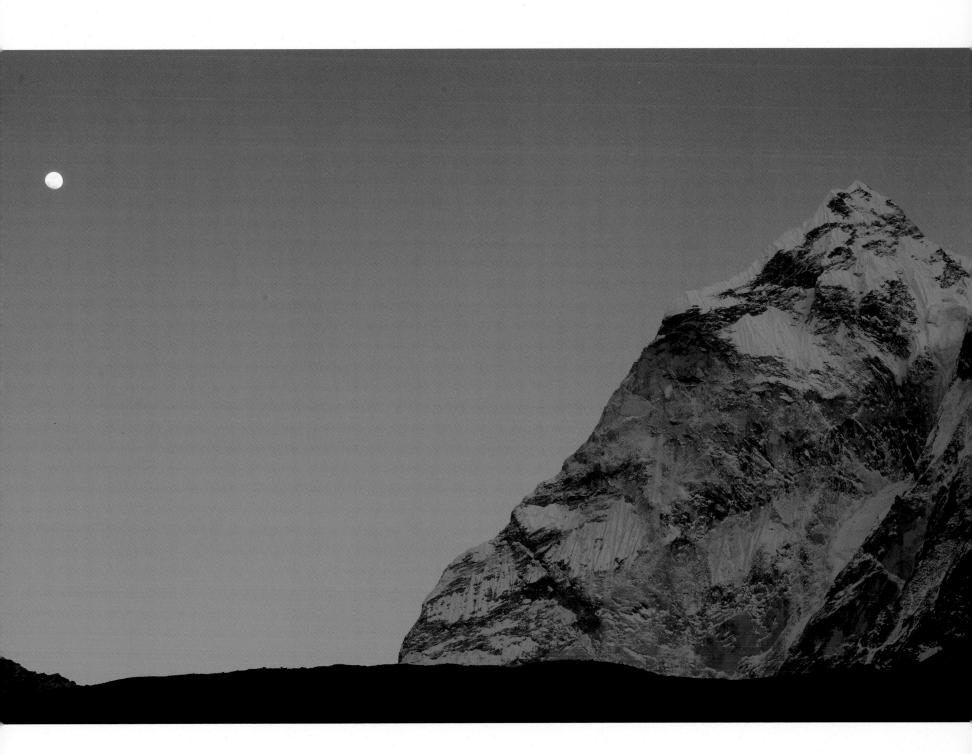

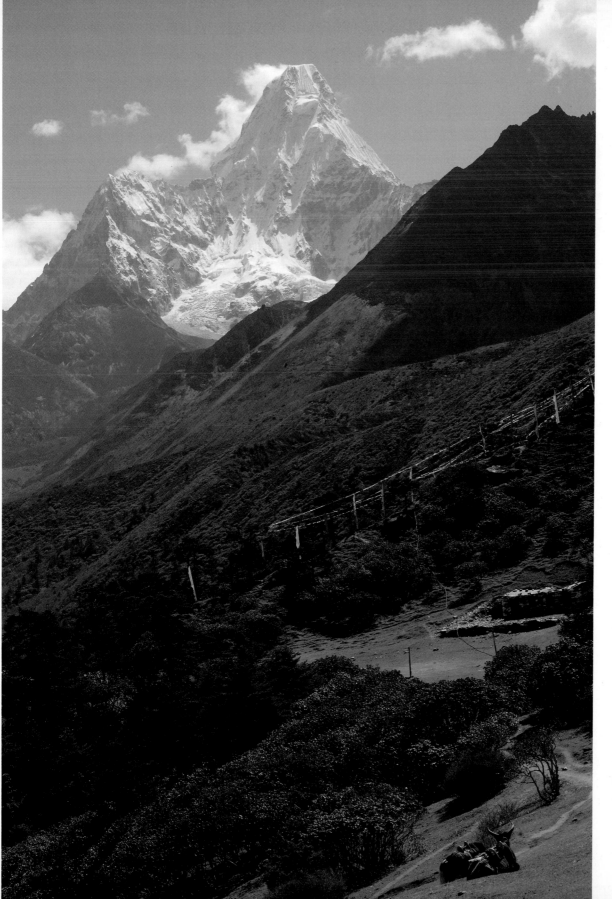

Ama Dablam looms above the
pasture at the Tengboche Monastery,
Nepal.

HOPEFUL LOCAL STRATEGIES

Subsistence villagers' ability to adapt to climate change is limited, but that hasn't stopped them from trying—and in some cases succeeding, to a degree. Villagers and nomads of the Himalayas' upper valleys—where the severity of both floods and droughts is escalating—are keenly dependent on a consistent, predictable supply of water. To reduce erosion and the drying up of traditional hillside springs, Pragya, an Indian nongovernmental organization dedicated to rural development and preservation of indigenous lifestyles, has been planting native trees in the catchment areas above springs and installing snow fences and check walls, all of which mitigate runoff and increase water collection and infiltration. Pragya and a team of "technopreneurs" has also helped Himalayan villagers construct storage and desilting tanks at the base of glaciers, and they have replaced open irrigation channels with pipelines, reducing evaporation and maintenance costs.

Another group, Practical Action, impatient with the glacial pace of government response, is improving villagers' preparedness for floods and landslides, while introducing alternate income-earning opportunities to improve their self-sufficiency. Founded in 1966 by the visionary economist E. F. Schumacher, Practical Action has been proving that small-scale, inexpensive solutions executed by villagers themselves can change the world.

Diversifying villagers' sources of livelihood helps, but extreme conditions deserve drastic measures. In the high corners of Hunza, Pakistan, farmers hungry for irrigation water have channeled rivulets of melting snow to their crops. Gradually, however, the snowfields above their villages have been shrinking. With access to few technical resources beyond their own elbow grease, residents of some valleys have revived a peculiar technique said to date from Genghis Khan: glacier grafting. By "grafting" pure, white snow taken from a "female" glacier onto the "seed" of rocky, dirty snow of a "male" glacier, they claim to be able to *grow* glaciers.

Two Sherpa girls along the trail up the Khumbu River valley en route to Mount Everest in Nepal

Far-fetched? Ingvar Tveiten, of the Department of International Environment and Development Studies at the Norwegian University of Life Sciences, has been studying the process with some skepticism but now sees a thread of possibility that some of these "glaciers" (more like static snowfields) have actually grown in size. This ancient practice, accompanied by a modest ritual ceremony, is now being revived and supported by the government of Pakistan at nearly a score of sites.

APPLYING SCIENCE AND PROTECTING LIVES:
GLOBAL AND LOCAL INITIATIVES

To address the bigger, changing climate picture, it might be useful to call in a bit more science. If the 1985 glacial-lake outbreak west of Mount Everest had any benefit, it is that it galvanized the study of Himalayan glacial lakes. Scientists now take aerial photographs, scour satellite imagery, take ground-level measurements, and draft computer models, allowing them to rank these lakes' risk of imminent catastrophic flood and to assess the vulnerability of villagers downstream.

It appears that Bhutan, which counts more than 670 glaciers and 2600 glacial lakes, may be next on the outburst list. In 1994, a mile-long glacial lake, the Luggye Tsho, ruptured catastrophically. Over a period of several hours, its water rampaged downvalley, sweeping away an artisans' colony next to the town of Punakha and killing seventeen people. At Bhutan's border with India, 200 kilometers (125 mi) away, a hydrograph that measures the river's level broke when the water topped out at 2.4 meters (8 ft) above normal.

The divot of the busted-out Luggye Tsho lies adjacent to an even larger lake, the Thorthormi Tsho, the level of which has also risen dramatically. Scarily, a third lake in this series, the Raphstreng Tsho, is just as immense as Thorthormi and lies a mere 152 meters (500 ft) away—measured horizontally—yet is 79 meters (260 ft) lower in elevation. Raphstreng and Thorthormi are separated by a crumbling, swiss cheese–like moraine that is being infiltrated by erosive tendrils of water

GLACIER LAKE OUTBURST FLOODS

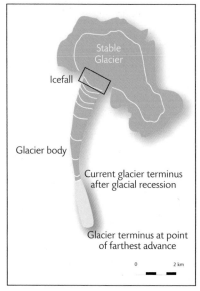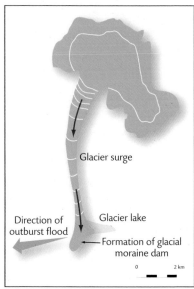

A surging glacier repeatedly causes lake formation, followed by outburst floods when the ice dam gives way. *Source: Hugo Ahlenius, UN Environmental Programme/ GRID-Arendal (http://maps.grida.no/go/graphic/formation-of-lakes-and-glacier-lake-outburst-floods-glofs-by-medvezhi-glacier-pamirs)*

through a process called *piping*. This is not exactly a stable situation.

When Thorthormi inevitably breaches, its water will rush directly into Raphstreng, surely causing that lake to breach too. Water from both lakes—more than twice the volume of the 1994 outburst—will careen down the same valley (at higher speeds because of the path scoured in 1994) and inundate an even wider swath of villages and croplands.

John Reynolds, of Reynolds Geo-Sciences, Ltd., an environmental engineering firm based in Wales that specializes in glacier hazard assessment and remediation projects, predicts that "this next flood

will surge across most of Bhutan, rage well into northeast India and possibly into Bangladesh—a distance of more than 320 kilometers (200 mi)." The Bhutan government, with $7 million from the United Nations Development Programme, is planning to install an early warning system in villages downstream and to dig a channel at the outlet of the Thorthormi Tsho to hopefully lower its level by 5 meters (16 ft). The site is too risky for the use of explosives, so this monumental task will be done by hand.

With a lot less funding, Sherpa villagers in the shadow of Everest are taking action on their own. In 2008 Dawa Steven Sherpa, leader of the Eco Everest Expedition, climbed the mountain for the second time—a secondary goal, he said, compared to the objective of drawing local and international attention to the threat of glacial lakes and climate change. With the help of Wi-Fi, satellite communications, and scientists based in Kathmandu, Nepal, and Japan, villagers near Everest are learning to monitor glacial lakes, while establishing an early warning system for hamlets downstream.

Dawa represents a new generation of Sherpas—many of them educated in schools built by the late Sir Edmund Hillary—who are stepping forward to tackle landscape-sized challenges, backed by focused foreign assistance. Their initiative is all the more laudable considering that—like the Pakistanis who carry baskets of snow to home-grow their glaciers, or the farmers alternately fighting floods and droughts—they have inherited climate change mainly from sources thousands of miles away.

NEXT STEPS

Emergency relief and humanitarian aid, which can help afflicted people through a year or two of tough times, fall short of a long-term solution. Ultimately, when villagers are faced with finding landslide- and flood zone–free sites for their houses, with determining what crops to plant, and with knowing where to fetch water, they are mostly on their

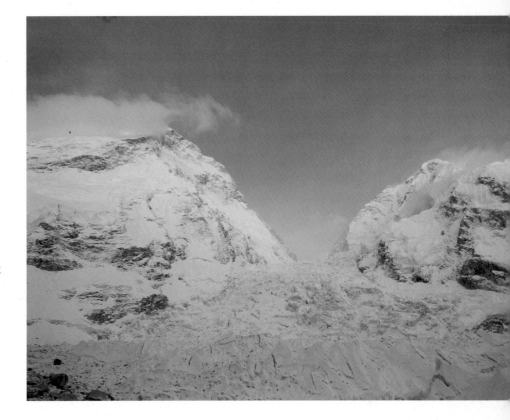

The formidable Khumbu Icefall at night; from Everest Base Camp, mountaineers must cross this treacherous terrain to continue up toward Mount Everest.

own. Some may have to move away. But perhaps their Himalayan-sized desire to survive, and the remarkable ways in which they have adapted and thrived for centuries in the midst of extreme, moving landscapes, can offer a lesson to the industrialized world.

The flow of information, and hope, will need to come *from* the developed world as well. Can science and technology be applied to protecting and providing for subsistence villagers and the millions who live downstream? Specialists at the International Centre for Mountain Environments and Development, based in Kathmandu, Nepal, hope so and have been carefully studying the watersheds, rivers, and glacial lakes of the Himalayas in order to better predict where and when the next river will dry up, the next flood will occur, the next glacier will melt, and the next lake will burst. From these observations, they can assess the vulnerability of riverside communities and propose mitigation measures.

Already, with outside support, villagers have invested in tree plantations, seed storage (in the event of disaster), and renewable energy sources such as solar power and microhydroelectricity. Meanwhile, the Clean Development Mechanism of the Kyoto Protocol has funded carbon offsets such as biogas technology. Nepal alone now has more than 180,000 farmstead-scale "digesters" that capture methane gas from livestock manure. Methane, a potent greenhouse gas, is now used as cooking fuel rather than escaping and accumulating in the atmosphere.

THE BEGINNING, OR THE END?

Glaciers are no longer changing at a glacial pace. And the level of the sea—what could be more constant?—has already begun to rise by measurable increments. Distressingly, least developed countries and the international community have initiated little planning for population relocation or infrastructure enhancement to deal with these inevitable changes. For politicians and decision makers, technological interventions are expensive—beyond their reach and resources, and certainly beyond the time frame of elections. Meanwhile, a February 2007 World Bank policy research paper stresses that "much higher concentrations of greenhouse gases will undoubtedly be reached before any global agreement can be implemented."

In earlier, less populated times, entire civilizations responded to climatic shifts by uprooting, migrating, and pioneering new territory. In this millennium of melting, in which we are all daisy-chained to a destiny of climate change, where will the displaced billions of Asia and other continents move to? Getting scientists and villagers to recognize the impacts and hazards of climate change is one thing. The next essential task will be to apply some global heat to governments and decision makers, to get them to agree on a plan of action, and to cooperate on implementing that plan. We have no choice. ❈

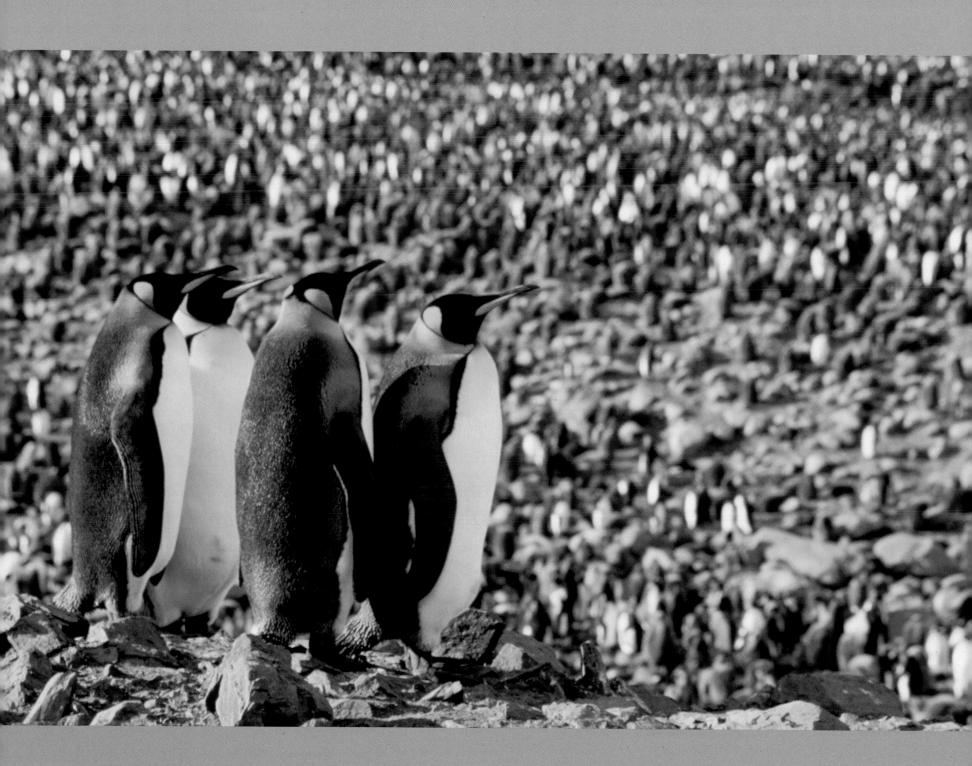

FOCUS ON ICE

A TALE OF TWO POLES: NORTH & SOUTH (AND IN BETWEEN)

At one end of the planet, the geographic North Pole is located in the Arctic Ocean at a depth of about 4080 meters (13,386 ft) below the surface and about 725 kilometers (450 mi) north of Greenland. The pole is covered in drifting pack ice—thick, frozen seawater, or sea ice. Without land to rest on, this sea ice never accumulates and solidifies to form an ice sheet—as on Antarctica—but instead expands in the winter and retreats in the summer, moving with the wind, waves, ocean currents, and tides.

Some Arctic sea ice usually melts in summer, but on average a little more than half remains, covering a huge area: 7 million square kilometers (2.7 million sq mi), or just shy of the size of Australia. In the summer of 2007, the Arctic sea ice melted the most since satellite record keeping began in 1979, raising the specter of an ice-free North Pole and the reality of the fabled Northwest Passage. The iconic polar bear, dependent on sea ice for survival, is threatened, and the Iñupiaq cultures that evolved with the animal are living in a changing world.

LEFT In the South Atlantic, four adult king penguins overlook a large rookery on the north shore of South Georgia Island, which has the largest king penguin population in the world.

FOLLOWING PAGES An end moraine (also known as a terminal moraine) that is partially underwater blocks icebergs floating out of a fjord, causing them to crash together until they melt enough to float over the obstruction; this image was captured at midnight.

At the other end of the world, there are no polar bears at the South Pole. In Antarctica, there are no terrestrial predators because the gap of inhospitable ocean between South America and Antarctica is too wide for such species to cross. Instead, the creature unique to the South Pole is the penguin, which ranges in the Southern Hemisphere. Though penguins travel thousands of miles, and the Galapagos penguin lives near the equator, they are primarily built for cold.

The South Pole sits on the Antarctic continent, which is covered by the world's largest ice sheet. Sea ice rings Antarctica in winter, but almost all of it melts in summer, because the sea ice floats in the open ocean and moves north with currents and wind into warmer waters.

And what of the so-called Third Pole, the name some give to the mighty Himalayas? Though the Himalayas and the Tibetan Plateau contain far less ice than the North and South Poles, the area does boast the greatest concentration of snow and ice outside of the polar regions—Himalaya means "abode of snow" in Sanskrit. Western China and Tibet are home to more than 46,000 glaciers, and another several thousand are strung across the 1600-kilometer (994-mi) arc of the Himalayas and Hindu Kush, traversing Pakistan, India, Nepal, and Bhutan.

These frozen realms not only provide freshwater for two of the world's most populous nations, India and China, but receding Himalayan glaciers play a significant role in predictions of global sea-level rise. The Third Pole nickname reminds us how important this vast region is to life on Earth, as are the North and South Poles. –*James Martin*

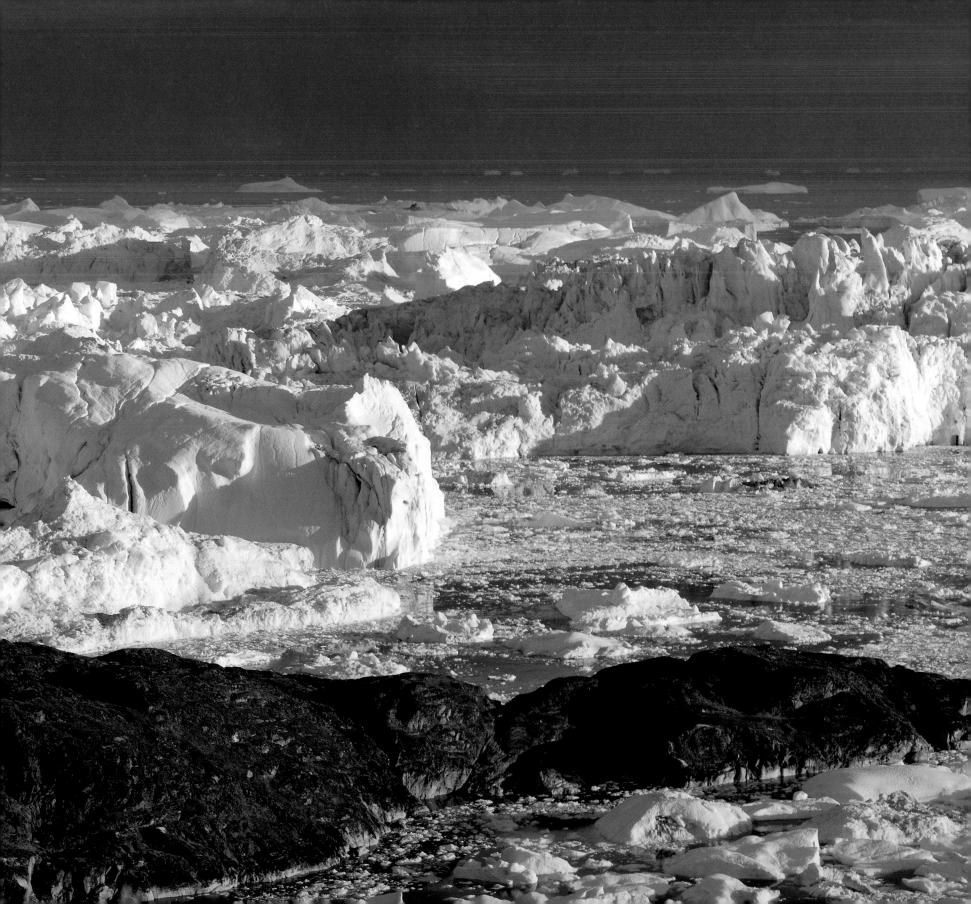

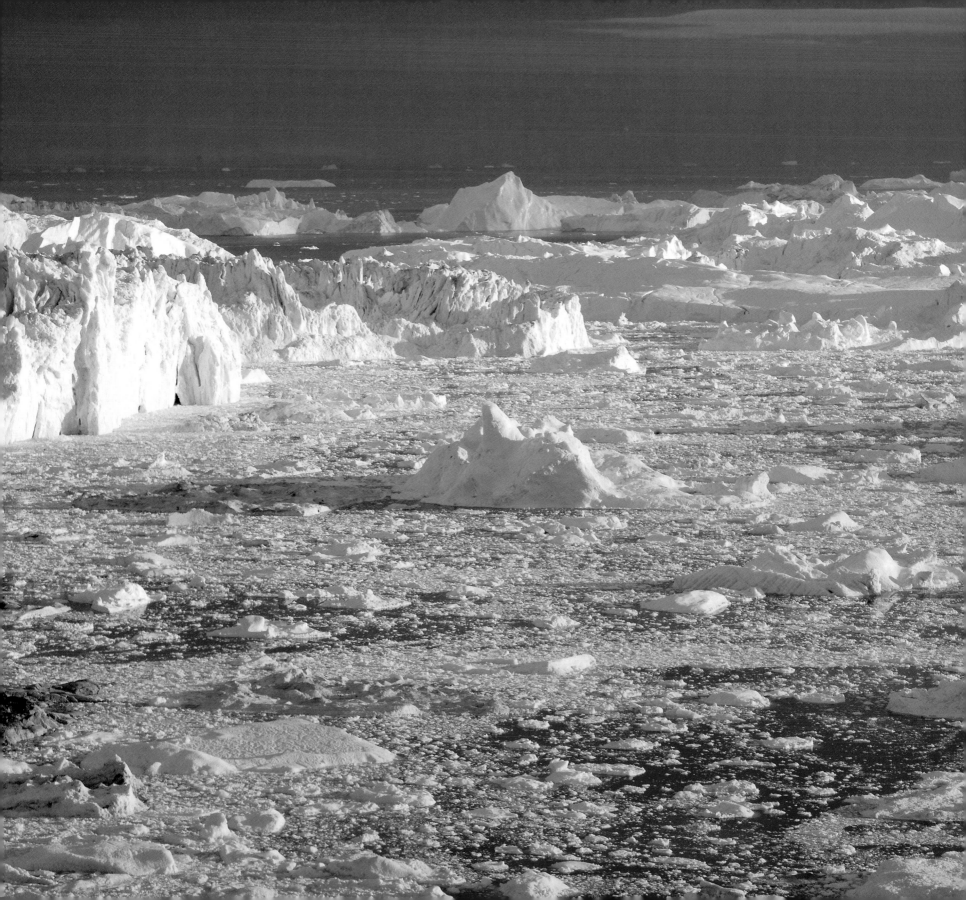

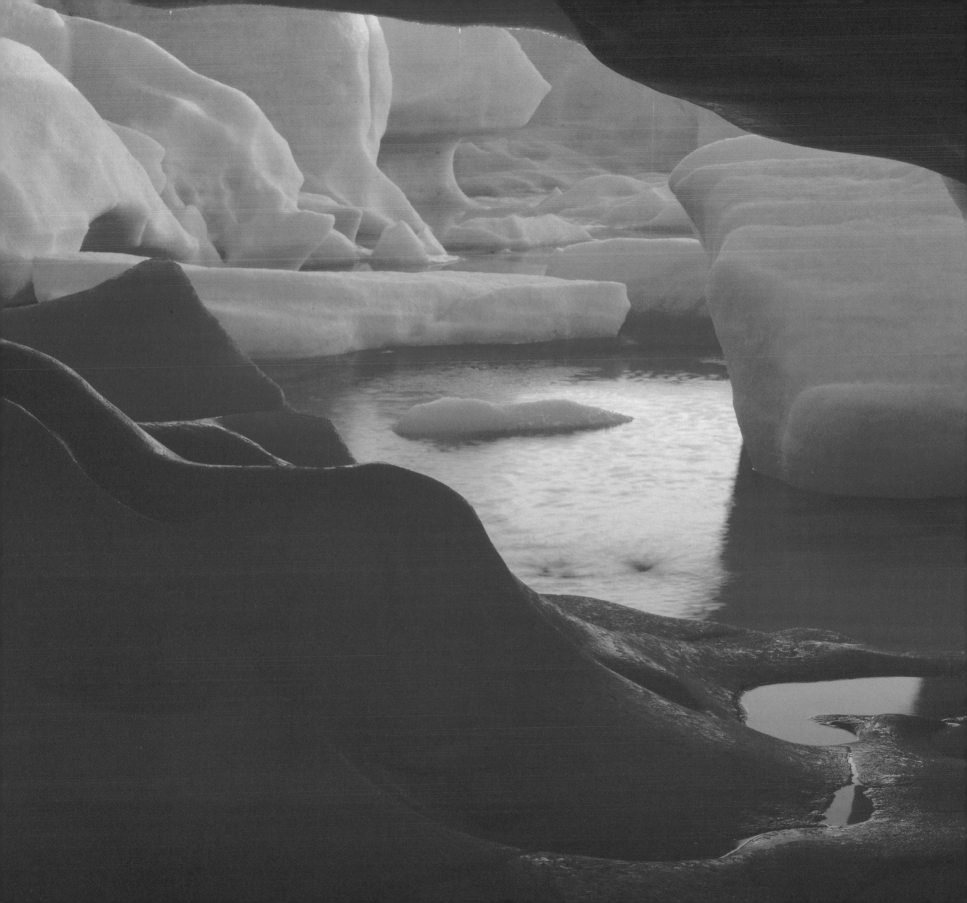

EPILOGUE
THE END OF ICE

Gretel Ehrlich

GRETEL EHRLICH began traveling in the high Arctic in 1991. She is the recipient of many awards for her writing, including a National Endowment for the Arts grant, a Whiting Award, and Guggenheim and Bellagio Fellowships. She is the author of thirteen books, including *The Solace of Open Spaces, A Match to the Heart, This Cold Heaven,* and *The Future of Ice.* A book about indigenous people and climate change is forthcoming. *Photograph courtesy of Gretel Ehrlich*

Lakes that form in summer on the surface of the Greenland Ice Sheet drain rapidly, leaving ponds and ice caves, such as the interior of this ice cave seen around midnight.

When water meets cold, ice is born. Coming from water, it is laid flat by stillness. Once formed, it lives at the beck and call of wind. Ice begets ice: below a lid of sea ice, water is waiting to freeze. But just as often, water begets water, undercutting and lubricating the sole of a glacier's foot until it slides.

Ice is heavy—it can push an island below sea level—but it can also float. It is wet and dry, hot and cold, liquid and oxygen, solid and permeable, hard and surrendering. Ice is everything and nothing that it appears to be. It is the solid aspect of emptiness and the empty aspect of solidity. Ice is leaf and lid and it shines.

Ice is eye and mirror, archivist and wastrel, a jeweled mountain and a rough floor. Pack ice grinds against shore-fast ice in roaring collisions. In autumn, sea ice comes on in silence, a black translucence, a rubbery, see-through wilderness that bends in waves underfoot, imitating and mocking what it is not, which is water.

Once, I crossed the Barents Sea under full sail between Tromso, Norway, and the Arctic islands of Svalbard and watched a whole ocean freeze. The water's skin rose in lumps, curdling, and crystalline discs rolled. Sea ice is platform, highway, drift boat, and bed ground for much that lives in the Arctic: walrus, human, seal, gull, eider duck, polar bear. There is no life without ice.

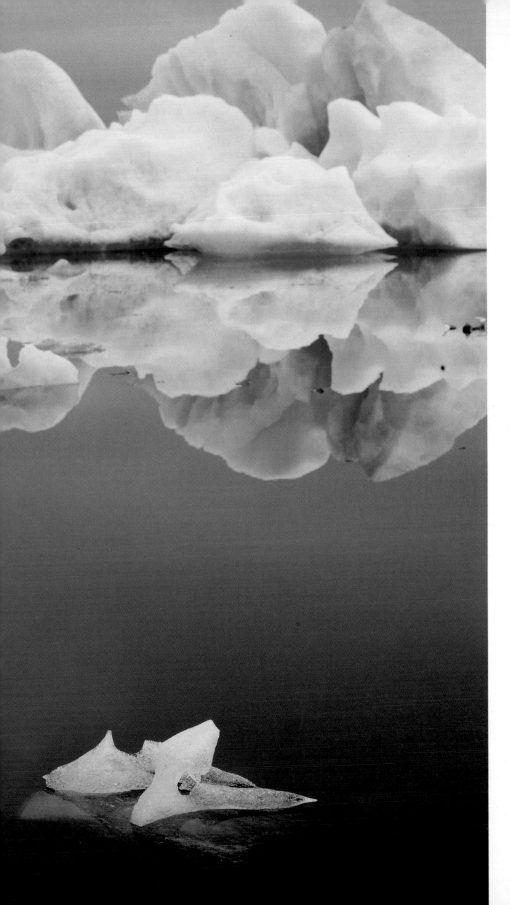

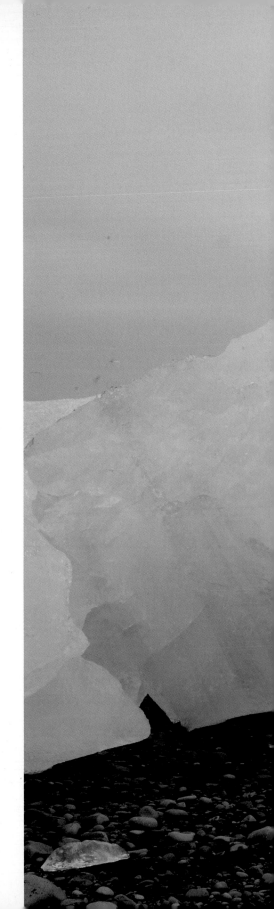

LEFT Icebergs in Iceland's
Jökulsárlón (glacier lagoon)

RIGHT When icebergs flow out to
sea from the Jökulsárlón, wind and
tide often drive them back to the
beach, where they rest like stranded
vessels.

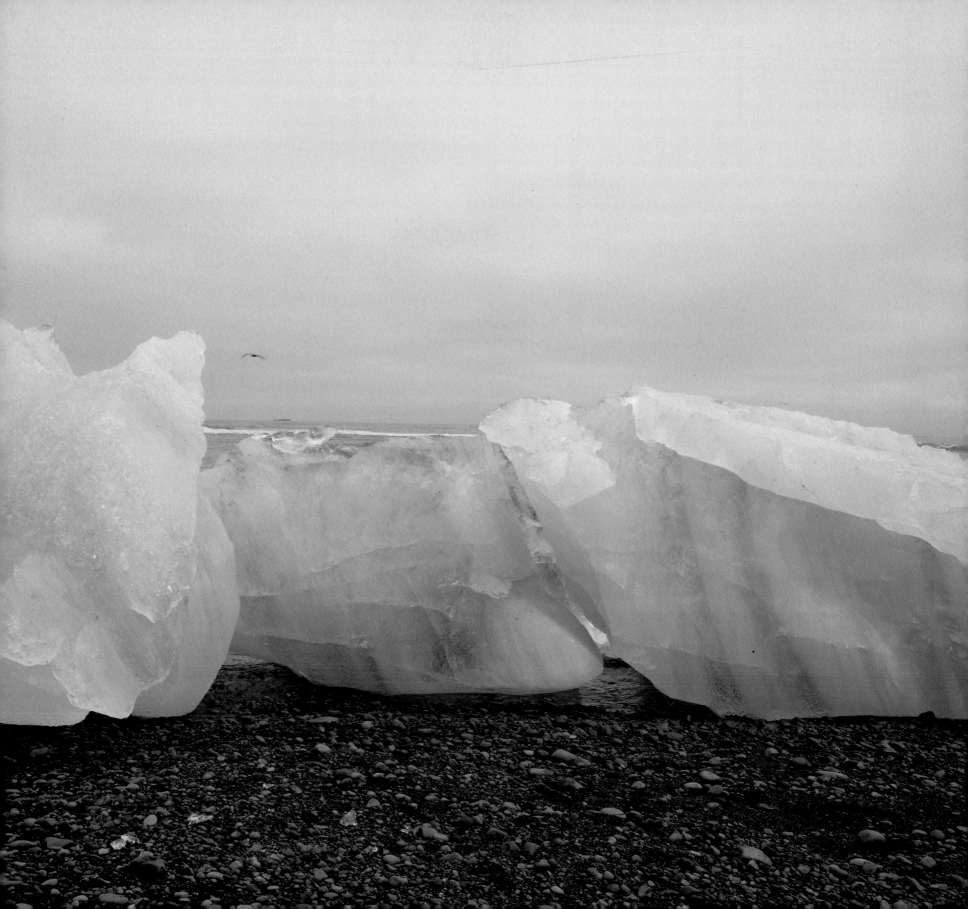

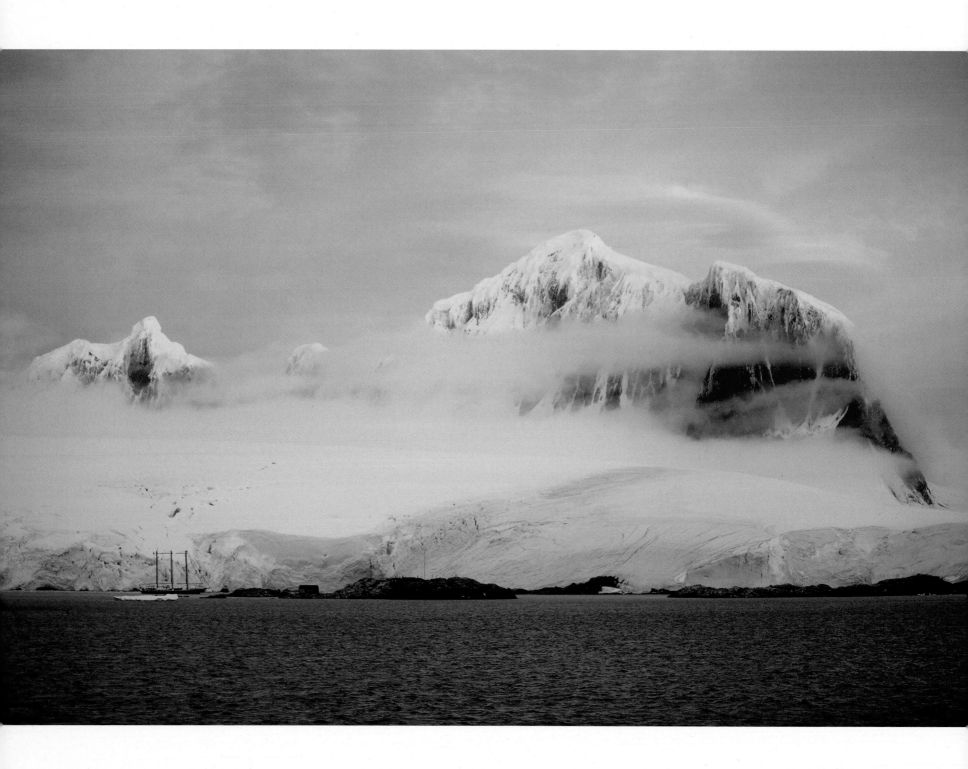

Ice is time. It can hold the climate's accumulated instants for a million years, but in a single moment, it can dump a living being, burst apart, and dissolve. Open water is a heat sink, whereas a cover of ice sends heat skyward and shelters the planet from burning. Yet early Arctic people, longing for warmth, said they remembered a time when ice burned.

Ice stands for adamantine clarity but can be mistaken for solid ground. It resembles what Tibetans call *shilap sunjuk*—thought moving with no direction, no bias, but with precision. Pushing up and over a corner of the Greenland Ice Sheet on a dogsled is like sliding over an eyeball: the glacier is all seeing, yet we, its travelers, are unable to distinguish ice from sky, seeing from thinking, the edge of the dogsled from the horizon. Though made of water, ice is its own desert, an unfurnished mind.

In the Arctic, flesh is ornament, ice is real. It can be black, white, blue, or gray. Wind-driven, it is see-through panes and timpani; in stillness, it is gong, bone, and wail. Accumulation and ablation are what a glacier is all about. Its mass balance means that what it takes, it also gives away.

Ice is time because it is always on the move. Pancake ice spins, brash ice shushes. Ice cracks and re-forms into another realm of geometry. It grinds and polishes rock as it seeks the sea. When I walk on glacial chatter marks, I walk on a glacier's walking.

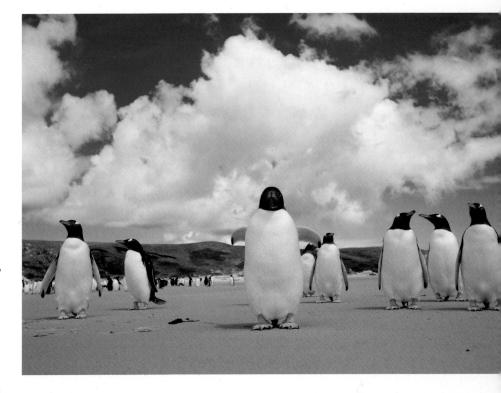

ABOVE Gentoo penguins on a beach in the Falkland Islands, a British territory also claimed by Argentina

OPPOSITE A small sailing vessel rests at anchor near Port Lockroy on Anvers Island in the Palmer Archipelago of the western Antarctic Peninsula.

~❦~

Now we are losing this world of ice. Wind waves break Arctic sea ice from beneath. Where it was once a dozen feet thick, it is now half a foot. Multiyear ice—ice that never melted in its first year—is mostly gone. New ice comes and goes, freezing and melting on a whim. *Sikuliaq*—Inuit for new ice—is salty, can't be used for drinking or cooking, and is cold on the feet. Open water begets open water: "sea smoke," a fine mist, rises from it and holds heat in a positive feedback loop, creating more open water.

Glaciers in retreat are rivers running backward and uphill. The reflective power of all snow and ice—the albedo effect that keeps the whole Earth temperate—is on the wane.

Impermanence has always been the thing, yet we deny it. Now ice is teaching us that time is running short, that the path of ice is melting. If we would only choose to transform the Gross National Product into large-scale biological health and Gross National Beauty, we might be able to preserve ice and its social, economic, spiritual, and aesthetic lessons: the way it moves effortlessly beyond boundaries, its come-and-go freedoms within its nemesis, water.

Ice teaches us about appearance and reality as they drift and collide, form walls and passages. Ice reminds us of our certain mortality and the everyday impermanence of thoughts, things, events, self-regard, and situations.

Traveling by dogsled on newly formed ice, my Inuit companion warned me that new ice is dangerous and hard to distinguish from open water. "It's easy to go under and never be seen again," he said.

We find it hard to believe that human life on the planet may be coming to an end or that our sled will go through ice into water. But if we surrender to ice's glistening, it will work on our minds and eyes. We'll understand that the water aspect of ice and the ice aspect of water are one and the same.

Ice has come to teach us how to die, my Inuit friend said, as well as how to see and how to live. Once the sheen of ice has been torn off the face of the Earth, its intoxicating beauty gone, human life may no longer be possible. ❈

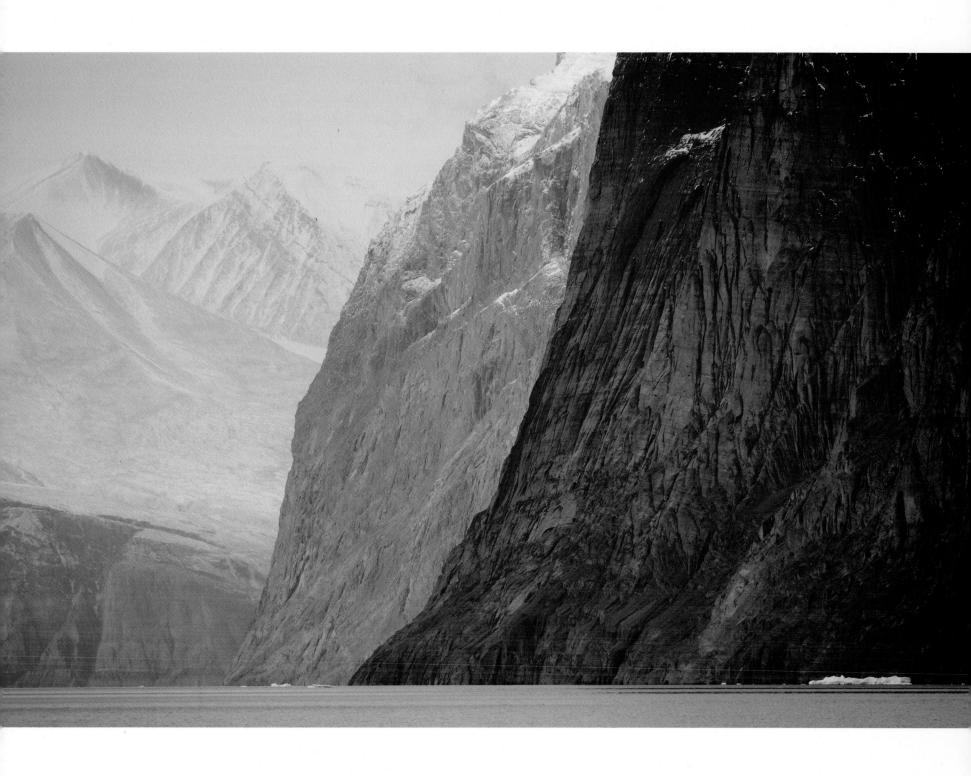

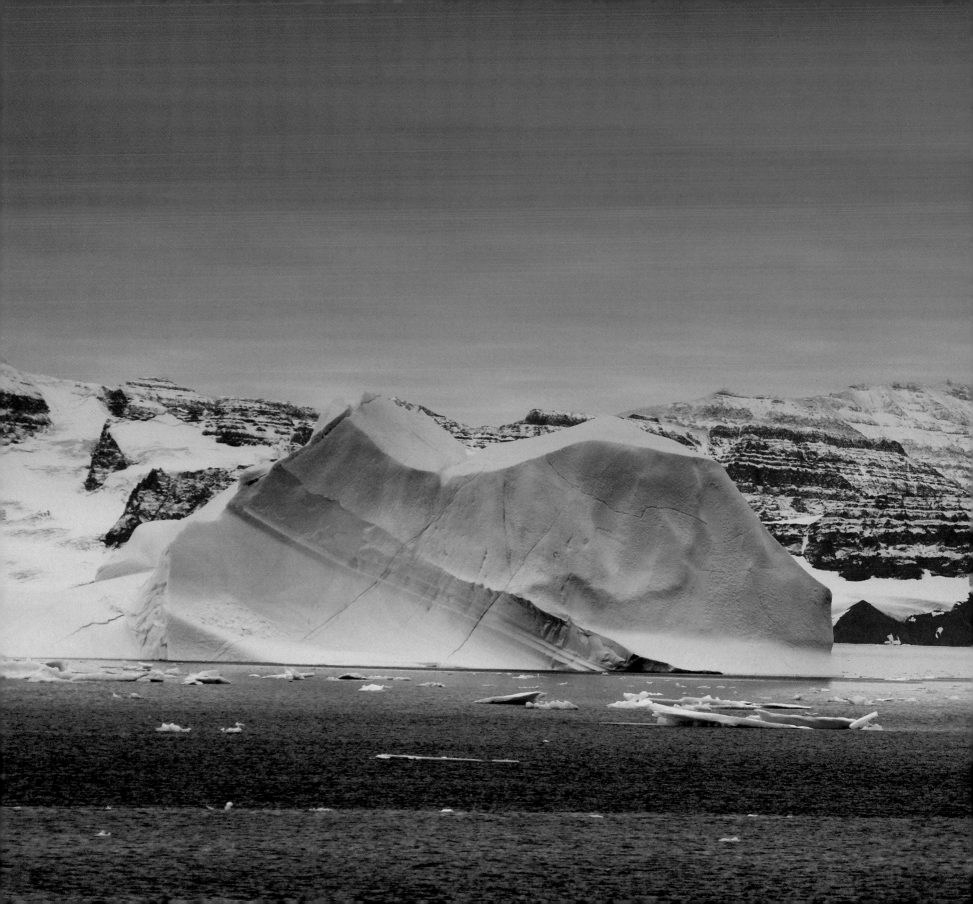

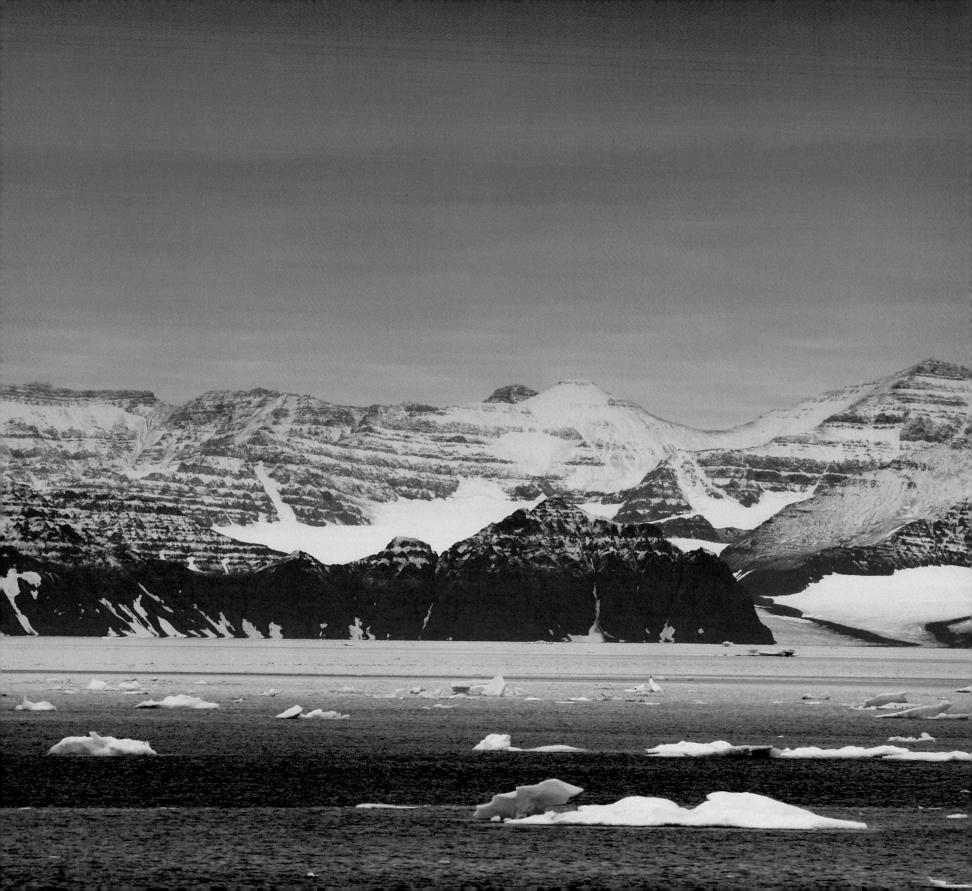

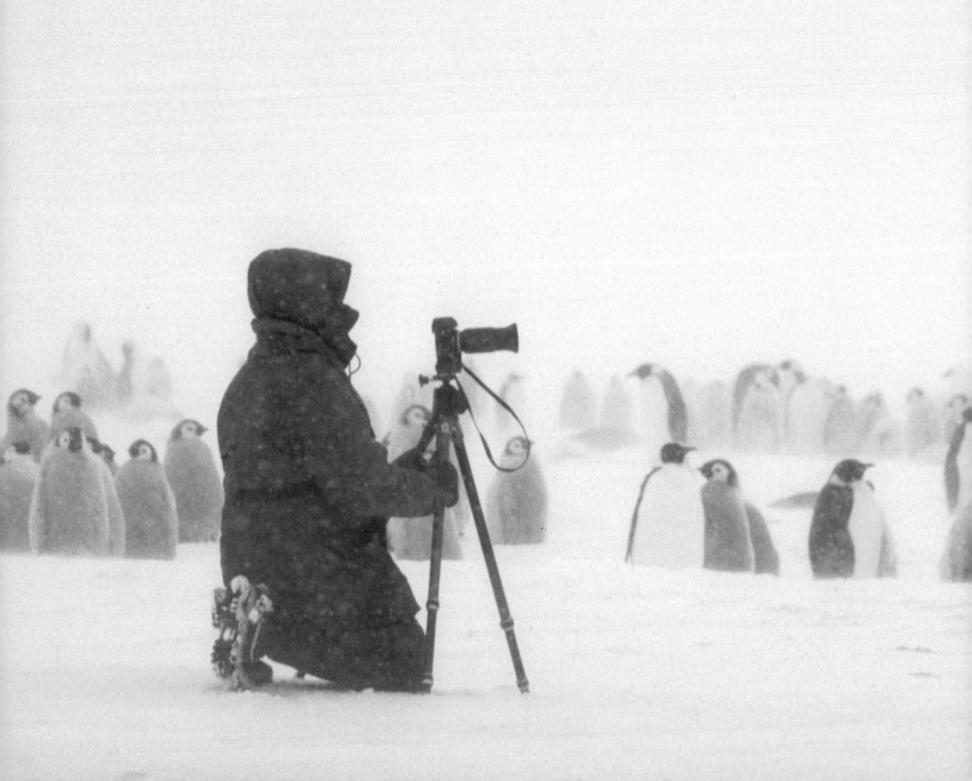

A photographer at work in an
Antarctic snowstorm, photographing
emperor penguins

PHOTOGRAPHER'S NOTES

Although I shot some of the images in this book on film as long as fifteen years ago, I photographed most of them digitally with either a Canon 1Ds or 1Ds Mark II between January 2006 and August 2008.

Lens focal length ranged from a 15mm fisheye to a 500mm telephoto with a 1.4 extender, the equivalent of a 720mm lens. Except in very difficult conditions, I used the heaviest tripod I could carry. I avoided filters except for a polarizer and a graduated neutral density filter.

Each digital image passed through Adobe Lightroom and Photoshop. I limited myself to basic color and contrast corrections. I also had to remove dust spots manually. Photomerge in Photoshop stitched adjacent images together to assemble the panoramas.

The few film images were shot with 35mm Canons and a range of medium-format cameras, always with Fuji Velvia film.

For information on this project, visit www.planeticebook.com.

ACKNOWLEDGMENTS

From James Martin

First, always, I must thank my wife, Terrie, for her encouragement, support, and forbearance during this project and in the previous decades.

I am thankful that the leading scientists in their fields agreed to contribute. I met Dr. Ian Stirling, the doyen of polar bear and Arctic seal researchers, on a ship to Antarctica. I knew him as a quiet, supremely knowledgeable man with a Canadian's imperviousness to beer. When we returned to Ushuaia, Argentina, he was met by a group of scientists so solicitous I expected them to repeat, "We're not worthy." Other ice researchers speak of Dr. Richard Alley in tones normally reserved for visitors to Graceland when speaking of the King. He has led ice core projects in Greenland and Antarctica that contributed to our understanding of climate change over hundreds of millennia. Dr. Gino Casassa, a Chilean glaciologist and an accomplished alpine climber, agreed to explain the basic science of ice.

I met Yvon Chouinard at Camp Four in Yosemite in the 1960s before he started Patagonia Inc. and when he was best known as one of the finest climbers the valley had seen. I knew his passion for the wild and wanted his personal, deeply felt perspective to bring fire to the book. I had long admired the prose of Gretel Ehrlich, as well as her acute sensitivity to the character and effects of landscape and weather on the human soul. Both Gretel and Yvon express how contact with the wild is a need we disregard at our peril. Thanks to them both.

Brot Coburn and Nick Jans help to connect how changes in the environment, in the Himalayas and the Arctic, affect cultures materially and spiritually. They added a perspective I am ill equipped to deliver. U.S. Geological Survey glaciologist Dan Fagre graciously agreed to serve as scientific advisor for the book.

I am indebted to Helen Cherullo at Braided River for green-lighting the project and to Deb Easter and Kris Fulsaas for herding the writers and especially the photographer toward the timely completion of the book. Designer Jane Jeszeck and map and illustration artist Ani Rucki added their elegant touches.

Finally, I have to thank everyone who helped me in the field, from the porters and guides in the Himalayas and Africa, to Ian Joughin at the University of Washington and the crew from Woods Hole, to the National Science Foundation for letting me hitch a ride to Greenland on a C-130, to Quark for help getting on an icebreaker voyage up the island's east coast, to Jiban Ghimire of Shangrila Treks in Nepal, and to everyone who shared information, pointed out errors, or smoothed the way.

From Richard Alley

My writings here are based on my research and that of my colleagues. This research is largely supported by taxpayers through the U.S. National Science Foundation, NASA, and other federal agencies, as well as by our universities, and I thank them. Private philanthropy also benefits us, and I thank the Comer and Packard Foundations for their support over the years.

From Nick Jans

I'm grateful to everyone who shared their expertise and insight. Special thanks to Dr. Mark Serreze of the National Snow and Ice Data Center; Dr. Steven Amstrup of the U.S. Geological Survey; Mayor Edward Itta of the North Slope Borough; Daniel Agoochuk; and the many Iñupiaq who, over the years, have been good friends, travel companions, and neighbors.

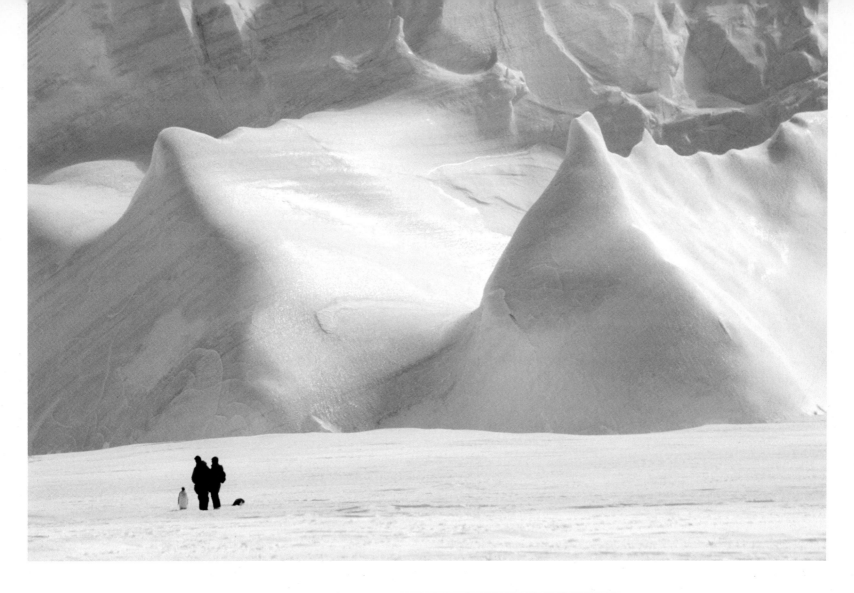

On the frozen Weddell Sea, two tourists and a lone emperor penguin are dwarfed by stranded icebergs.

From Braided River

The publisher wishes to thank U.S. Geological Survey glaciologist Daniel B. Fagre for his assistance in reviewing the scientific information in *Planet Ice*, as well as for his ongoing work on behalf of the glaciers of Glacier National Park, Montana, and elsewhere. Fagre, research ecologist for the USGS Northern Rocky Mountain Science Center in West Glacier, Montana, is director of the Climate Change in Mountain Ecosystems Project. He holds a PhD and has authored more than 120 publications and three books.

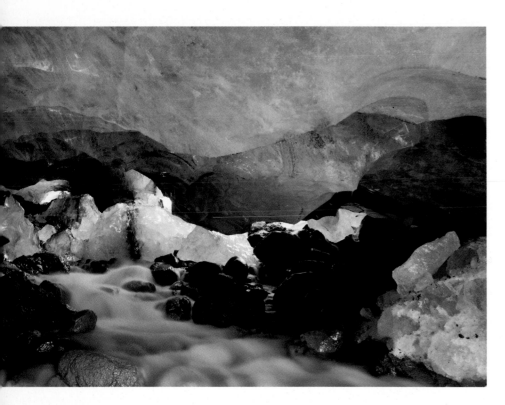

Inside an ice cave in the disintegrating toe of a glacier in Iceland, rockfall and the deep thump of falling ice blocks resound.

RESOURCES

Center for Remote Sensing of Ice Sheets, founded by National Science Foundation in 2005: *www.cresis.ku.edu/education/iceicebaby.html*

Glaciers Online: *www.swisseduc.ch/glaciers/earth_icy_planet/index-en.html*

Glaciology Group, California Institute of Technology's Division of Geological and Planetary Sciences, supported by National Science Foundation: *http://skua.gps.caltech.edu/hermann/ice.htm*

International Centre for Integrated Mountain Development, serves the eight countries of the Hindu Kush–Himalayas: *www.icimod.org*

Magellan Penguin Project, research organization directed by Dr. Dee Boersma, University of Washington professor of biology, sponsored by Wildlife Conservation Society, among others: *www.penguinstudies.org*

Mountain Forum, publisher of *Asia Pacific Mountain Network (APMN) Bulletin*: *www.mtnforum.org*

Mountain Research and Development, quarterly journal published by International Mountain Society and U.N. University: *www.mrd-journal.org*

National Ice Center, operated by U.S. Navy, National Oceanic and Atmospheric Administration, and U.S. Coast Guard: *www.natice.noaa.gov*

National Snow and Ice Data Center, Boulder, Colorado: *www.nsidc.org*

Penguin Science, a collaboration of private and nonprofit research organizations funded by National Science Foundation, U.S. Antarctic Program, and New Zealand Antarctic Program: *www.penguin science.com*

Practical Action, founded by Dr. E. F. Schumacher in 1966: *www.practical action.org*

RealClimate: *www.realclimate.org*

Reynolds Geo-Sciences Ltd., independent geological and geophysical consultants: *www.geologyuk.com*

60-Second Science, *Scientific American*'s quick hit on science and technology: *www.sciam.com/blog/60-second-science/index.cfm*

United States Antarctic Program, managed by National Science Foundation's Office of Polar Programs: *www.usap.gov*

World Glacier Monitoring Service, University of Zurich's Department of Geography, since 1986 continuing international glacier monitoring begun in 1894 by International Glacier Commission: *www.geo.uzh.ch/wgms*

SUGGESTED READING

Adhikari, D. P. "Climate Change and Geoenvironmental Concerns in the Mountains." *Asia Pacific Mountain Network Bulletin* 8, no. 2 (winter 2007): 1–4.

Alley, Richard B. *The Two-Mile Time Machine: Ice Cores, Abrupt Climate Change, and Our Future.* Princeton: Princeton University Press, 2002.

Arctic Climate Assessment Group. *Arctic Climate Impact Assessment.* New York: Cambridge University Press, 2005.

Braasch, Gary. *Earth Under Fire: How Global Warming Is Changing the World.* 2nd ed. Berkeley: University of California Press, 2009.

Brown, Lester R. "Melting Mountain Glaciers Will Shrink Grain Harvests in China and India." Earth Policy Institute, March 20, 2008.

Byers, Alton C. "An Assessment of Contemporary Glacier Fluctuations in Nepal's Khumbu Himal Using Repeat Photography." *Himalayan Journal of Sciences* 4, no. 6 (2007): 21–26.

Chouinard, Yvon. *Climbing Ice.* San Francisco: Sierra Club Books, 1978.

Coburn, Broughton. *Aama in America: A Pilgrimage of the Heart.* New York: Anchor, 1996.

———. *Everest: Mountain Without Mercy.* Washington, DC: National Geographic Books, 1997.

———. *Triumph on Everest: A Photobiography of Sir Edmund Hillary.* Washington, DC: National Geographic Children's Books, 2003.

Connell, Evan S. *The White Lantern.* New York: Farrar, Straus & Giroux, 1989.

Douglas, Ed. "How to Grow a Glacier," *New Scientist* 2641, February 2, 2008.

Ehrlich, Gretel. *This Cold Heaven: Seven Seasons in Greenland.* New York: Vintage, 2003.

———. *The Future of Ice: A Journey into Cold.* New York: Vintage, 2005.

Gore, Al. *An Inconvenient Truth: The Planetary Emergency of Global Warming and What We Can Do About It.* New York: Rodale, 2006.

Gurung, Gehendra Bahadur. "A Coping Strategy to the Impacts of Climate Change in Mountain Regions of Nepal," *Mountain Forum Bulletin* 8, no. 1 (January 2008): 24–26.

Hewitt, Kenneth. "Glaciers of the Karakoram Himalaya, Climate Change and Water Supply Concerns." *Asia Pacific Mountain Network Bulletin* 8, no. 1 (summer 2007): 1–4.

Jans, Nick. *The Last Light Breaking: Living Among Alaska's Iñupiat Eskimos.* Portland, OR: Alaska Northwest Books, 2007.

———. *A Place Beyond: Finding Home in Arctic Alaska.* 2nd ed. Portland, OR: Alaska Northwest Books, 2009.

Kaser, G., and H. Osmaston. *Tropical Glaciers* International Hydrology Series. Cambridge: Cambridge University Press, 2002.

Kazlowski, Steven. *The Last Polar Bear: Facing the Truth of a Warming World.* Seattle: Braided River/The Mountaineers Books, 2007.

Kolbert, Elizabeth. *Field Notes from a Catastrophe: Man, Nature, and Climate Change.* New York: Bloomsbury USA, 2006.

Lemke, P., et al. "Observations: Changes in Snow, Ice and Frozen Ground." In *Climate Change 2007: The Physical Science Basis. Contribution of Working Group I to the Fourth Assessment Report of the Intergovernmental Panel on Climate Change,* edited by S. Solomon, D. Qin, M. Manning, Z. Chen, M. Marquis, K. B. Avery, M. Tignor, and H. L. Miller, 337–383. Cambridge and New York: Cambridge University Press, 2007.

"Melting Asia." *The Economist,* June 5, 2008.

Orlove, Ben, Ellen Wiegandt, and Brian H. Luckman, eds. *Darkening Peaks: Glacier Retreat, Science, and Society.* Berkeley: University of California Press, 2008.

Post, Austin, and Edward LaChapelle. *Glacier Ice.* Rev. ed. Seattle: University of Washington Press, 2000.

Rosenzweig, C., G. Casassa, et al. "Assessment of Observed Changes and Responses in Natural and Managed Systems." In *Climate Change 2007: Impacts, Adaptation and Vulnerability. Contribution of Working Group II to the Fourth Assessment Report of the Intergovernmental Panel on Climate Change,* edited by M. L. Parry, O. F. Canziani, J. P. Palutikof, P. J. van der Linden, and C. E. Hanson, 79–131. Cambridge: Cambridge University Press, 2007.

Sharp, Robert P. *Living Ice: Understanding Glaciers and Glaciation.* Cambridge: Cambridge University Press, 1991.

Stirling, Ian. *Polar Bears.* Ann Arbor: University of Michigan Press, 1999.

United Nations Environmental Programme. *Global Outlook for Ice and Snow.* Birkeland Trykkeri A/S, Norway: UNEP/GRID-Arendal, 2007.

United Nations Environmental Programme World Glacier Monitoring Service. *Global Glacier Changes: Facts and Figures.* New York: UNEP, WGMS, DEWA/GRID-Europe, 2008.

Williams, T. *The Penguins.* Oxford: Oxford University Press, 1995.

Wohlforth, Charles. *The Whale and the Supercomputer: On the Northern Front of Climate Change.* New York: North Point Press, 2004.

INDEX

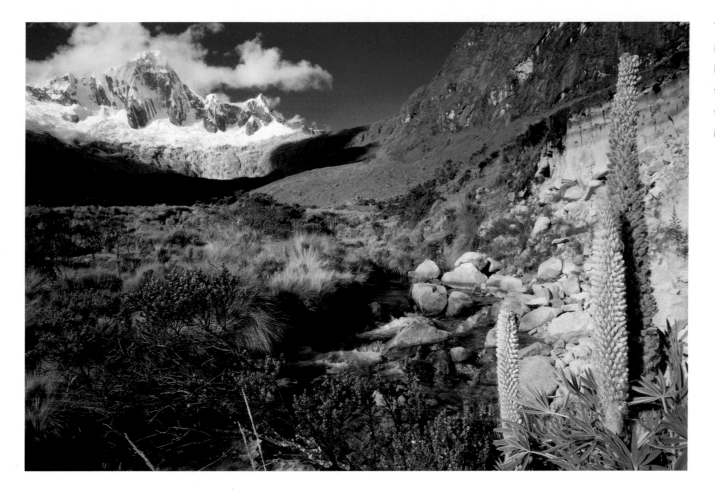

The Cordillera Blanca, in the Peruvian Andes, lost 22 percent of its ice from 1970 to 2007—and the rate of melting has increased tenfold.

Braided River, founded in 2008, is a nonprofit organization that combines the arts of photography, literature, and journalism to build broader public support for wilderness preservation campaigns—and to inspire public action—through books, multimedia presentations, and museum exhibits. Please visit www.BraidedRiver.org for more information on projects, events, exhibits, speakers, and how to contribute to this work.

Braided River books are published by The Mountaineers Books. Information on the imprint may be found at www .BraidedRiverBooks.org. Braided River books may be purchased for corporate, educational, or other promotional sales. For special discounts and information, contact our sales department at (800) 553-4453 or mbooks@mountaineersbooks.org.

BRAIDED RIVER
CHANGING PERSPECTIVES

1001 SW Klickitat Way, Suite 201
Seattle, WA 98134
www.BraidedRiver.org
www.BraidedRiverBooks.org

First edition 2009

Manufactured in China on ancient-forest-friendly paper with 100% recycled content. Carbon offset credits were purchased to offset the emissions generated by the paper manufacturing, printing, and ocean freight.

Project Manager: Kris Fulsaas
Acquisition Editors: Helen Cherullo, Deb Easter
Directors of Editorial and Production: Kathleen Cubley, Margaret Sullivan
Developmental Editors: Deb Easter, lead editor; Christine Clifton-Thornton; Margaret Foster; Linda Gunnarson; Julie Van Pelt
Copyeditors: Laura Case, Julie Van Pelt
Cover Design: Jane Jeszeck, Jigsaw / www.jigsawseattle.com
Book Design and Layout: Jane Jeszeck, Jigsaw
Map Art and Design: Ani Rucki, Bees Knees Studio
Illustrations: Ani Rucki, Bees Knees Studio; Jennifer Shontz (page 87)

Cover: *Tabular icebergs at sunset in the southern Atlantic Ocean off the Antarctic Peninsula*
Back Cover: *A pair of king penguins meet over their nest on South Georgia Island.*

Library of Congress Cataloging-in-Publication Data
Martin, James, 1950-
 Planet ice : a climate for change / photographs by James Martin ;
essays by Yvon Chouinard ... [et al.]. — 1st ed.
 p. cm.
 Includes bibliographical references and index.
 ISBN 978-1-59485-085-1
 1. Ice—Antarctica—Pictorial works. 2. Ice—Arctic regions—Pictorial works. 3. Ice—Greenland—Pictorial works. 4.Global environmental change—Pictorial works. 5. Climatic changes—Environmental aspects—Pictorial works. I. Chouinard, Yvon, 1938- II. Title.
 GB2403.6.M37 2009
 508.311—dc22
 2009014826